THE CHESLEY AWARDS

FOR SCIENCE FICTION & FANTASY ART

A RETROSPECTIVE

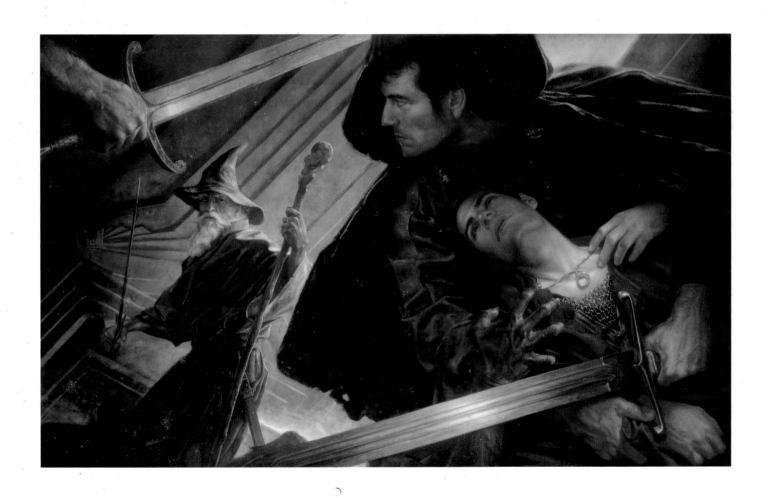

JOHN GRANT AND ELIZABETH HUMPHREY
WITH PAMELA D. SCOVILLE

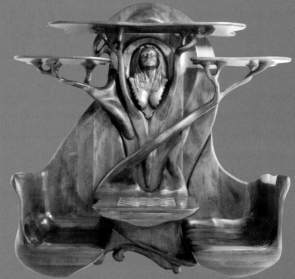
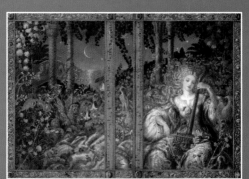

THE CHESLEY AWARDS

FOR SCIENCE FICTION & FANTASY ART

A RETROSPECTIVE

JOHN GRANT AND ELIZABETH HUMPHREY
WITH PAMELA D. SCOVILLE

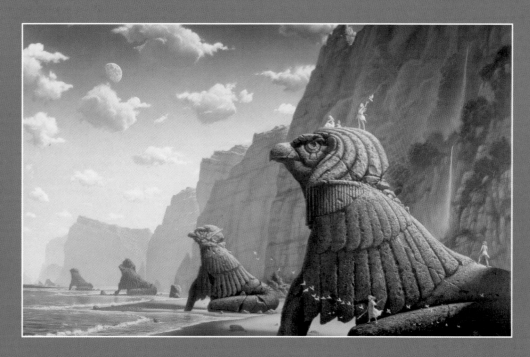

DEDICATIONS

I want to dedicate my effort in this book to my sweet family. Michael my husband, Aja, my older daughter, and Rhianna, the younger, have inspired the wonder and joy in my life that allow me to do this kind of work. I want to thank them for putting up with me while I disappeared into the abyss of email, phone calls and endless hours of mumbling at a computer screen. I love you dearly – thank you for making my dreams come true.
Elizabeth Humphrey

This book is, like life itself, for Pam and Jane.
John Grant

THE CHESLEY AWARDS

Published in Great Britain and USA by
AAPPL Artists' and Photographers' Press Ltd
10 Hillside
London SW19 4NH UK
info@aappl.com www.aappl.com

Sales and Distribution
UK and export : Windsor Books Intl., windsorbooks@compuserve.com
USA and Canada: Sterling Publishing Inc., NY sales@sterlingpub.com

ISBN 1-904332-10-2

Editor: Paul Barnett
Art Director and Designer: Malcolm Couch
Reproduction and printing by: Imago Publishing info@imago.co.uk

Half-title page
Donato Giancola: *The Lord of the Rings* (1999)

Title spread, left to right
Jean Pierre Targete: *Circle at Center* (2000) . Michael Dashow: *The Rhinoceros Who Quoted Nietzsche* (1997)
Tom Kidd: *The Far Kingdoms* (1993) . Barclay Shaw: *Ellison Wonderland Chess Table* (1995)
Bob Eggleton: *The Howling Stones* (1998) . Kinuko Y. Craft: *Song for the Basilisk* (1998)
Jody Lee: *The Oathbound* (1988) . Stephen Hickman: *Norhala of the Lightnings* (2002)
Michael Whelan: *Sentinels* (1986) . Vincent Di Fate: *To Bring in the Steel* (1978)
Todd Lockwood: *Swashbuckler* (2000)

CONTENTS

THE CHESLEY AWARDS

FOREWORD · RON MILLER

THE CHESLEY AWARDS honour Chesley Bonestell, the euphoniously named astronomical painter whose life spanned almost the entirety of the twentieth century. Born before motion pictures were even invented, he contributed to some of the artform's greatest classics. A college dropout, he helped design some of the great US architectural icons of his century. Born when Robert Goddard was only 6 years old and the Wright brothers just 21 and 18, Bonestell lived to see humans land and walk on the moon. Indeed, he was instrumental in making possible that crowning achievement of the last century.

Born in San Francisco in 1888, Bonestell studied architecture at New York's Columbia University. Dropping out in his third year, he worked as a renderer and designer for several of the leading architectural firms of the time. While with William van Alen, he designed the façade of the Chrysler Building as well as its distinctive "gargoyles". Returning to

the West Coast, he worked on the Golden Gate Bridge, where he illustrated the various stages of the bridge's construction as well as contributing to the final design. When the Depression dried up architectural work in the United States, Bonestell went to Britain, where he rendered architectural subjects for the *Illustrated London News*. Instead of returning to New York when he came back to the US in the late 1930s, he went to Hollywood. There he used his talent for realistic painting to work as a special-effects artist, creating matte paintings for such films as *Citizen Kane*, *The Magnificent Ambersons* and *The Hunchback of Notre Dame*.

Eventually becoming the highest-paid matte artist in Hollywood, Bonestell realized that he could combine what he'd learned about camera angles and painting techniques with his lifelong interest in astronomy. The result, a series of paintings of Saturn as seen from several of its moons, was published in *Life* in 1944. Nothing like these had ever been

ABOVE:
Liebnitz

RIGHT:
Saturn as seen from Titan
From *The Conquest of Space* (1949)

FACING PAGE:
Chesley Bonestall

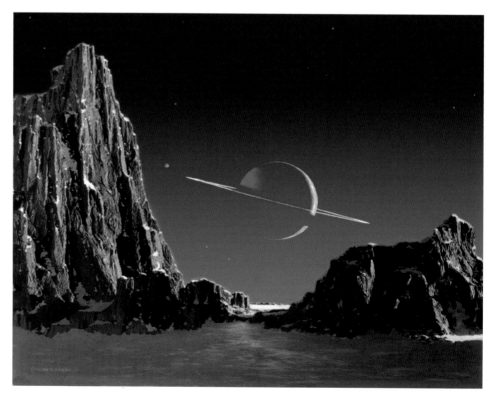

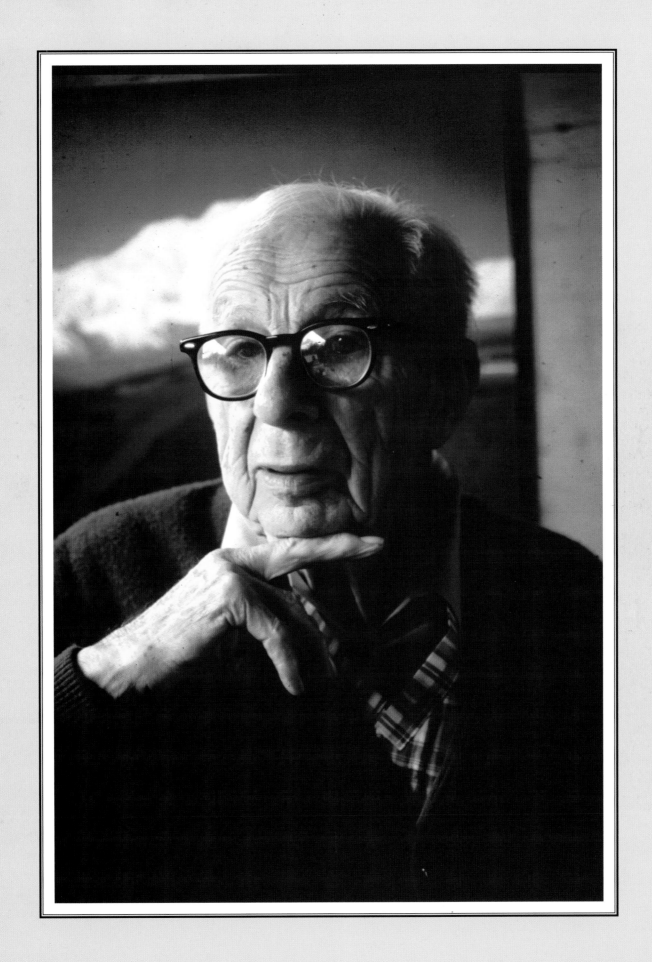

seen before: they looked like excerpts from a *National Geographic* expedition into the future. Bonestell followed up the sensation these paintings created by publishing further astronomical and space paintings in *Life* and other leading national magazines. Many of these were eventually collected in book form as *The Conquest of Space* (1950), which immediately became a best seller. Meanwhile, Bonestell did his final stint in Hollywood, contributing special-effects art and technical advice to the seminal science fiction films produced by George Pal, such as the semi-documentary classic *Destination Moon*.

When Wernher von Braun organized a spaceflight symposium for *Collier's* magazine, he invited Bonestell to illustrate his concepts for the future of spaceflight. If the *Life* paintings caused a sensation, the *Collier's* series started a revolution. For the first time, spaceflight was shown to be a matter of the immediate future and not a Buck Rogers fantasy for the twenty-fifth century. Von Braun and Bonestell showed that it could be accomplished with the technology existing in the mid-1950s, and that the only questions concerned money and will. Coming as it did at the beginning of the Cold War and just before the sobering shock of the launch of Sputnik, the *Collier's* series was a powerfully influential kick-start to the US space program.

As appropriate as it is, in some ways it is also ironic that the awards presented by the members of the Association of Science Fiction and Fantasy Artists (ASFA) are named "Chesleys" in honour of Bonestell. The artist himself always denied any interest in science fiction. "I simply have always felt that truth is stranger than fiction," he wrote. "It is an old saying, but that's really so . . . The size of the galaxy to me was always more wonderful than the trash of science fiction. Now, I made a good deal of money doing science fiction covers, but I love money, too."

Some of Chesley's avowed disapproval of science fiction may have to be taken with a grain of salt, if for no other reason than that he very much enjoyed playing the curmudgeon. But in truth, most of his science-fiction magazine covers were not commissioned but were submitted by the artist on speculation. And a great many of these depicted ideas and themes that were clearly sciencefictional (as opposed to science-inspired like those for *Life*, *Collier's* and *The Conquest of Space*). To take just one example, there is his grim painting of a spaceship destroyed by collision with an asteroid, complete with mangled bodies of the astronauts. That he could do, and did, such artwork on his own seemed to demonstrate a familiarity with science fiction that certainly belied – at least to some degree – his dislike of the genre.

Bonestell died in 1986 with an unfinished painting on his easel. By then he had been honoured internationally for the contribution he had made to the birth of modern

Mercury
Scientific American 1948

astronautics, from a bronze medal awarded by the British Interplanetary Society to a place in the International Space Hall of Fame to the naming of an asteroid for him. His paintings are prized by collectors and institutions such as the National Air & Space Museum and the National Collection of Fine Arts. Today there are few participants in the aerospace industry – from engineer to astronaut – who do not acknowledge Bonestell's influence on their careers. One of his classic paintings, an ethereally beautiful image of Saturn seen from its giant moon Titan, has been called "the painting that launched a thousand careers". Wernher von Braun wrote that he had "learned to respect, nay fear, this wonderful artist's obsession with perfection. My file cabinet is filled with sketches of rocket ships I had prepared to help in his artwork – only to have them returned to me with . . . blistering criticism." Carl Sagan once said that he had no idea what the planets really looked like until, as a youngster, he saw Bonestell's paintings. Chesley Bonestell, Arthur C. Clarke summed up, "had a wonderful life and saw nearly all of his dreams come true . . . I hope that his name will appear on maps of the worlds he drew before the Space Age dawned."

Ron Miller
Bonestell Space Art

THE CHESLEY AWARDS

INTRODUCTION

IN A BANQUET HALL glowing red and gold with plush carpet and rich wallpaper, a typical fixture of convention centres and grand hotels the world over, people move about the room, busy with their appointed tasks. The mood is light though nervous; one can feel the anticipation crawling through the hairs on the back of the neck. Brand new padded folding chairs, aligned in rows, each bear a neatly folded program book, awaiting the imminent flow of guests, both esteemed professionals and curious onlookers. All that is left is to unwrap the glittering slabs of dark crystal, aglow with their very own spinning stars, and give them one last buff so that they will glitter just so for the proud recipients . . .

It is an hour before the 2001 Chesley Awards Ceremony in Philadelphia. A wonderful collection of artists and art professionals will soon find out that their dedication and hard work in the previous year have met the high standards recognized as the best in the industry.

The Chesley Awards celebrate the fantastic arts within the literary genres of science fiction and fantasy. Established by the Association of Science Fiction and Fantasy Artists (ASFA) in 1985, they were initially called the ASFA Awards; the name-change was made in honour of the master astronomical artist Chesley Bonestell after his death in 1986. Created as the only peer-driven accolades of their kind, they are meant to highlight the outstanding talent and dedication of the many artists who create the amazing imagery bringing visual life to the fantastic concepts expressed in the literature and other media of the fantasy and science fiction genres.

Long before there were movies or television – or even the written word – there were artists devoted to bringing the images of the wondrous and fantastic into our mundane lives. From the very beginning, man has held some concept of creatures, places and things that transcend the basic understanding of the tangible world. Experiences and ideas that were bigger than life and frequently imparted knowledge to the benefit of the species drove the imagination to create amazing expressions of mystery and awe. These concepts held our dreams, our hopes and our fears; and, being the social creatures we are, it was not surprising that we were compelled to share them. It is thought by many that this very same desire for expression was the foundation of myth, and that it frequently went hand in hand with the spiritual concepts of our lives. And these seeds of wonder continue to inspire us to even more fundamental understandings of who we are, why we are here and, perhaps, where we are going.

Whether they take the form of prehistoric paintings in caves, carvings found in ancient tombs or the illustration on the cover of a best-selling fantasy/science fiction novel in your local bookstore, the artistic expressions of the human experience of wonder, mystery or even fear have ever been a driving force for the imagination. This imagination feeds upon itself, continually creating new and inspiring examples. Simply stated, it is the very same imagination that helps make our lives interesting and meaningful. In the past century or more, the overlapping literary genres of science

LEFT:
RICHARD BOBER
Cleopatra 2000

fiction and fantasy have become permanent parts of our cultural identities. And, of course, extraordinary artists have risen to the challenge of giving these literary genres visual form.

At some point very early on, and certainly before the emergence of the distinction between science fiction and the rest of fantasy, fantasy became a vehicle not just for amazement and entertainment but for inspiration and hope, and sometimes even for prophetic vision and warning. It takes a bold and daring talent to relay concepts and experiences with that kind of depth and complexity. Not surprisingly, artists devoted to the fantastic regularly dazzle us with that same special breed of talent.

Generations of aspiring artists, writers, philosophers, engineers, astronomers, physicists and scientists of all kinds – and even politicians – have been inspired by great artists such as J. Allen St. John, Frank R. Paul, Richard M. Powers and Chesley Bonestell, or by the earlier masters: Hieronymus Bosch, Richard Dadd, Leonardo da Vinci, René Magritte and others too many to mention. Appropriately enough, as the speed and accuracy by which we are able to share art increases exponentially thanks to advances in communications technology, new artists and media appear with equal vigour to illustrate the growth and the constantly changing directions of science fiction and fantasy.

By the latter part of the twentieth century the art of fantasy and science fiction had become too wondrous to keep hidden behind the auspices of a then poorly defined market. A whole new artistic genre was finally coming into its own. It seems only natural in hindsight that an organization of artists and associated professionals would spring up in the fantasy and science fiction industry. This new entity was created to encourage and support the continued advancement of the artistic talent and vision that set the genre apart. It came to be known as the (international) Association of Science Fiction and Fantasy Artists (ASFA).

This new organization became a badly needed resource for the stereotyped – far too often with good reason! – solitary, struggling artists who chose to pursue the wonder they caught a glimpse of when they read their first fantasy or science fiction classic. ASFA was created to advance not only the art, through promotion and education, but the artists as well. It was obvious that artists focusing on the fantastic worked in a broad range of styles, techniques and media and likewise seemed to utilize a myriad of business strategies. To complicate matters even worse, the artists were spread across an extremely broad geographic area.

Soon ASFA was creating a network of individuals, resources and educational materials designed to help the artist move more efficiently within the fantasy and science fiction industry. To the amateur artist and the art enthusiast, ASFA opened up a whole new world of information. To the professional artist it not only offered a means of reaching out to others within the industry, it helped create new business

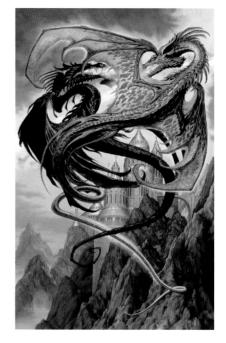

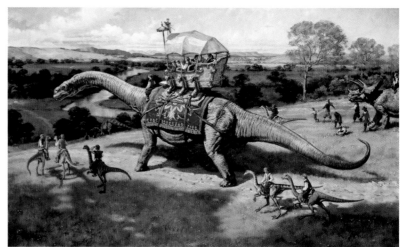

TOP RIGHT:
STEPHEN HICKMAN
Redeeming the Lost 2001

TOP LEFT:
KINUKO Y. CRAFT
Song for the Basilisk 1999

ABOVE:
JAMES GURNEY
The Excursion 1994

RIGHT:
FRANK FRAZETTA
Pencil sketch 1995

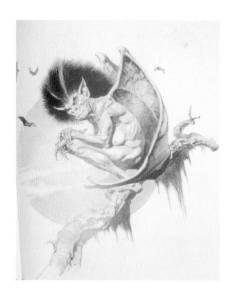

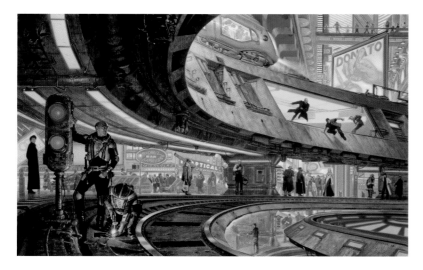

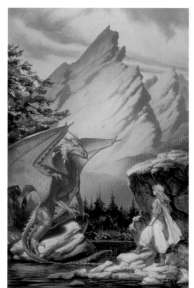

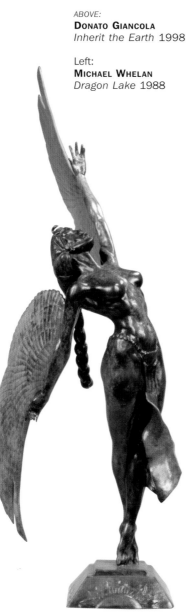

ABOVE:
DONATO GIANCOLA
Inherit the Earth 1998

Left:
MICHAEL WHELAN
Dragon Lake 1988

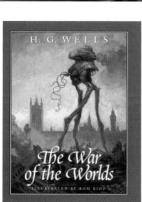

ABOVE:
TOM KIDD
The War of the Worlds 2002

RIGHT:
CLAYBURN MOORE
Celestial Jade 1992

strategies that began to bridge the gulf between publishing and private patronage.

I sometimes wonder if ASFA created the Chesley Awards after the fact or if the need for such awards was actually part of the inspiration to create ASFA. It is not infrequent to hear some of the founding members say that for years they had thought there was a real necessity to recognize the variety of artists specializing in fantastic art. Creating an annual award seemed a perfect way of doing just that; and the Chesleys follow in a long tradition of recognizing extraordinary talent within the genre. The Chesleys are very much the artist's counterpart to the writer's Nebula Awards, which, voted on by fellow writers, have highlighted literary science fiction achievements for the past three and a half decades. What makes the Chesleys stand apart from all the other major awards in the fantasy and science fiction world is that the focus is strictly on the art. It is not surprising that the Chesleys have become the foremost peer-initiated awards of their kind in the world.

Traditionally the Chesleys are presented annually at the World Science Fiction Convention (WorldCon), usually slated for the Labor Day weekend at the end of August and/or the beginning of September. There are currently twelve categories in which awards are given every year, although on extremely rare occasion a special and unique Chesley is awarded. The twelve annual categories into which the nominations for excellence are organized are listed as follows:

Cover Illustration, Hardbound Book
Cover Illustration, Softbound Book
Cover Illustration, Magazine
Interior Illustration
Monochrome Work, Unpublished
Colour Work, Unpublished
Three-Dimensional Art
Gaming-Related Illustration
Product Illustration
Art Director
Artistic Achievement
Outstanding Contribution to ASFA

When a specific work is involved, it must have been released to the public within the current award year, which is the calendar year prior to the date of the award. The Chesley for Best Art Director is likewise based on work performed and/or product published in the given year. The award for Artistic Achievement can be given for a specific accomplishment during the given year or for a body of work done over a lifetime.

While any deserving work or individual can be nominated, whether the artist or individual is a member of ASFA or not, only a member of ASFA can actually make a nomination, and only members of ASFA can actually cast votes. To ensure that

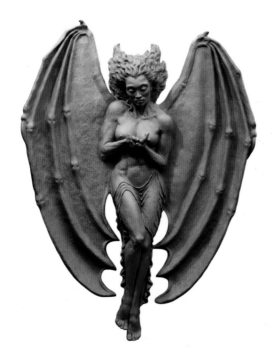

LEFT:
SANDRA LIRA
Millennium Angel
2001

entire membership and a ballot is created, which is in turn sent out to the ASFA membership along with a high-quality brochure of images of all the nominated art. Announcements are made to every member and throughout the fantasy and science fiction art community in general via the organization's journal, *ASFA Quarterly*, and various other press sources. Once the ballots have been tallied, the identities of the winners are, in order to preserve the excitement, held in strictest confidence until the Chesley Awards Ceremony at the annual WorldCon.

Oddly enough, when the lights go down in Philadelphia in 2001 and the show is about to begin, I am as always somewhat oblivious to all the details listed above. I am now thoroughly caught up in the anticipation of the spectacle to come.

There is an extra reason why tonight is special. Tonight will see the presentation of a posthumous Honorary Chesley Award to Chesley Bonestell himself. Ron Miller and Frederick C. Durant III of Bonestell Space Art, which officially represents the Bonestell Estate, are present to accept this unique accolade.

The talented vision of fantasy and science fiction artists and the fruits of their labours are a true gift to a struggling world – in fact, a part of how we identify ourselves as human. Because of the efforts of a number of caring, dedicated individuals, the Chesley Awards will hopefully, in some small way, continue to inspire and perpetuate the dreams of those who create and cherish the fantastic in our lives.

Elizabeth Humphrey
President
ASFA

sufficient effort is made to identify talent, throughout the year members of ASFA and its Board of Directors scout for artists and work. They then make an open call for nomination suggestions from people across the industry, as well as from enthusiasts of the art of the fantastic based all over the world. Once a collection of nominees has been established, it is narrowed down, according to the number of nominations made, to typically five nominations (sometimes more, sometimes less) in each category.

These nominations are then ready for a vote from the

ACKNOWLEDGEMENTS

Countless people have helped in the creation of this book, and any attempt at a
definitive list might risk offence through omission.
Nevertheless, we would like to offer our most humble thanks to
Mike Ashley, Dawn Astram, Ted Atwood, Cameron Brown, David Cherry, Janet Cole,
Malcolm Couch, Aaron Ethridge, Jane Frank, Wendy Froud, Irene Gallo, Delena Holmes,
Mark R. Kelly, Janet Kofoed, Karl Kofoed, Jim Liddle, Ron Lindahn, Todd Lockwood,
Ron Miller, Ingrid Neilson,
Teresa Paterson, Lynn Perkins, Andrew I. Porter, Suzanne Quigley, Ron Miller, Pamela D. Scoville,
Gordon Van Gelder, Bob Walters, Terri Windling
and most especially all the artists who gave so generously of their time and energies
to supply us with material and fill in the gaps in our researches.
We mean it when we say we couldn't have done this book without you!
Individual works are copyright by their artists except where otherwise indicated.

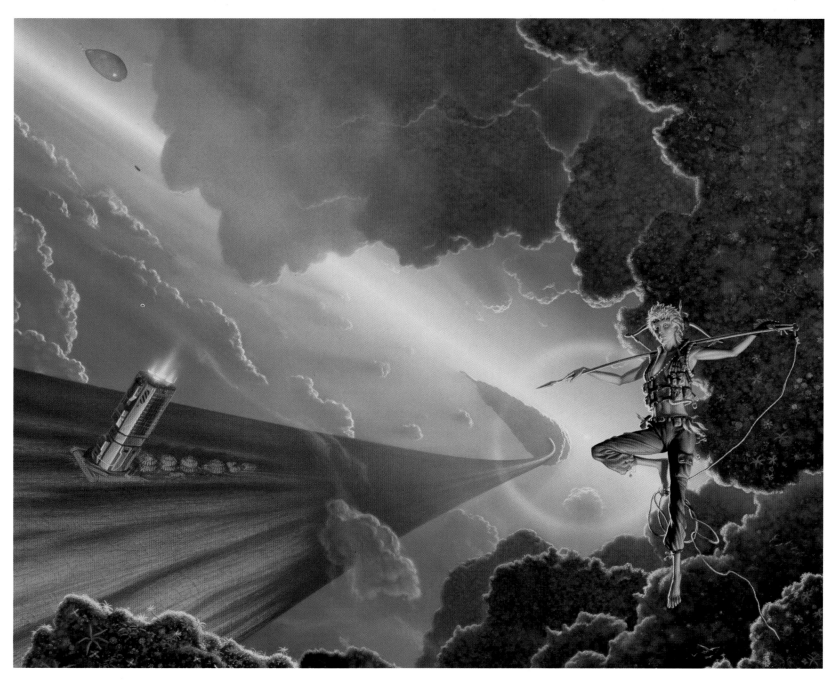

COVER ILLUSTRATION, HARDCOVER
MICHAEL WHELAN
The Integral Trees
Cover for the novel by Larry Niven (Ballantine Del Rey)
Acrylics on watercolour board
28in x 38in (71cm x 97cm)

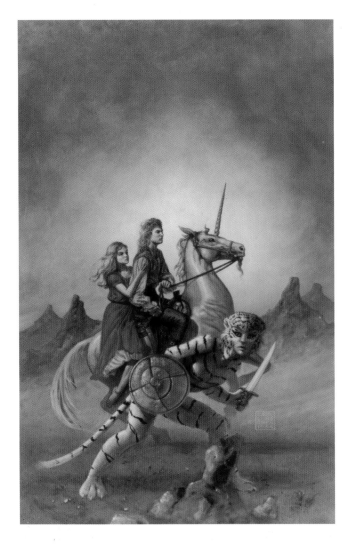

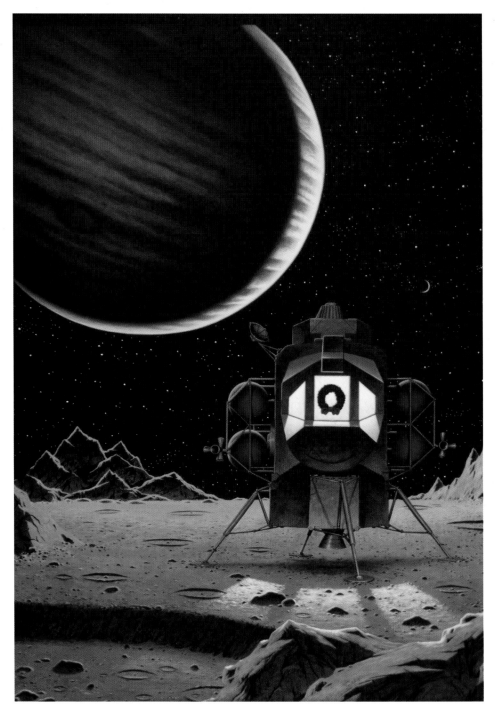

COVER ILLUSTRATION, PAPERBACK
CARL LUNDGREN
The Day of the Dissonance
Cover for the novel by Alan Dean Foster (Warner)
Oils on hardboard
18in x 30in (46cm x 76cm)

INTERIOR ILLUSTRATION
DELL HARRIS
Analog, Mar 1985

MONOCHROME WORK, UNPUBLISHED
SUZANNA GRIFFIN
Can I Keep Him, Mom?

CONTRIBUTION TO ASFA
MICHELLE LUNDGREN

COVER ILLUSTRATION, MAGAZINE
BOB WALTERS
Promises to Keep
Cover for *Asimov's*, December 1984, illustrating the story by Jack McDevitt
Acrylics on illustration board
16in x 20in (41cm x 51cm)

"This painting has been exhibited in a number of museums, most recently as part of an exhibit at the Bruce Museum in Greenwich, Connecticut, titled Space 2001: To the Moon and Beyond *along with works by Chesley Bonestell, Robert Rauschenberg, Jamie Wyeth, Robert McCall and Paul Calle. The assignment from Asimov's gave me the opportunity to create a work paying homage to my favourite space artist, Chesley Bonestell, and I designed it as a sort of Norman Rockwell Christmas in Space painting."*

COLOUR WORK, UNPUBLISHED
DAWN WILSON
Winter's King
Oils on masonite
36in x 48in (91cm x 122cm)

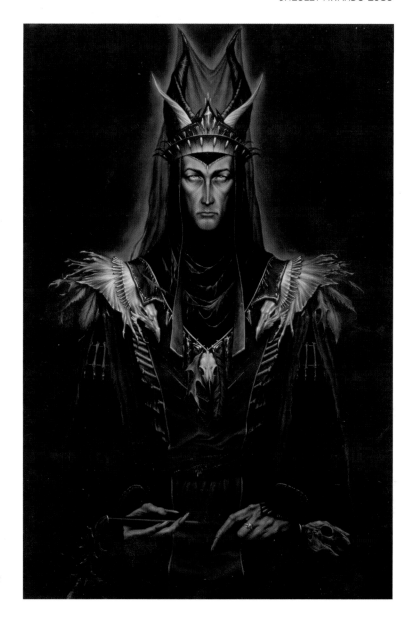

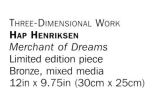

THREE-DIMENSIONAL WORK
HAP HENRIKSEN
Merchant of Dreams
Limited edition piece
Bronze, mixed media
12in x 9.75in (30cm x 25cm)

ARTISTIC ACHIEVEMENT AWARD 1985 CARL LUNDGREN

The Chesley Award is an example of recognizing talented artists for their work in a very small area of a publishing genre. Science fiction and fantasy novels are relatively rarely read any more and cover art and interior art are seldom seen or appreciated – not like it was in the 1970s and 1980s. People today know about books, but instead of reading them they wait to see the movie!

However, as long as members of this elite group of artists and writers continue to produce work, conventions will still meet and award presentations should continue. The Chesleys are an important facet of the Association of Science Fiction and Fantasy Artists, and should be supported. I am very appreciative of this recognition in my field, and my Chesley awards hold a place of honour in my studio.

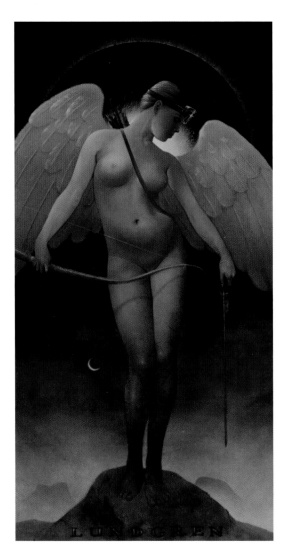

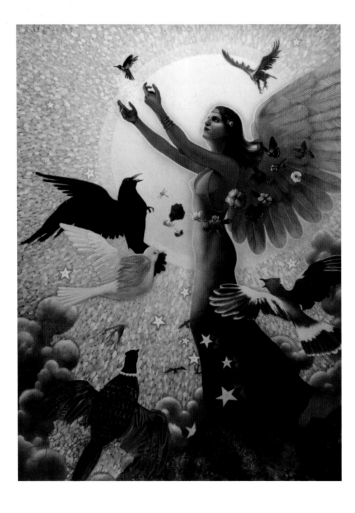

ABOVE:
Aeros
2000
Gallery work
Oils on hardboard
30in x 50in (76cm x 127cm)

LEFT:
Air
2000
Gallery work
Oils on hardboard
36in x 48in (91cm x 122cm)

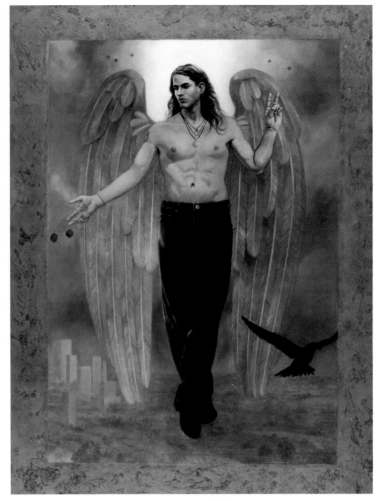

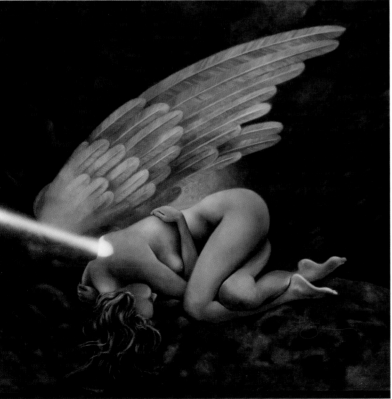

ABOVE:
Chance
1994
Gallery work
Oils/mixed media on hardboard
40in x 60in (102cm x 152cm)

TOP LEFT:
Earth
1999
Gallery work
Oils on hardboard
36in x 48in (91cm x 122cm)

LEFT:
Rest
1995
Gallery work
Oils on hardboard
30in x 30in (76cm x 76cm)

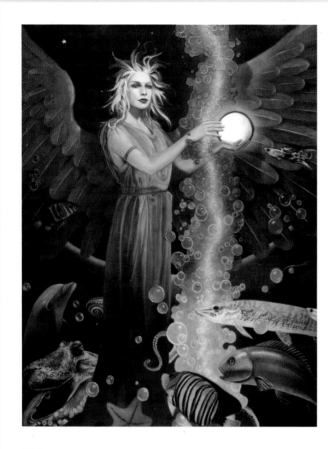

Water
2000
Gallery work
Oils on hardboard
36in x 48in (91cm x 122cm)

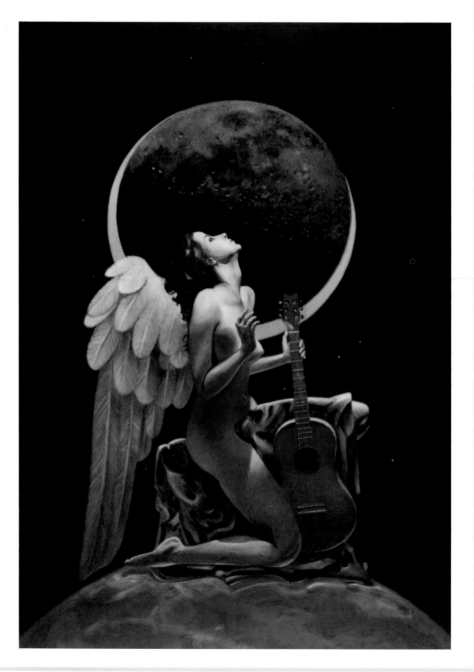

Spirit of Music
1995
Gallery work
Oils on hardboard
20in x 34in (51cm x 86cm)

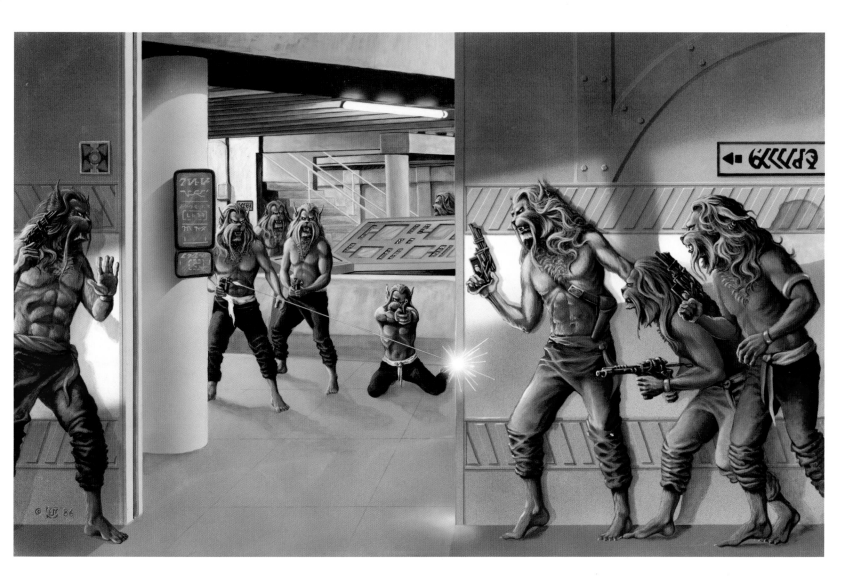

COVER ILLUSTRATION, HARDCOVER
DAVID A. CHERRY
Chanur's Homecoming
Cover for the novel by C.J. Cherryh
(Phantasia Press)
Acrylics on board
14in x 21in (36cm x 53cm)

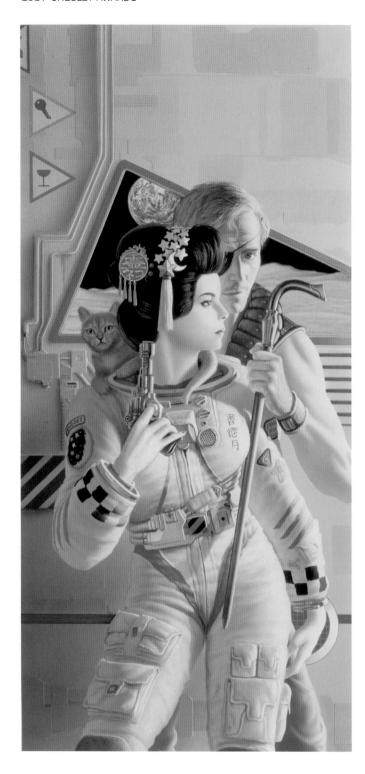

COVER ILLUSTRATION, PAPERBACK
MICHAEL WHELAN
The Cat Who Walks Through Walls
Cover for the novel by Robert A. Heinlein (Berkley)
Acrylics on watercolour board
30.5in x 13.5in (77cm x 34cm)

BELOW:
COVER ILLUSTRATION, MAGAZINE
BOB EGGLETON
Vacuum Flowers
Cover for *Asimov's*, January 1987, illustrating the serial by
Michael Swanwick
Acrylics on board
20in x 30in (51cm x 76cm)
*"This was my first cover for any sf magazine. The overall look
was straitjacketed by the insistence that type could not be over
or even near the 'elements'. Based on Swanwick's story, it had
to have a certain design to the spacecraft."*

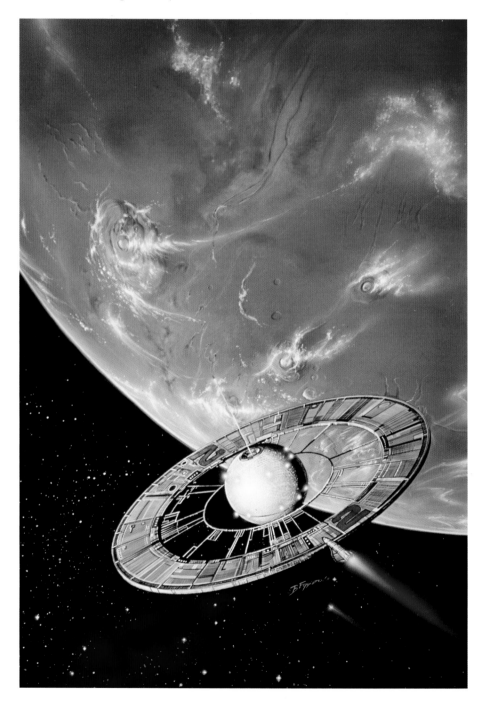

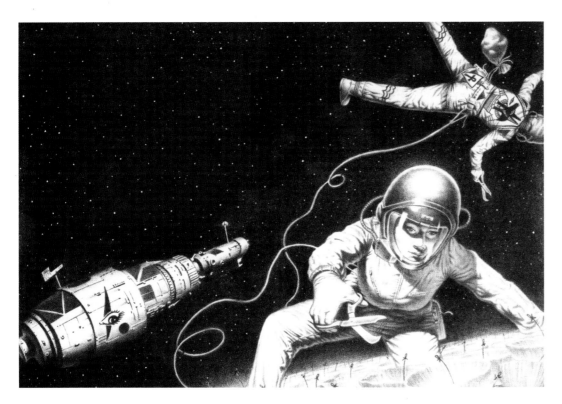

INTERIOR ILLUSTRATION (TIE)
DELL HARRIS

INTERIOR ILLUSTRATION (TIE)
BOB WALTERS
Vacuum Flowers
Asimov's, mid-December 1986, illustrating
the serial by Michael Swanwick
Pencil on illustration board
14in x 10in (36cm x 25cm)
*"This is the opening illustration for Michael
Swanwick's novel, which was serialized in
three issues of Asimov's. Michael is a good
friend of mine, and we designed the vacuum
flowers themselves, as well as the basic
illustration concept, on a napkin and in
Michael's notebook in a small sidewalk café
around the corner from my old digs.
I enjoy working with the writers when I can –
deadlines and distance permitting."*

BELOW:
COLOUR WORK, UNPUBLISHED (TIE)
MICHAEL WHELAN
Sentinels
Personal work, later used on book covers, etc.
Acrylics on canvas
21in x 32in (53cm x 81cm)

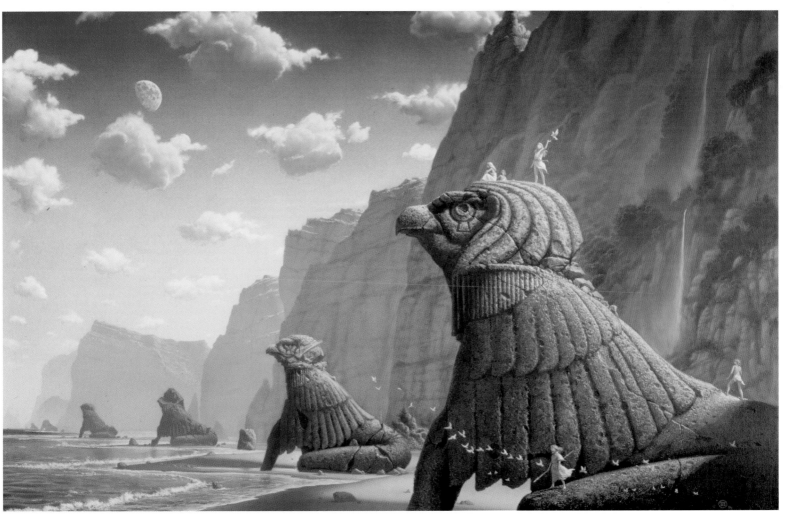

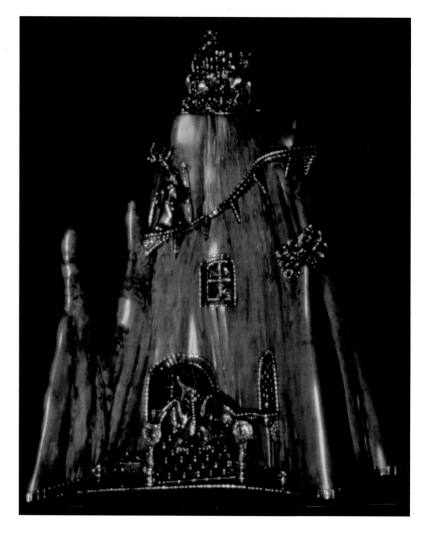

COLOUR WORK, UNPUBLISHED (TIE)
DAVID A. CHERRY
The Offering
Personal work
Acrylics on board
11in x 14in (28cm x 36cm)
*"This started as a doodle done to pass the time one evening.
Ultimately it saw use as the cover of my artbook* Imagination:
The Art and Technique of David A. Cherry *(1987)."*

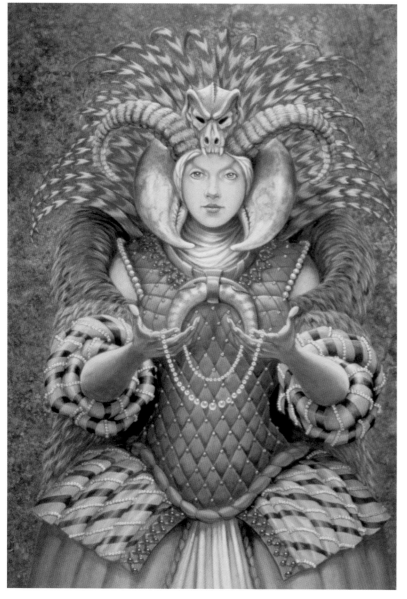

THREE-DIMENSIONAL WORK
BUTCH & SUSAN HONECK
Magic Mountain
Personal work
Wood, bronze, Austrian crystal, clockwork, opal, etc.
42in x 30in x 24in (107cm x 76cm x 61cm)
*"The base is a big cypress knee. The wood had to be dried out for months, because
cypresses grow in swamps and hold water like sponges. I removed the bark and
hollowed out spaces for caves; I also cut the tip off the top, but otherwise the
shape is natural (although, after years of showing, there are now fingernail imprints
in the wood!). I smoothed the wood to a glossy finish, then stained it and put on a
clear protective coat. The bronze was first designed in wax, then cast using the
lost-wax method and ceramic shell moulds in my own foundry. The Austrian crystal
at the top is turned by a clock motor. The dragon's head has a door in the back to
insert an incense cone, so the smoke comes out of his mouth. The wizard at the
top is an oil lamp; the flame comes out of his palm and the reservoir is below
him. The wizard's study, in the centre of the piece, is backlit using a small bulb to
illuminate a stained-glass window. All of the dragons have opals for eyes. There
are many details on the desk, walls and floor of the study, including objects and
animals. There is a scary-looking rat walking towards you on his hind legs in a
little tunnel at the side; he has red eyes in Austrian crystal that glitter in the dark.
A whole family of dragons is guarding the entrance at the bottom. The bones lying
around them are those of hapless, over-curious adventurers!"*

CONTRIBUTION TO ASFA
MATT FERTIG

ARTISTIC ACHIEVEMENT 1987
ALEX SCHOMBURG

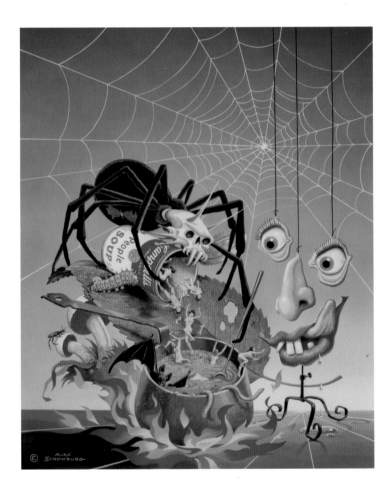

On the Tinsel Screen
1980
Cover for *Asimov's*, February 1980, illustrating the article
"On the Tinsel Screen: Science Fiction & the Movies" by
James Gunn
Airbrush on illustration board
21in x 16in (53cm x 41cm)

Nightmare with Black Widow
Personal work
Date unknown
Airbrush on illustration board
19.5in x 15.5in (50cm x 39cm)

TOP LEFT:
Impossible Dream
Personal Work
Date unknown
Airbrush on illustration board
20in x 16in (51cm x 41cm)

ABOVE:
The World at Bay
1954
Cover for the novel by Paul Capon (Winston)
Airbrush on illustration board
21.5in x 16in (55cm x 41cm)

LEFT:
The World at Bay
1954
Endpaper for the novel by Paul Capon (Winston)
Airbrush on illustration board
20in x 26in (51cm x 66cm)

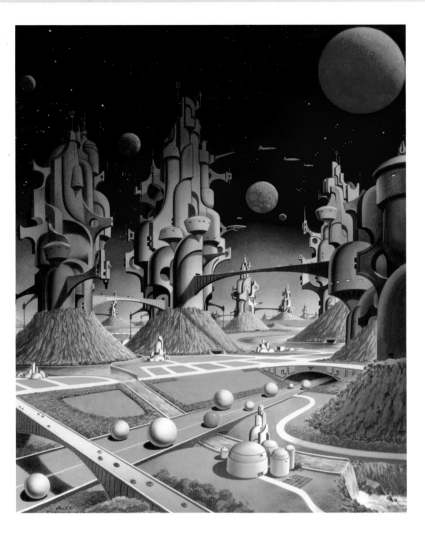

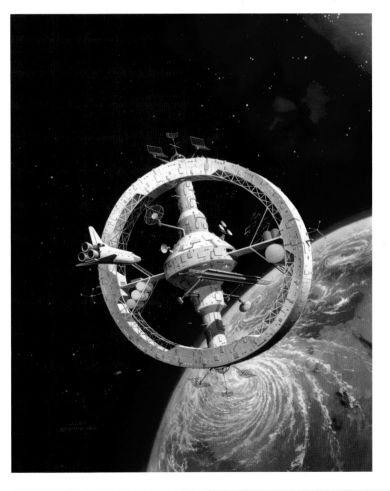

ABOVE:
Tower City
1968
Cover for the book *Isaac Asimov* by James Gunn (OUP)
Airbrush on illustration board
22in x 18in (56cm x 46cm)

TOP RIGHT:
Earth Revisited
Date unknown
Personal work
Airbrush on illustration board
24in x 20in (61cm x 51cm)

RIGHT:
Space Station
1978
Cover for *Analog*, January 1978
Airbrush on illustration board
24in x 19in (61cm x 48cm)

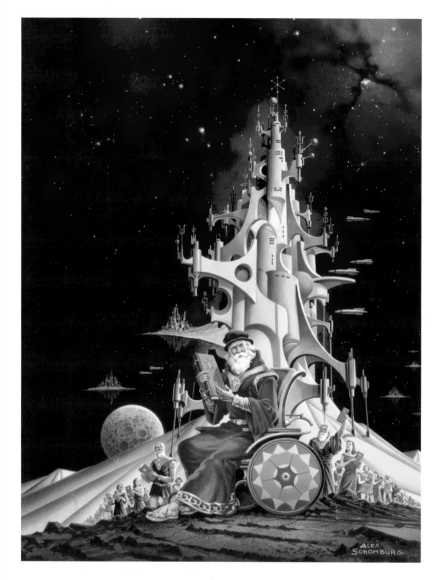

ABOVE:
Prophet and Tower
1980
Cover for *Asimov's*, April 1980, illustrating the article
"On the Foundations of Science Fiction" by James Gunn
Airbrush on illustration board
21in x 16in (53cm x 41cm)

TOP RIGHT:
Asteroid
1984
Cover for *Amazing*, January 1985
Airbrush on illustration board
21in x 16in (53cm x 41cm)

RIGHT:
Rocket Crash
1978
Cover for the anthology *The Best of Astounding*,
edited by Anthony R. Lewis (Baronet)
Airbrush on illustration board
22in x 16in (56cm x 41cm)

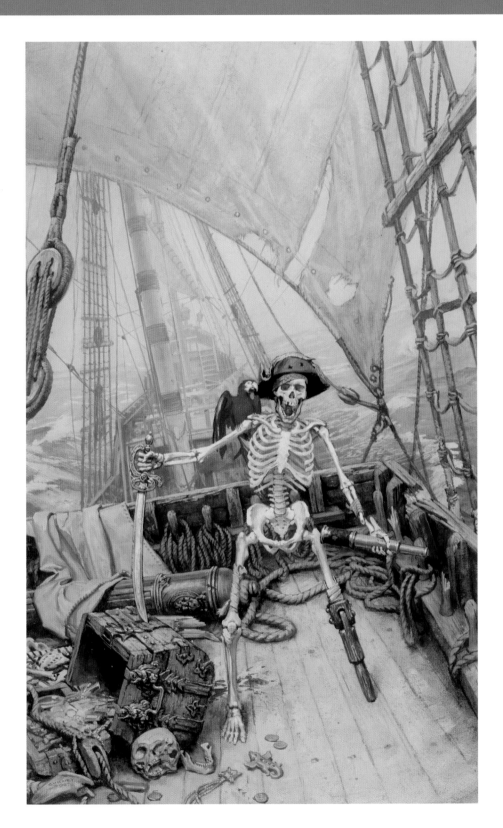

COVER ILLUSTRATION, HARDCOVER
JAMES GURNEY
On Stranger Tides
Cover for the novel by Tim Powers (Ace)
Oils on canvas
15in x 9in (38cm x 23cm)
"This tiny painting was commissioned as the cover
for Tim Powers's spooky pirate story. I wanted to
evoke the classic pirate images of Pyle and Wyeth
that show the buccaneer astride upon the deck of a
heaving ship, as well as to suggest the legend of
the Flying Dutchman aboard a doomed ghost-ship.
I placed the figure on the foredeck of the ship
rather than astern, giving me the opportunity to
show the layers of rigging disappearing into the
distant fog. Storms have tossed debris about on
the deck, making a mess of cannons, gold coins
and skulls, while a cannonball has broken through
the railing and removed the skeleton's leg, which
he has replaced with the end of an oar."

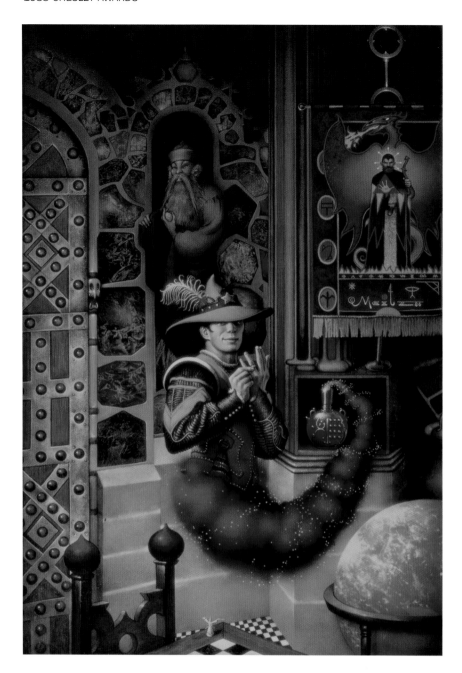

COVER ILLUSTRATION, PAPERBACK
DON MAITZ
Wizard in a Bottle
Cover for the novel *Wizard War* by Hugh Cook (Popular Library Questar)
Acrylics on masonite
30in x 20in (76cm x 51cm)
"Warped perspective with the hint of an overall greenish tint add a sense of mystery to a painting incorporating wizards and their doings. A bit of airbrush spices the work."

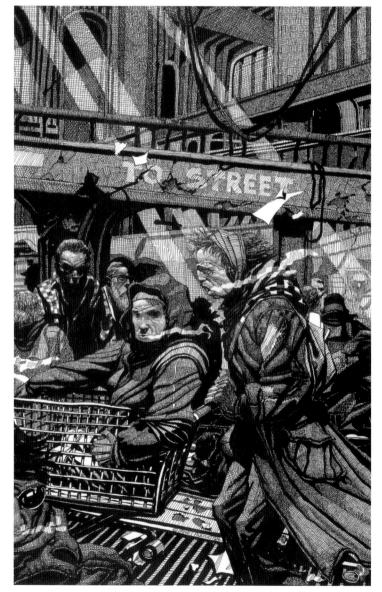

INTERIOR ILLUSTRATION
JANET AULISIO
A Bomb in the Head
Amazing Stories, May 1987, illustrating
the story by David E. Cortesi
Waterproof ink applied with pen and nib
on Strathmore Bristol board
11in x 16in (28cm x 41cm)

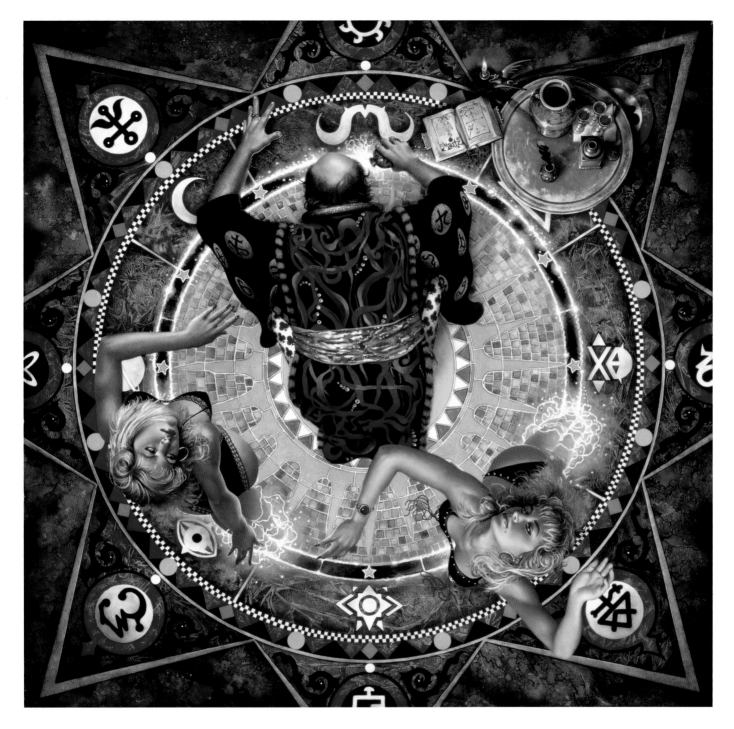

COLOUR WORK, UNPUBLISHED
DON MAITZ
Conjure Maitz
Personal work
Oils on masonite
30in x 30in (76cm x 76cm)
*"Creating paintings can be a magical experience for me, and the title
I chose is of course a deliberate pun. To further that implication,
I placed my signature in the book of magic on the page that provides
the conjury. The painting was begun following a 'Visiting Guest'
teaching position at the Ringling School of Art and Design in Florida.
It was the first painting I had produced from personal inspiration since
my art school efforts ten years earlier. In addition to the Chesley,
this painting received four art awards at the 1988 World Science
Fiction Convention, including two Bests in Show."*

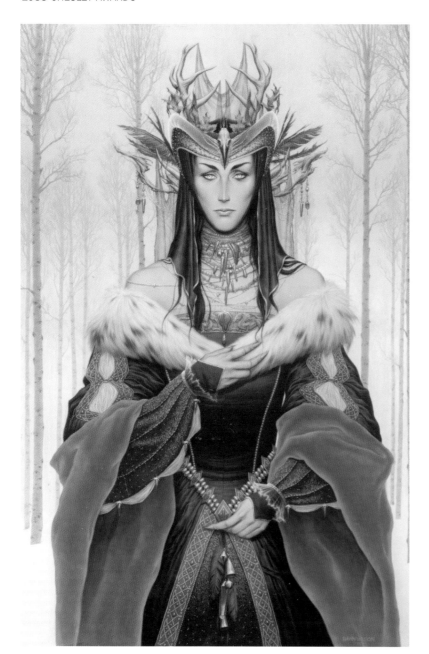

MONOCHROME WORK, UNPUBLISHED
DAWN WILSON
Queen of the Snows
Oils on masonite
36in x 48in (91cm x 122cm)

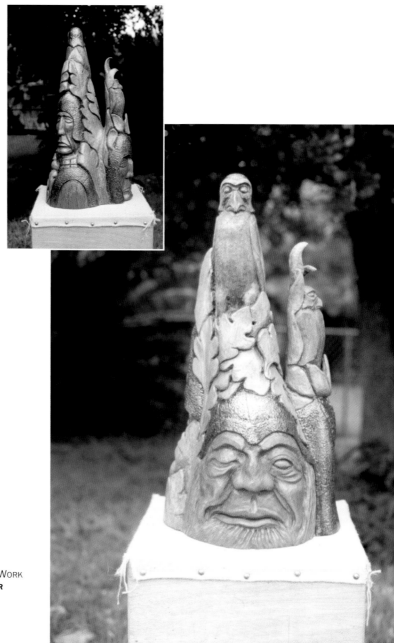

COVER ILLUSTRATION, MAGAZINE
TERRY LEE
Amazing Stories, January 1988

CONTRIBUTION TO ASFA
MATT FERTIG

THREE-DIMENSIONAL WORK
JOHN LONGENDORFER
Hawk Mountain
Personal work
Wood and copper
26in (66cm) tall

ARTISTIC ACHIEVEMENT
FRANK FRAZETTA

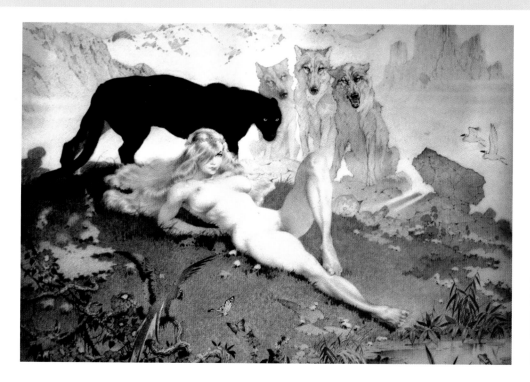

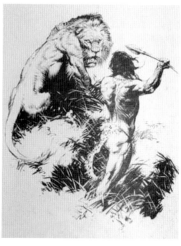

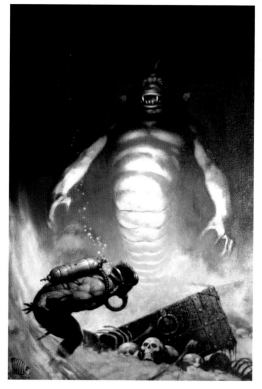

ABOVE:
Golden Girl
1957
Watercolours on artist paper
11in x 13in (28cm x 33cm)

Pen-and-ink sketch from 1968

LEFT:
The Sea Monster
1966
Oils on hardboard
17in x 23in (43cm x 58cm)

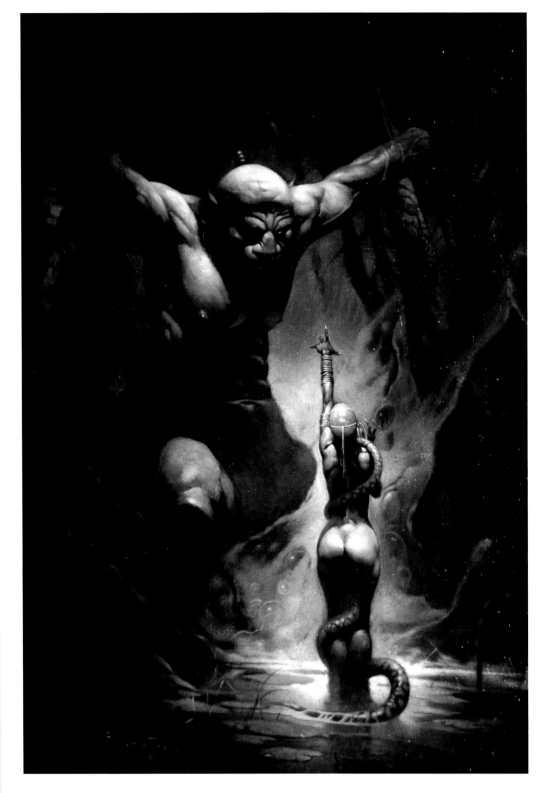

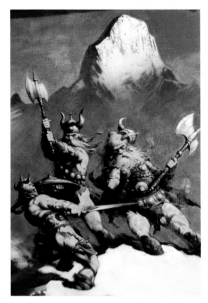

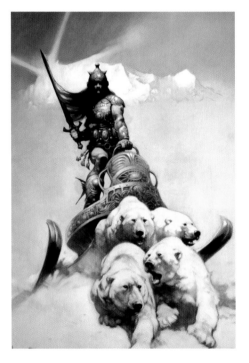

Swamp Demon
1968
Oils on hardboard
16in x 20in (41cm x 51cm)

TOP:
The Snow Giants
1968
Oils on hardboard
16in x 20in (41cm x 51cm)

ABOVE:
The Silver Warrior
1972
Oils on hardboard
15in x 22in (38cm x 56cm)

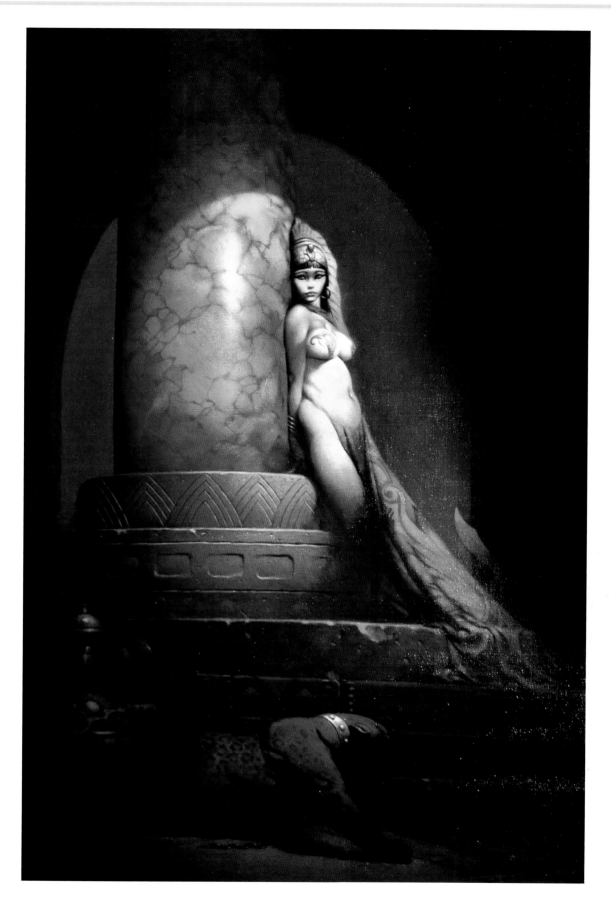

Egyptian Queen
1969
Oils on canvas
17in x 22in (43cm x 56cm)

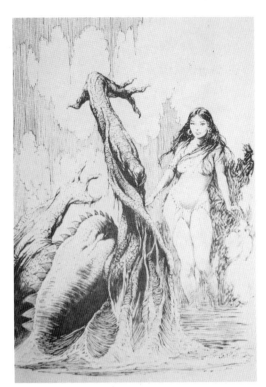

Pen-and-ink sketch from 1968

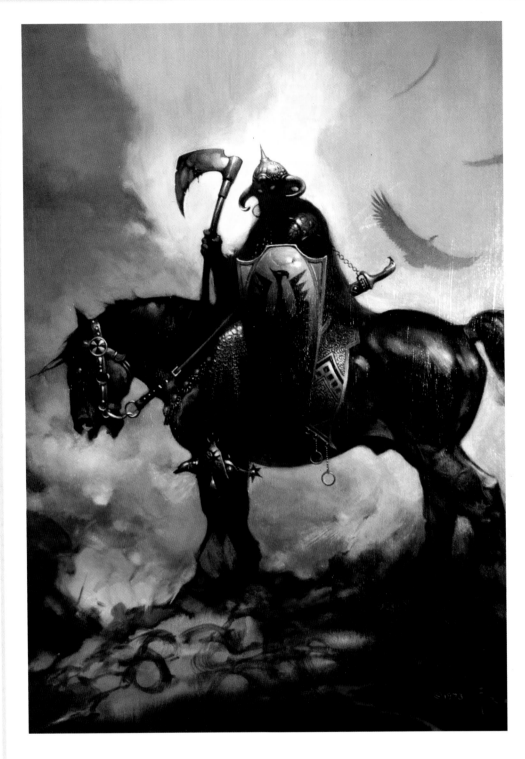

Death Dealer
1973
Oils on hardboard
15in x 22in (38cm x 56cm)

Atlantis
1972
Oils on hardboard
15in x 23in (38cm x 58cm)

The Galleon
1973
Oils on hardboard
15in x 23in (38cm x 58cm)

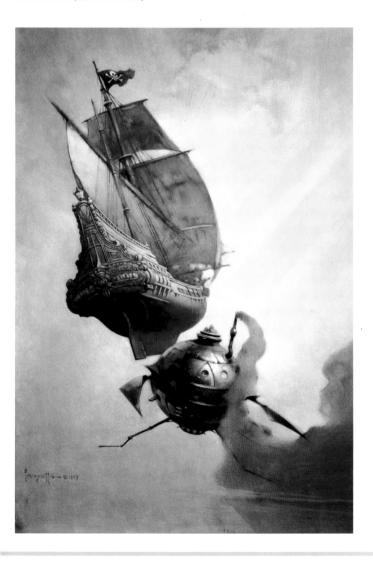

The Huntress
1977
Oils on hardboard
16in x 22in (41cm x 56cm)

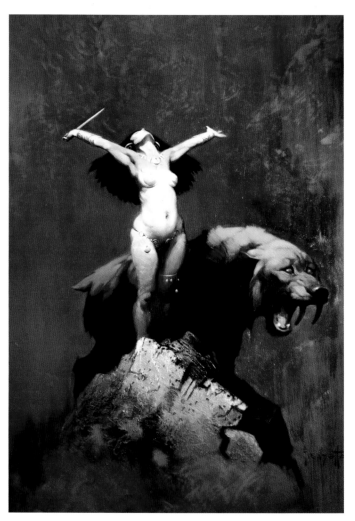

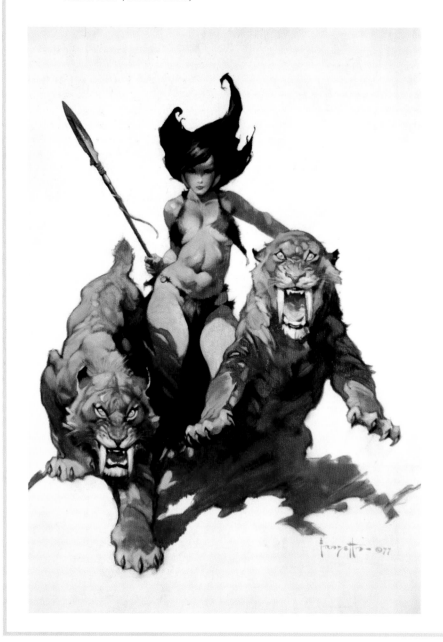

Sun Goddess
1978
Oils on hardboard
15in x 23in (38cm x 58cm)

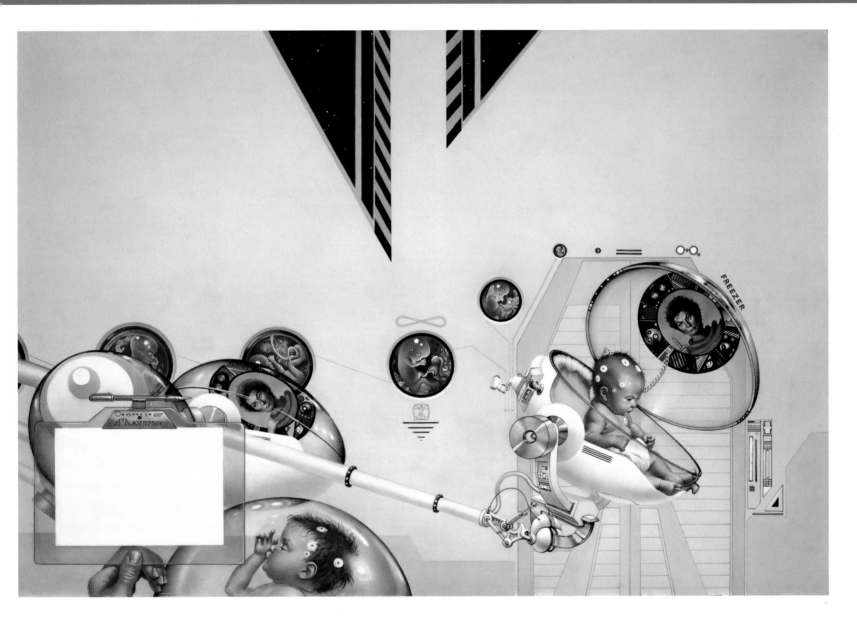

COVER ILLUSTRATION, HARDCOVER
DON MAITZ
Cyteen
Cover for the novel by C.J. Cherryh (Warner)
Oils on masonite
22in x 32in (56cm x 81cm)
"A visualization of the cloning process, complete with an instructional data link. The woman on the video screen is the assassinated donor to the clone baby. Here she posthumously warns her clone of danger in a recording being fed as taped information through sensors. An egg and a locket were inspirational sources for presenting a symbolic approach to the clone tutorial pod. By gluing an egg-shaped pantyhose container, then slicing it in half lengthwise, I was able to get the reference for an object reminiscent of both an egg and a locket, providing the symbology that I desired. I borrowed photos of the author to present her as the assassinated ruling scientist on a world that served as a cloning factory to supply inhabitants to remote colonial outposts. The novel received the 1989 Hugo."

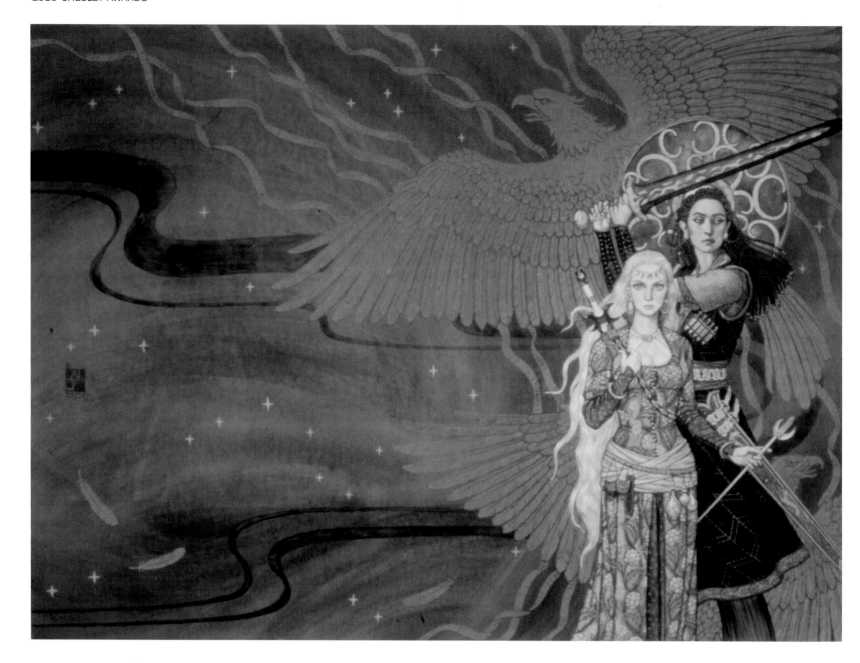

COVER ILLUSTRATION, PAPERBACK
JODY LEE
The Oathbound
Cover for the novel by Mercedes Lackey (DAW)
Acrylics on illustration board
30in x 35in (76cm x 89cm)
"I wanted to do a painting with highly detailed figures against a plain background. I followed the author's description of her characters, and gave a Turkish costume to one who came from a male-dominated society and a kind of Cossack look to one who came from clans that raised horses. The swords were inspired by reproductions of early Greek knives and Japanese metalwork. The background came from looking at the art of Japanese lacquer boxes."

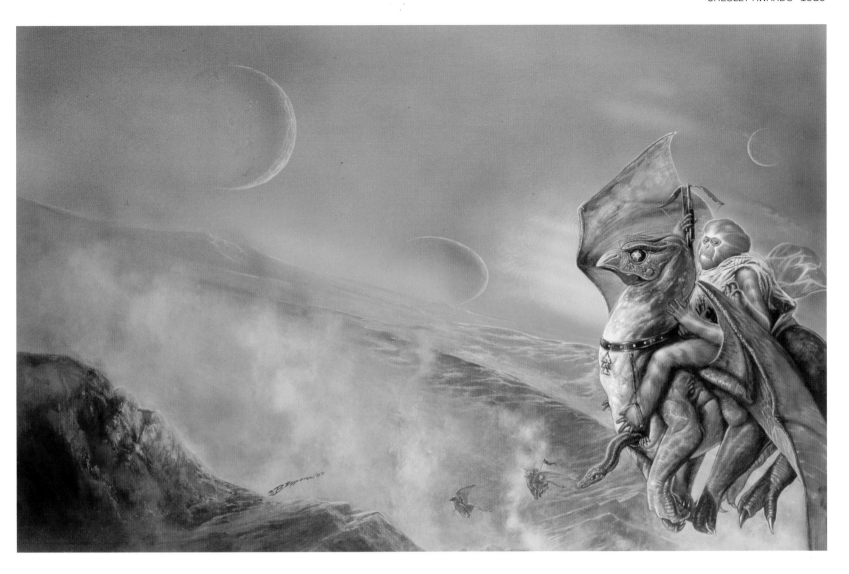

COVER ILLUSTRATION, MAGAZINE
BOB EGGLETON
The Limit of Vision
Asimov's, July 1988, illustrating the story by John Barnes
Acrylics on board
20in x 30in (51cm x 96cm)
*"This was not the way the cover appeared; instead they published
an abortion of a sketch which they 'liked better'. To be fair, part of
the reason they used the highly finished sketch was that this, the
final version, didn't have enough room for the type."*

INTERIOR ILLUSTRATION
ALAN LEE
Merlin Dreams
Novel by Peter Dickinson
(Gollancz)

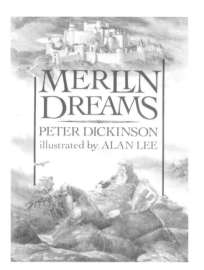

"*Guarding the bridge stood a centaur . . .*"
Watercolours on board
10in x 10in (25cm x 25cm)

"*Smell showed him the place . . .*"
Watercolours on board
10in x 9.5in (25cm x 24cm)

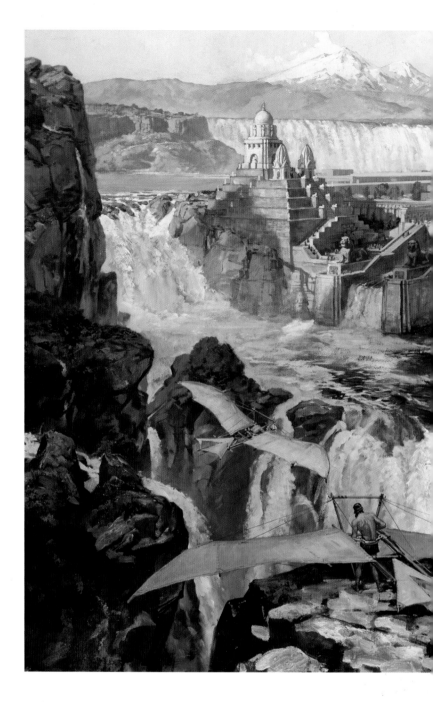

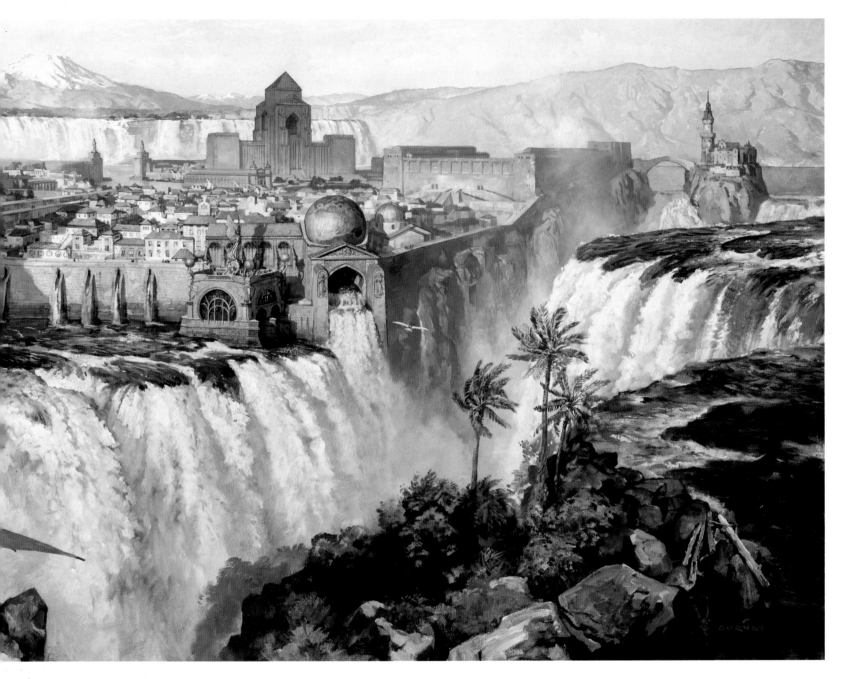

COLOUR WORK, UNPUBLISHED
JAMES GURNEY
Waterfall City
Oils on canvas
24in x 48in (61cm x 122cm)
"This image helped set the direction for Dinotopia, even before I came up with the idea of an island of humans and dinosaurs. I painted it in my spare time while working as an archaeological illustrator for National Geographic. I had just been sent on assignment for the magazine to Rome, Jerusalem and Athens. Brimming with inspiration, I wanted to create a scene from a lost empire in the style of the Hudson River School. I brought the painting to various sf conventions to seek the feedback of my artistic colleagues. Buoyed by their enthusiasm for the idea, I continued to fashion other cities and scenes that later developed into Dinotopia.

"Waterfall City became the centre of learning and museums in Dinotopia. It recalls the hill towns of Italy but is reachable only by water or by air. The thundering cascades that embrace the city are modelled on the Niagara Falls. To achieve realism in the rendering of the architecture, I built reference models."

BRAD W. FOSTER
Night Floater
Personal work
Central figure completed with technical pens; background tone done in ink with airbrush
14in x 26in (36cm x 66cm)
"This is part of a series of highly detailed pieces I have been creating for a world I call Argent Park, where all flora and fauna are based around metallic and jewelled forms rather than organic flesh and blood. They're not machines – they're alive, just otherworldly in appearance. While there are things in Argent Park that are totally unique in shape and look, I also work on animals such as this, based on very controlled realistic renderings of actual animals then reworked and manipulated into Argent creatures. It's an attempt to take a realistic approach to nature and then let my own imagination redesign the surface into something new."

THREE-DIMENSIONAL WORK
JOHN A. MORRISON
Metropolis
Private work
Glass carving with wooden base
40in x 15in x 0.5in
(102cm x 38cm 1cm)

CONTRIBUTION TO ASFA
DAVID A. CHERRY

ARTISTIC ACHIEVEMENT 1989
DON MAITZ (for his book *First Maitz*)

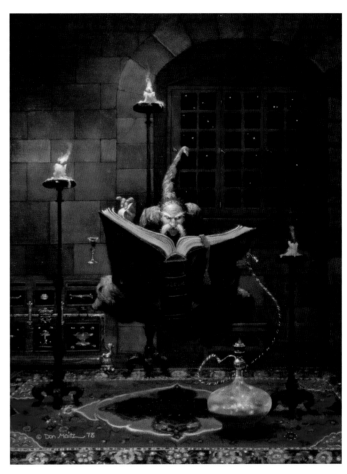

Second Drowning
1979
Cover for the novel *The Road to Corlay* by Richard Cowper (Pocket)
Oils on masonite
28in x 35in (71cm x 89cm)
"This painting portrays the aftermath of a second great flood, brought on by the worship of technology – symbolized by a television antenna. Confronting death and the realization of lost faith has set the woman adrift both spiritually and physically. I changed the painting's title from that of the book to reflect its content. The grey coloration was chosen to symbolize the emotion and reinforce the sombre mood.
　　"This picture won a 1980 Silver Medal (Book Category) from the Society of Illustrators and a Library Association Award."

The Wizard
Personal work
1978
Oils on canvasboard
24in x 18in (61cm x 46cm)
"There is a magical element in paintings, a suspension of disbelief that transforms two dimensions into the sensation of three. Realistically painting things that are not possible adds yet another dimension to that magic. I first conceived this idea in art school and completed it two years later. My future wife, artist and author Janny Wurts, asked my permission to write a short story inspired by the painting; it was titled "The Snare". Story and art were published in her short story collection That Way Lies Camelot.*"*

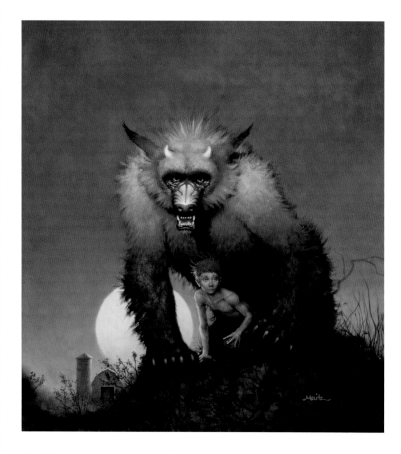

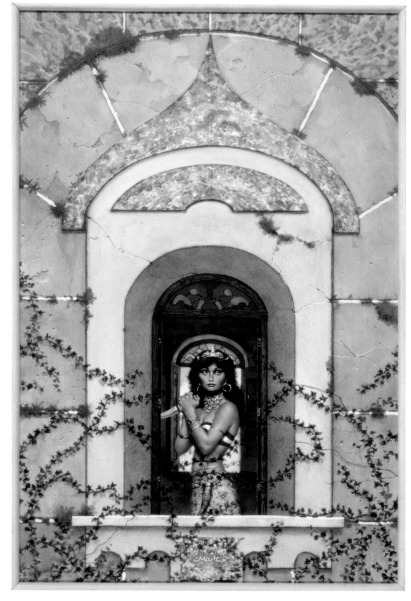

The Orphan
1979
Cover for the novel The Orphan by Robert Stallman (Pocket)
Oils on masonite
23in x 20in (58cm x 51cm)
"The novel was the first in a trilogy about a unique creature from another dimension that is able to switch form with a dying human. The person then carries on a werewolf-like relationship with the beast. The painting shows the metamorphosis in progress from boy to creature. The original art was stepped on while in the publisher's care, leaving a footprint mark and a crack across the masonite one-third of the way from the top. It thus had to be cropped from 30in [76cm] to 23in [58cm] in height."

Green Abductor
1979
Cover for the novel The Green Gods by N.C. Henneburg, translated by C.J. Cherryh (DAW)
Oils on masonite
30in x 20in (76cm x 51cm)
"The princess sees her castle window flung open and she prepares to defend herself from an intruder. Her attacker is the malevolent vine creeping over the castle walls. The kingdom's plant life has become sentient and aggressive. The title I chose reflects the identity of her antagonist. I mixed sand into a gesso ground to create a realistic textured surface for the stonework areas."

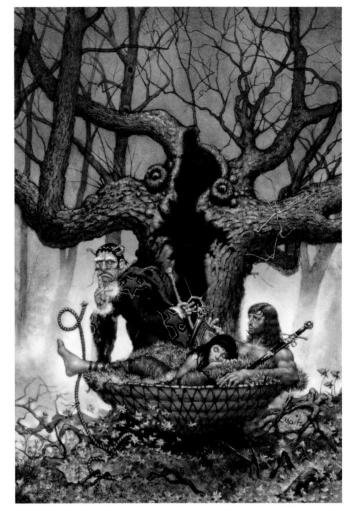

Wave without a Shore
1980
Cover for the novel by C.J. Cherryh (DAW)
Acrylics on masonite
30in x 20in (76cm x 51cm)
"A sculptor renowned throughout the known universe is commissioned to create the masterwork of the Galaxy. When he acknowledges a shunned alien race native to the occupied world selected as the site of the artwork, he falls into disaster. I volunteered myself to pose – that's me with and without the tentacles."

In the Forest
1981
Cover for the novel *Bard* by Keith Taylor (Ace)
Oils on masonite
30in x 20in (76cm x 51cm)
"The wizard has learned a spell to control that which was once alive, especially plants. He has a length of rope that does his bidding and a possessed basket for gathering. The basket's current contents are a hero with a sprained ankle and an exhausted girl. The dying tree wants no part of the wizard's magic. The rope is rustling a warning to the wizard as it is being grabbed by the tree's root. I truly enjoy expanding the premise of a book's story within the cover image. The sprained ankle is mine: I damaged it jogging. The injury was a stroke of good and bad luck, coming just in time to become a subject of reference to the painting."

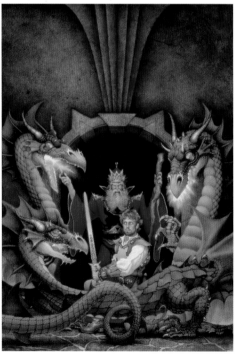

TOP LEFT:
It Takes Courage
1984
Cover for the novel *Witchdame* by Kathleen Sky (Berkley)
Oils on masonite
30in x 20in (76cm x 51cm)
"This painting is a reminder of when we find ourselves ill prepared and poorly equipped to confront our fears. An unexpected additional use for this image was on the cover to a business-empowerment book! The painting won a Bronze Award at the Delaware Art Museum Exhibition from the National Academy of Fantastic Art."

ABOVE:
Wicked Enchantment
1985
Cover for the novel *The Wicked Enchantment* by Margaret Benary-Isbert (Berkley)
Acrylics on masonite
30in x 20in (76cm x 51cm)
"An evil statue and a hideous gargoyle come to life in the guise of a grasping woman and her ill behaved son, and menace a village. They are lured back to their original perches by a magically endowed parrot and mouse, and unwillingly turn back to stone. This painting was shown at the Society of Illustrators' 28th Annual Exhibition, New York City, 1986."

LEFT:
Questing Hero
1987
Cover for the novel by Hugh Cook (Warner)
Oils on masonite
30in x 20in (76cm x 51cm)

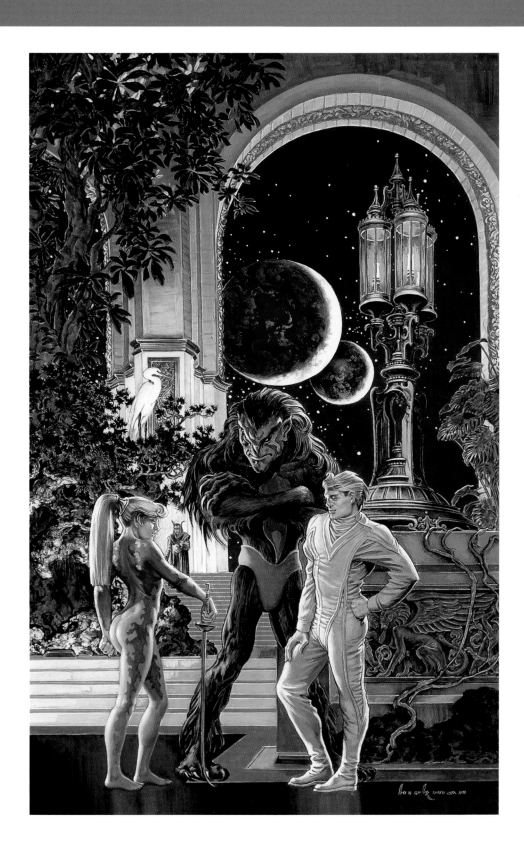

COVER ILLUSTRATION, PAPERBACK
STEPHEN HICKMAN
Gryphon
Cover for the novel by Crawford Killian
(Ballantine Del Rey)
Oils on panel
16in x 26in (41cm x 66cm)
*"I painted this in four days (very fast for me),
painting oil colour over a black-and-white acrylic
monochrome underpainting."*

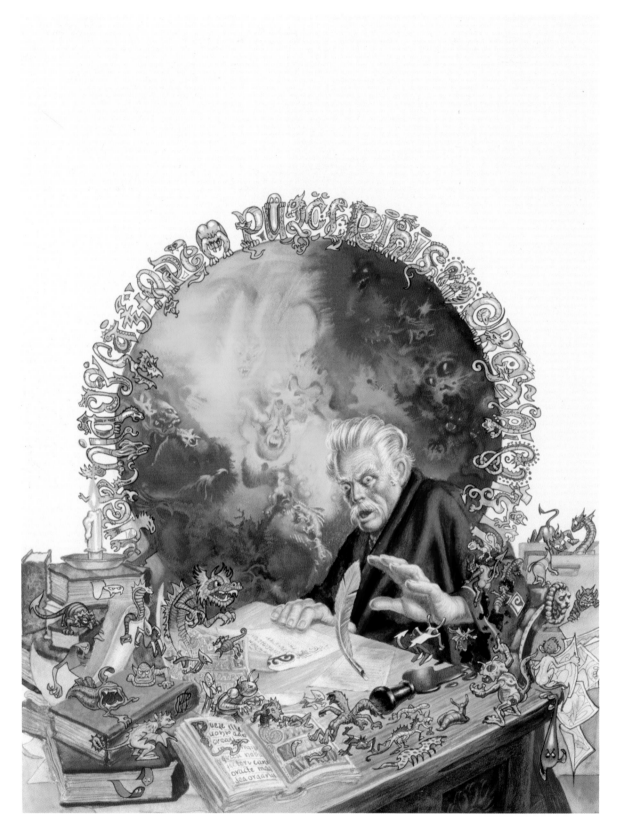

FRANK KELLY FREAS & LAURA BRODIAN KELLY-FREAS
Scribe
Cover for *Marion Zimmer Bradley's Fantasy Magazine*, Autumn 1989, illustrating the story "The Book of Souls" by Jason Van Hollander
Acrylics on illustration board
15in x 20in (38cm x 51cm)
"The circular format required by the magazine was done in wet-in-wet to achieve an organic flow. Out of that flow were rendered several horrifying creatures. Laura invented the alien alphabet (using The Book of Kells *for inspiration) as well as the illuminated manuscript (based on real liturgical text). She also laid out the positions of the characters, telling Kelly he'd better get into the studio and finish up or she'd number the spaces and give him numbered paints. Laura needed a good reference photo of a man recoiling in horror, so she focused a Polaroid camera on Kelly and snapped the shot of his reaction to the words: 'Dear, did you know that we're out of bourbon?' Kelly's Pierre Cardin robe is seen on the scribe, with the PC logo falling into place among the other alien letters."*

COVER ILLUSTRATION, HARDCOVER
KEITH PARKINSON
Rusalka (novel by C.J. Cherryh; Ballantine Del Rey)

INTERIOR ILLUSTRATION
TODD CAMERON HAMILTON
Dragonlover's Guide to Pern (nonfiction book by Jody Lynn Nye & Anne McCaffrey; Ballantine Del Rey)

MONOCHROME WORK, UNPUBLISHED
RUTH THOMPSON
The Guardian

ART DIRECTOR
BETSY WOLLHEIM & SHEILA GILBERT

CONTRIBUTION TO ASFA
DAVID A. CHERRY

THREE-DIMENSIONAL WORK
ARLIN ROBINS
Wave Borne
Commissioned piece
Bronze
48in (122cm) tall
Photographs (c) 1989 Michael Jhon

"I created the two mermaids Wave Borne *and* Sea Dreams *for the foyer of the Mirage Resort/Casino in Las Vegas, Nevada. The facility designer, Henry Conversano, saw my original piece, Wave Rider, at a fine arts and crafts show. He contacted me and commissioned the larger pieces to be redesigned for display in the hotel. Since these pieces were intended for a high-traffic area I paid special attention to ergonomic considerations, pulling in the edges of the wave and incorporating the curled tail flukes to avoid barked shins. The two mermaids and their companion dolphins were produced in approximately ten months, from contract to delivery. At first glance, you would think they were cast from the same mould, but I actually created two individual sculptures. Conversano's original plan was to position them to frame the entrance facing forward, so they were designed as mirror images. There are, however, subtle differences. The hands and faces are different and* Sea Dreams *has braids plaited amidst her strands of loose hair."*

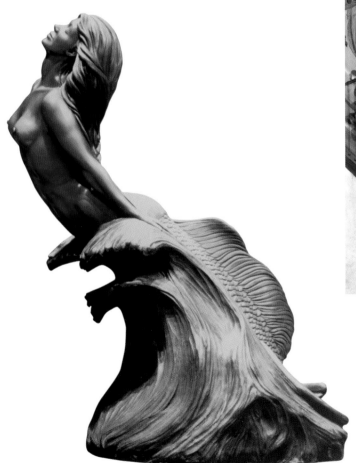

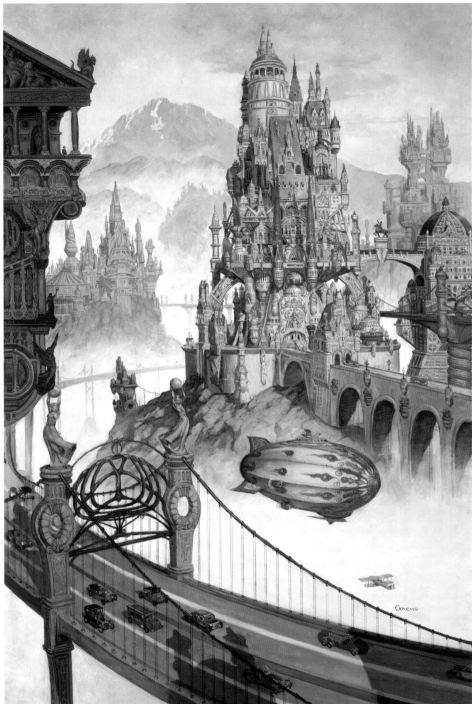

COLOUR WORK, UNPUBLISHED
TOM KIDD
Winsor McCay City
Oils
24in x 36in (61cm x 91cm)
"This is the first of two hundred paintings I've done for an intended book, to be written and illustrated by myself, called Gnemo: Airships, Adventure, Exploration. *As a labour of love, this project has now spanned 13 years, but my passion for it still remains strong."*

ARTISTIC ACHIEVEMENT 1990
DON MAITZ

Escape from Below
1989
Cover for the novel *Sunset Warrior* by Eric Lustbader (Fawcett)
Oils on masonite
30in x 20in (76cm x 51cm)
"An underground feudal society develops in the future among the survivors of a devastating nuclear war that poisoned the atmosphere. Each lord had his champion warrior. Pictured is the warrior who 'came out on top'. This was the second time I had illustrated for the Sunset Warrior series. I painted the covers to the initial four-volume release; later, when Fawcett re-released them in a new edition, Lustbader specially requested that I illustrate their covers the second time."

Rimrunners
1988
Cover for the novel by C.J. Cherryh (Warner)
Acrylics on masonite
30in x 20in (76cm x 51cm)
"Airbrushed acrylic paint was used to enhance the spaceship interior. To achieve the curved gradations and arching lines, I needed a device that was oval in shape that would act as a template cutter for friskets and as a handrest to brace a brush at the height of its ferule, allowing me to make the uniform curved lines I intended. After much thought, the perfect device appeared before me: the toilet seat! The title of the book was quite appropriate as my wife and I were 'rimrunners' for two weeks while the toilet seat was borrowed for the studio.

"This painting received a Special Best Original Artwork Hugo in 1989."

Over the Clouds
1988
Cover for the collection *Classic Stories 2* by Ray Bradbury (Bantam)
Oils on masonite
18in x 30in (46cm x 76cm)
"Selected artists were assigned the cover art for reissues of Bradbury's works. We were allowed the opportunity of no art direction whatsoever! The stories I was asked to illustrate covered a range of topics; this collection combined the earlier ones A Medicine for Melancholy *and* S is for Space. *I chose to gather both the earthbound and the space-travel themes of the stories into one narrative image."*

Kai-feng
1989
Cover for the novel *Dai-san* by Eric Lustbader (Fawcett)
Oils on masonite
30in x 20in (76cm x 51cm)
"This story had a Japanese flavour, so I went to a museum that housed a large collection of feudal Japanese armour to research."

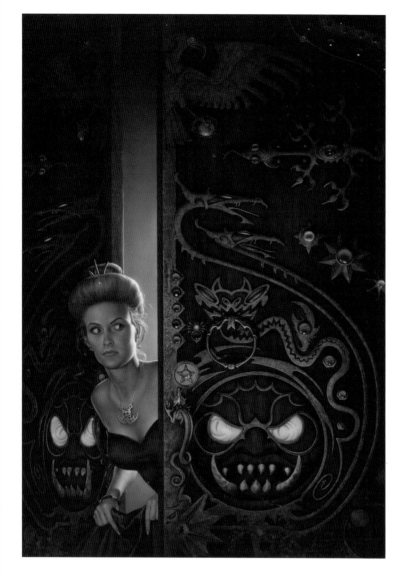

Mythology 101
1989
Cover for the novel by Jody Lynn Nye (Warner)
Oils on masonite
24in x 16in (61cm x 41cm)
"A Midwestern college campus has a colony of magical elves living under the foundation of the library. The elves occasionally borrow books from the shelves and, in return, they tutor selected students to help their grades. An actual college student posed as the main character – I happened to be a guest at a college-sponsored event when I was to begin working on the cover. Too bad there were no elves around to help me with the other characters!"

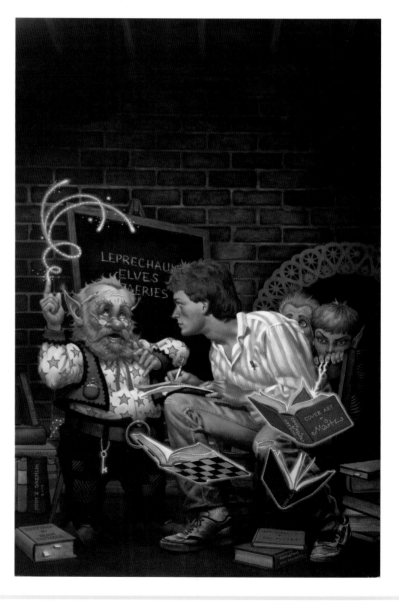

Faery Lands Forlorn
1990
Cover for the novel by Dave Duncan (Ballantine)
Oils on masonite
30in x 20in (76cm x 51cm)
"This book is the sequel to Magic Casement *(see page 56); the series continues in* Perilous Seas *and* Emperor and Clown. *The woman in the* Magic Casement *painting was a fabrication. For this new cover I wanted a model who looked like her – and one came from an unexpected source. The girl who returned the approved colour sketch to my door was perfect, and agreed to pose for me. My model arrived by FedEx!"*

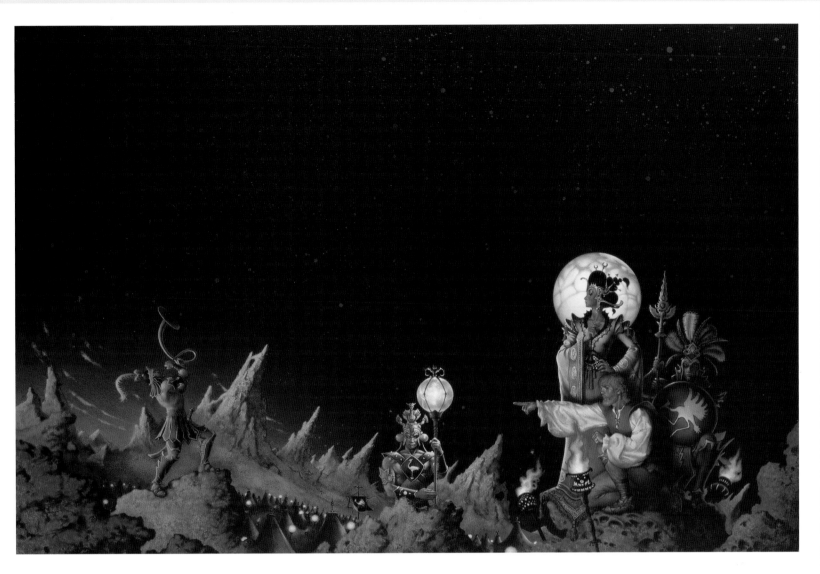

Servant of the Empire
1990
Cover for the novel *Servant of the Empire* by Raymond E. Feist and
Janny Wurts (Bantam)
Oils on masonite
24in x 36in (61cm x 91cm)
*"This work was part of a unique collaborative effort. Raymond Feist
and my wife, Janny Wurts, co-wrote three novels about a female
character who was part of an invading force, introduced in Feist's
popular Midkemia books. Janny had illustrated the initial edition's
cover to the first book in this trilogy: Daughter of the Empire. So,
while she was co-writing the final book, she was also working with
me on the visual interpretation of various elements she had helped
to write."*

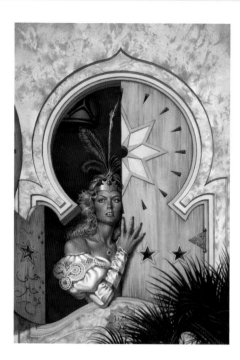

Perilous Seas
1990
Cover for the novel by Dave Duncan (Ballantine)
Oils on masonite
30in x 20in (76cm x 51cm)
"Arabian-style architecture has an exotic appeal for the damsel in distress at the window. This Western princess has been serenaded and sequestered in prison-like apartments awaiting her promised marriage to an Eastern prince. She is apprehensive of her betrothed and is secretly longing to be rescued from her fate as she looks toward the horizon where the sun sets upon her distant home."

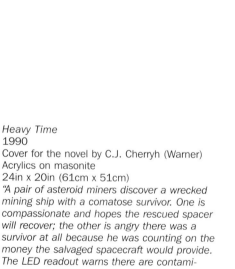

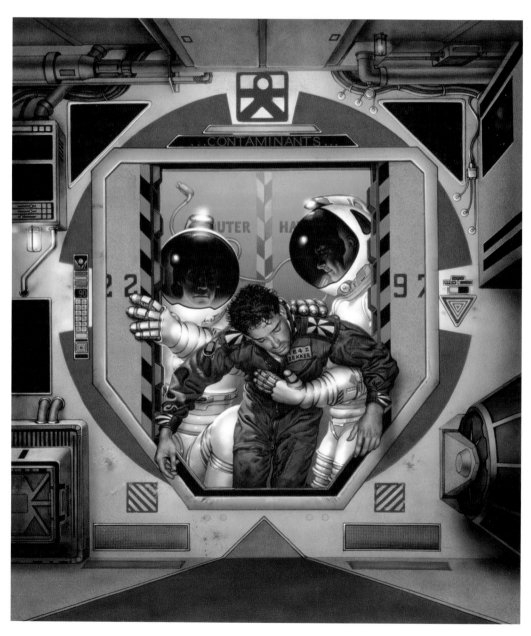

Heavy Time
1990
Cover for the novel by C.J. Cherryh (Warner)
Acrylics on masonite
24in x 20in (61cm x 51cm)
"A pair of asteroid miners discover a wrecked mining ship with a comatose survivor. One is compassionate and hopes the rescued spacer will recover; the other is angry there was a survivor at all because he was counting on the money the salvaged spacecraft would provide. The LED readout warns there are contaminants entering the spacecraft. In the lower right is the top of a 'spinner', a sleeping compartment that whirls to simulate gravity.

"Acrylics are my preferred choice when doing sf art. I do not enjoy working with them as much as with oils, but the plastic nature of the medium and the technical way they can be applied with an airbrush, friskets and so forth feel right for my intended results."

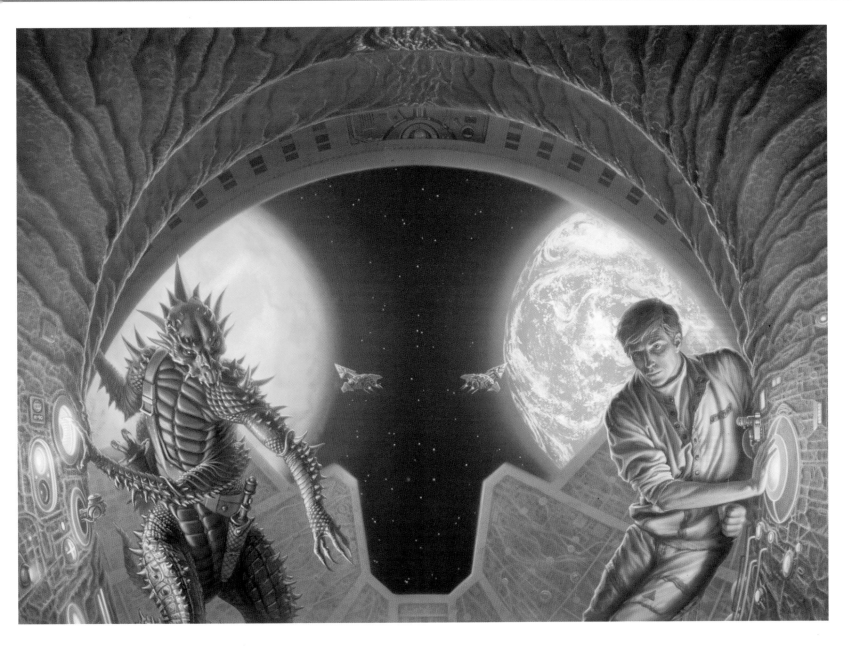

COVER ILLUSTRATION, PAPERBACK (TIE)
MICHAEL WHELAN
Daetrin
Cover for the novel *The Madness Season* by
C.S. Friedman (DAW)
Acrylics on watercolour board
22in x 30in (56cm x 76cm)

COVER ILLUSTRATION, PAPERBACK (TIE)
DON MAITZ
Magic Casement
Cover for the novel by Dave Duncan
(Ballantine)
Oils on masonite
30in x 20in (76cm x 51cm)
*"When one chooses to climb the castle
tower, brave the sorcerer's lofty chamber
and look out of this magical window,
important glimpses of one's future appear.
Events from the novel appear as scenes
rendered in stained glass. Watching the
glass patterns, one might expect to see the
scene actively change. I put my signature
within the stained-glass window.*

*"The model for this painting was
actually a combination of three women
and a photo from a shampoo
advertisement. This caused me some
difficulty in recreating the same character
for the sequels!"*

RIGHT:
COVER ILLUSTRATION, MAGAZINE
BOB EGGLETON
Azure Leaving the Solar System
Cover for *Aboriginal Science Fiction*,
January/February 1990
Acrylics on board
16in x 20in (41cm x 51cm)
*"Done totally on spec and inspired by
the Voyager 2 flyby of Neptune."*

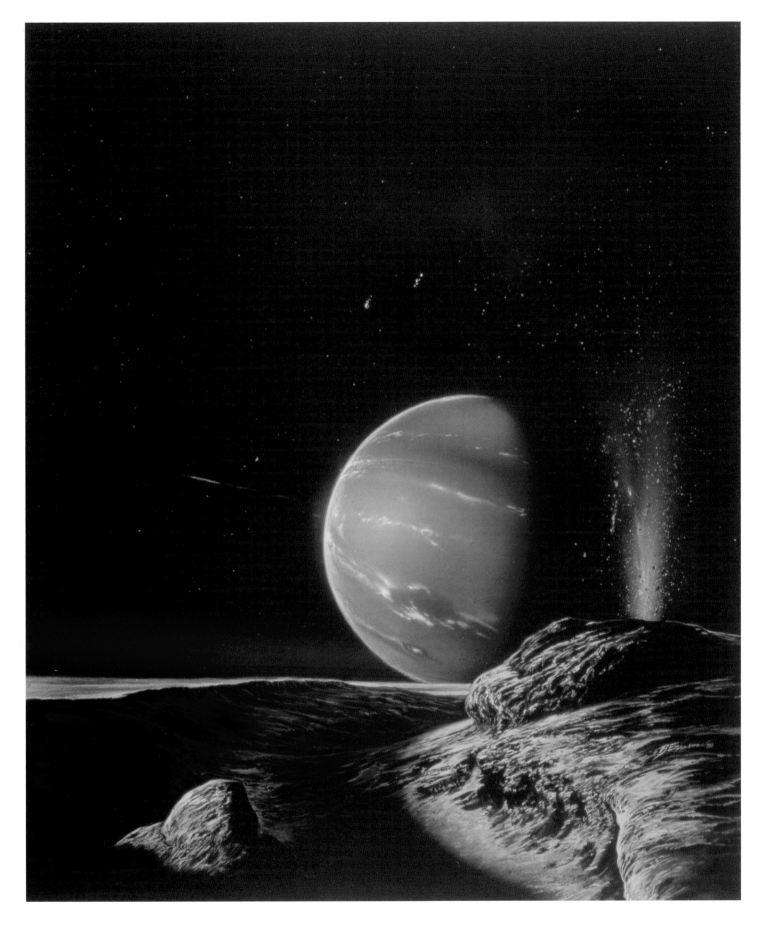

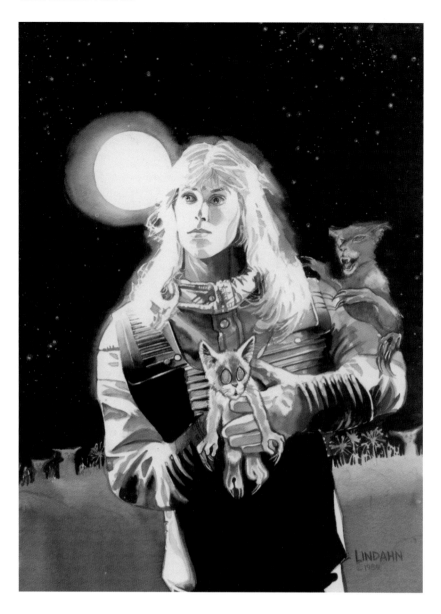

INTERIOR ILLUSTRATION
VAL LAKEY LINDAHN
The Flowers, the Birds, the Leaves, the Bees
Analog, June 1990, illustrating the story by
L.A. Taylor
Gouache on Strathmore illustration board
8in x 11in (20cm x 28cm)

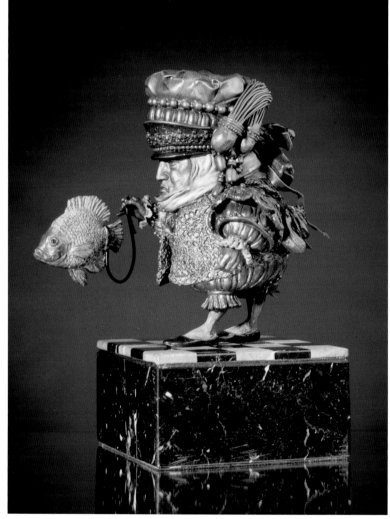

COVER ILLUSTRATION, HARDCOVER
KEITH PARKINSON
Chernevog (novel by C.J. Cherryh;
Ballantine Del Rey)

COLOR WORK, UNPUBLISHED
DEAN MORRISSEY
Charting the Skies

ART DIRECTOR
DON MUNSON

CONTRIBUTION TO ASFA
ERIN MCKEE & BETTYANN GUARINO

THREE-DIMENSIONAL WORK
JAMES C. CHRISTENSEN
The Fishwalker
Personal work
Bronze on inlaid marble base
10in x 5in x 8in
(25cm x 13cm x 20cm)

ARTISTIC ACHIEVEMENT 1991
MICHAEL WHELAN

"The dignity of the artist lies in his duty of keeping awake the sense of wonder in the world." – G.K. Chesterton

I have been interested in the imagery of fantasy since early childhood, and all my artwork is, at its most fundamental level, about creating a "sense of wonder". In my illustration, my primary concern has been to create a window into the themes and story elements of a particular book. My non-commissioned work, on the other hand, is concerned with more personal themes.

Stylistically my art is best described as "Imaginative Realism". Most closely allied to the scope and feeling of what is referred to as "Contemporary Visionary Art", my non-illustrative art is intentionally imbued with a strong sense of the mystical or dreamlike, and is suffused with symbolic content. There is a deliberate attempt to invest the image with layers of meaning while having an immediate initial subjective or emotional impression.

The majority of my work falls into one or another series of related paintings, which share common themes and symbols. In general terms, the paintings in my *Faded Star* series deal with the struggle against despair and hopelessness, humanity's instinctive striving against what Barbara Tuchman calls the "burdens of modern man": loss of faith in religion, progress and the perfectibility of the human species. My *Passage* series is concerned with a personal investigation into metaphysics, religion and near-death experiences. My Lumen paintings are about the quest for inner revelation and meaning, of finding one's true self, among other concerns. Further series of works in progress (for example, the *Virtues*, *Meditations* and *End of Nature* series) are about various other issues, both subjective and objective.

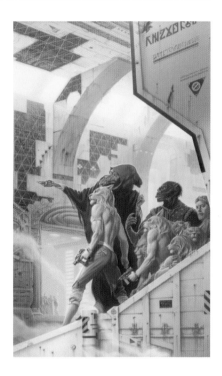

Chanur's Homecoming
1988
Cover for the novel by C.J. Cherryh (DAW)
Acrylics on watercolour board
30in x 20in (76cm x 51cm)

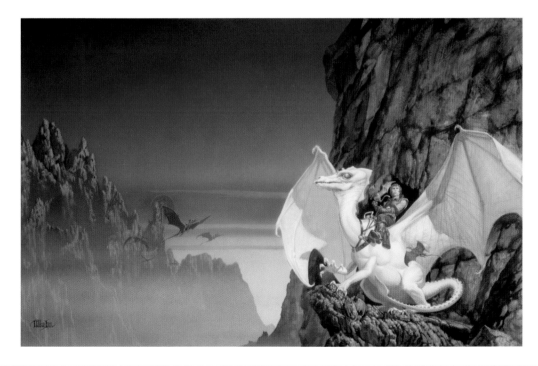

The White Dragon
1977
Cover for the 1978 novel by Anne McCaffrey (Del Rey)
Acrylics on panel
20in x 30in (51cm x 76cm)
"*The White Dragon was the first book cover I did that made it onto the* New York Times *bestseller list.*"

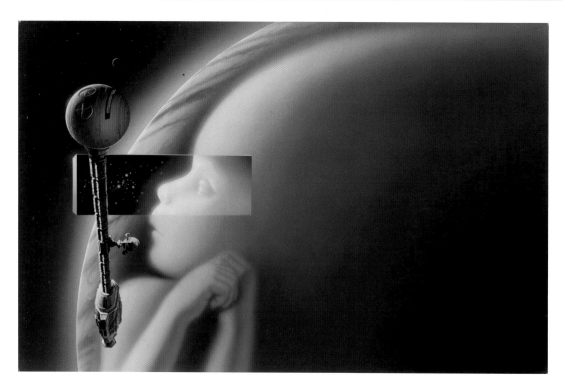

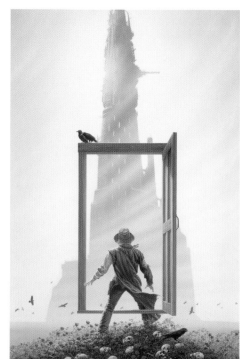

ABOVE:
2010
1982
Cover for the novel *2010,
Odyssey Two* by Arthur C.
Clarke (Del Rey)
Acrylics on panel
30in x 20in (76cm x 51cm)

TOP RIGHT:
Legend
1998
Cover for the 1999 anthology
Legends 1 edited by Robert
Silverberg (Tor)
Acrylics on panel
36in x 24in (91cm x 61cm)

RIGHT:
Golden Dream
1982
Cover for the novel *Golden
Dream: A Fuzzy Odyssey* by
Ardath Mayhar (Ace)
Acrylics on watercolour board
23in x 30in (58cm x 76cm)

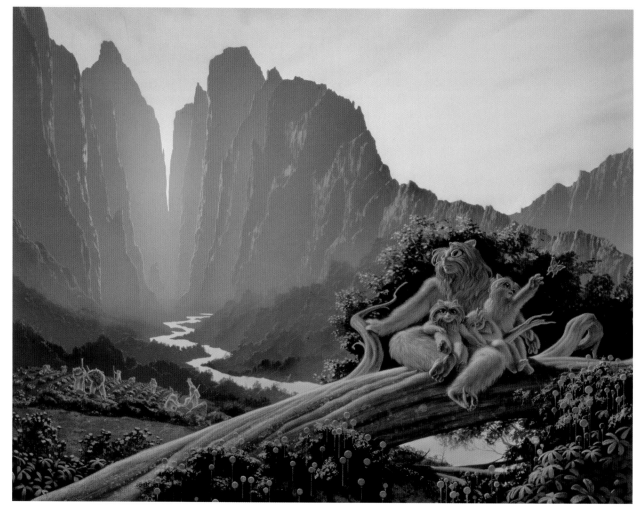

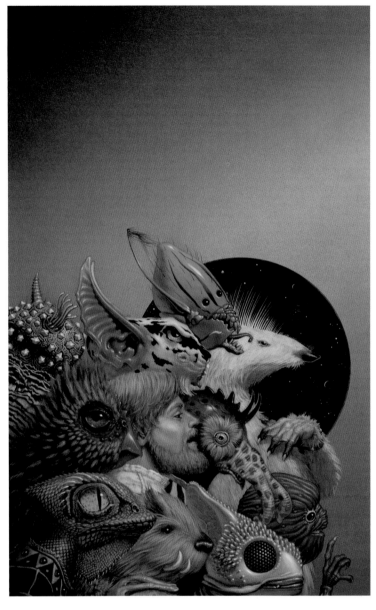

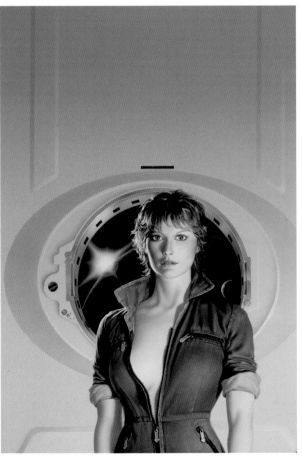

ABOVE:
Aliens
1979
Cover for the anthology *Aliens!* edited by Gardner
Dozois and Jack Dann (Pocket)
Acrylics on watercolour board
27in x 16in (69cm x 41cm)

TOP LEFT:
Leap of Faith
1997
Personal work
Acrylics on panel
10in x 9in (25cm x 23cm)

LEFT:
Friday
1982
Cover for the novel by Robert A. Heinlein
(Del Rey)
Acrylics on watercolour board
30in x 20in (76cm x 51cm)

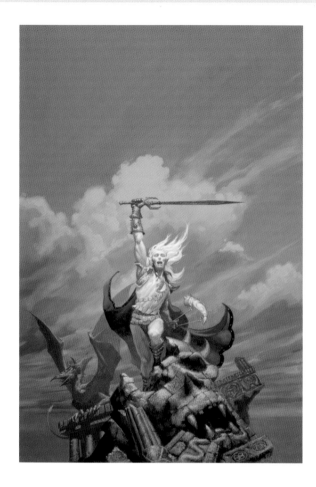

ABOVE:
Stormbringer
1978
Cover for the novel by Michael Moorcock (DAW)
Acrylics on panel
30in x 20in (76cm x 51cm)

TOP RIGHT:
Lumen 6
2001
Personal work
Oils on panel
32in x 32in (81cm x 81cm)
"This was later used as the cover for the 2002 iBooks edition of the anthology Dangerous Visions, *edited by Harlan Ellison."*

RIGHT:
Boogeyman
1986
Cover for the anthology *The Year's Best Horror Stories Series XIV* edited by Karl Edward Wagner (DAW)
Acrylics on watercolour board
28in x 17in (71cm x 43cm)
"I submitted this idea to DAW for years before they finally gave in and let me paint it."

COVER ILLUSTRATION, HARDCOVER
MICHAEL WHELAN
The Summer Queen
Cover for the novel by Joan D. Vinge (Warner
Questar)
Acrylics on canvas
36in x 24in (91cm x 61cm)

COVER ILLUSTRATION, PAPERBACK
DAVID A. CHERRY
The Healer
Cover for the anthology *Sword & Sorceress VII*, edited by Marion Zimmer Bradley (DAW)
Acrylics on board
c15in x 24in (38cm x 61cm)

RIGHT:
COVER ILLUSTRATION, MAGAZINE
DAVID MATTINGLY
The Subway Wizard
Cover for *Amazing Stories*, September 1991
Acrylics on board
27in x 21in (69cm x 53cm)
"This started as a rejected sketch for the cover of Simon Hawke's The Wizard of 4th Street. When Amazing Stories called and asked if I had any ideas for covers I would like to do, I had the sketch around the studio. I pulled it out and did the finished version. I'm the model on the left side; my late mother is the white-haired lady on the right; my wife is the woman in the right background. The cover is loaded with personal references, including the cover to Barclay Shaw's musical masterpiece Hose Head and an ad for my good friend Paul Chadwick's character Concrete."

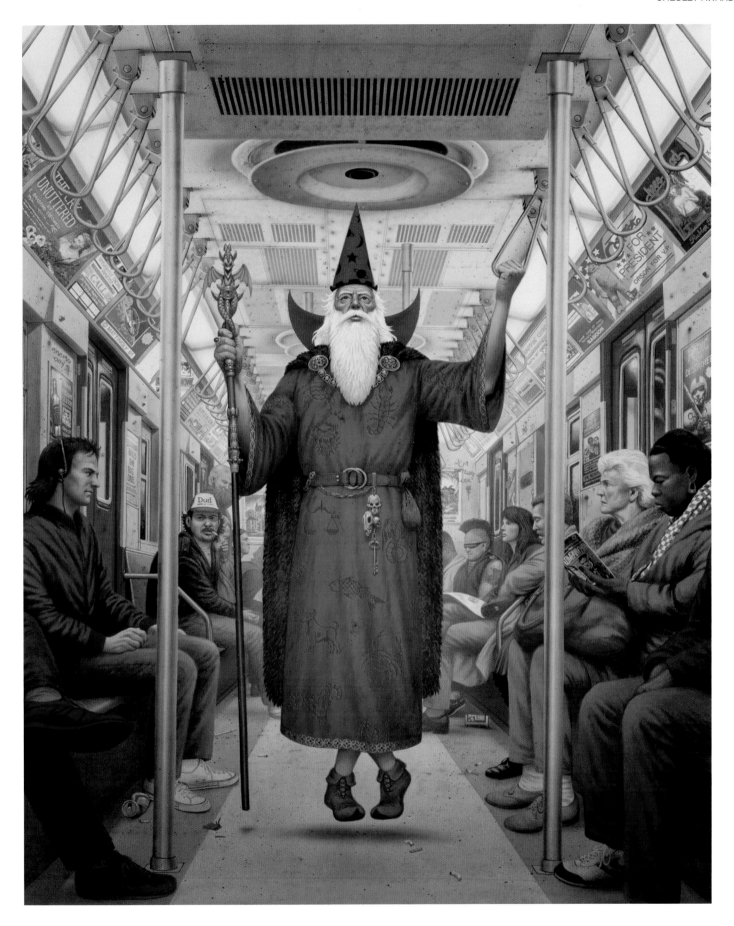

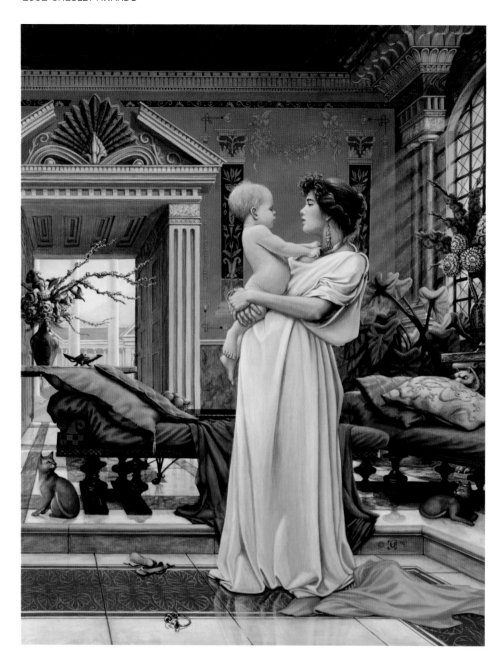

ART DIRECTOR
BETSY WOLLHEIM & SHEILA GILBERT

CONTRIBUTION TO ASFA (TIE)
RICHARD KELLY
JAN SHERRELL GEPHARDT

THREE-DIMENSIONAL WORK
CLAYBURN MOORE
Celestial Jade
Personal work
Plastiline clay
Height 29in (74cm),
including 5in (13cm) base

COLOUR WORK, UNPUBLISHED
DAVID A. CHERRY
Filia Mea
Personal work
Acrylics on board
18in x 24in (46cm x 61cm)
"My friend and favourite model, Jennifer Greeson, was pregnant at
the time, so we decided to do a piece dedicated to motherhood.
She is holding her daughter, Madeline. We took about seventy
photographs, and almost all could have resulted in a painting.
I intend to do more from that series one day. At present, this is
my favourite of all the paintings I have done."

MONOCHROME WORK, UNPUBLISHED
MICHAEL WHELAN
Weyrworld
Study for the cover of the novel *All the Weyrs of Pern*
by Anne McCaffrey (Del Rey)
Acrylics on watercolour board
9in x 12in (23cm x 30cm)

RIGHT:
INTERIOR ILLUSTRATION
BOB WALTERS
It Grows on You
Weird Tales, Summer 1991, illustrating the story by Stephen King
Pencil, pen and ink on hot press watercolour paper
8in x 12in (20cm x 30cm)
*"I liked the opportunity to do a more subtle piece, without the
intense horror or fantasy imagery often associated with* Weird Tales.
*I was gratified that my peers obviously thought it worked, too,
because they gave me a Chesley for it!"*

ARTISTIC ACHIEVEMENT 1992
JAMES GURNEY

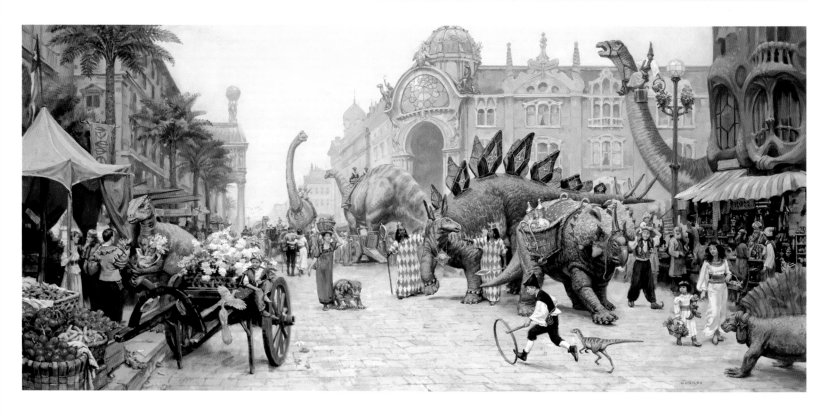

Dinosaur Boulevard
1991
Oils on canvas
24in x 48in (61cm x 122cm)
"Market day brings out a rainbow of people, dinosaurs and other prehistoric reptiles. A red Stegosaurus and a green Centrosaurus hold centre stage, while a Brachiosaurus raises its giraffe-like neck behind them. I rallied the people in my neighbourhood to wear colourful costumes and pose in my back yard as reference for the painting. The dinosaurs are based on an assortment of large models in my studio."

Dinosaur Nanny
1991
Oils on canvas
13in x 14in (33cm x 36cm)

Gesture of Thanks
1994
Oils on canvas
20in x 22in (51cm x 56cm)

Dream Canyon
1990
Oils on canvas
13in x 24in (33cm x 61cm)
*"In Canyon City, carved into the sandstone
walls of the Amu River gorge, young pilots
train to fly on gigantic winged pterosaurs.
The design of the canyons in Dinotopia
is based on my sketching trips to the
Grand Canyon and other locations in the
southwestern USA."*

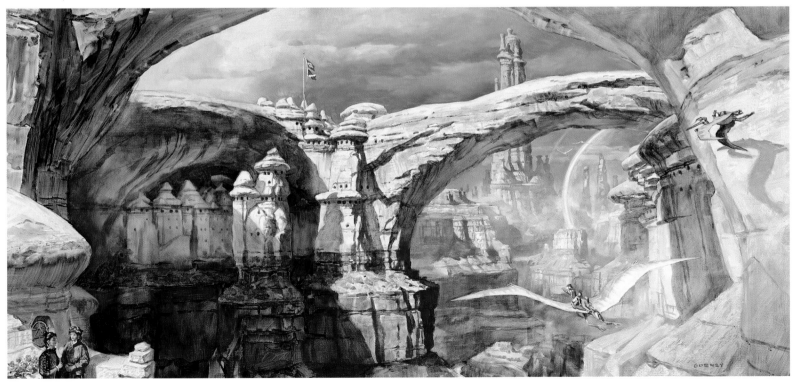

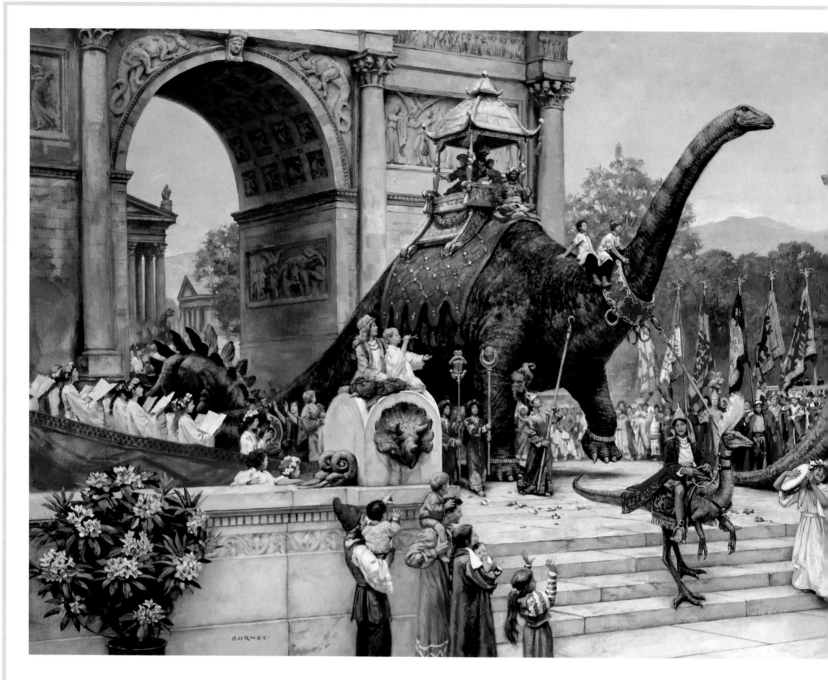

Dinosaur Parade
1989
Oils on canvas
24in x 48in (61cm x 122cm)
"To honour the children and dinosaur hatchlings, citizens of Dinotopia host an annual parade, full of pomp and pageantry. Here, a Triceratops youngster and adult are trailed by a gargantuan Apatosaurus. A Parasaurolophus rears up at right. This detailed oil painting, which appears on the cover of Dinotopia, helped to crystallize the concept of a world where humans and dinosaurs live together in harmony."

Giganotosaurus
1996
Oils on canvas
18in x 24in (46cm x 61cm)

Habitat Partners
1991
Oils on canvas
12in x 24in (30cm x 61cm)

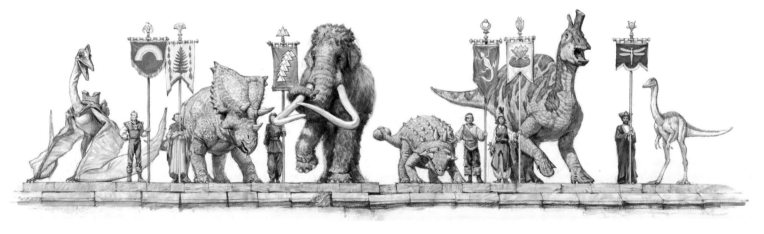

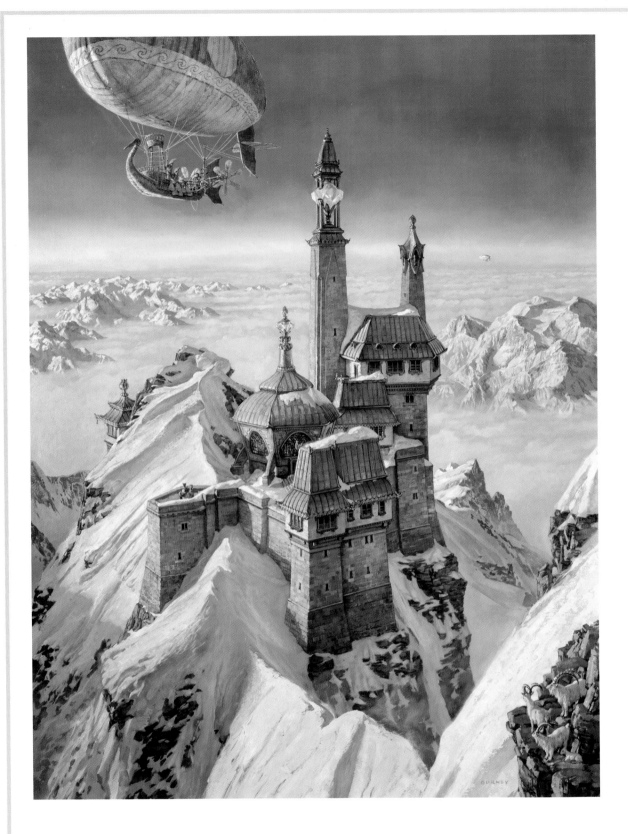

Palace in the Clouds
1989
Oils on canvas
30in x 40in (76cm x 102cm)
"This palace is often called the Tentpole of the Sky, because it seems to hold up the fabric of the heavens. It was built on the highest mountain in the centre of Dinotopia, and commands a fine view of the land in all directions. It is crowned by a gigantic sunstone, which was found intact in the great caverns beneath the island. It serves as a signal beacon to guide the Sky Galley dirigibles on foggy nights. To achieve realism in the architecture, I built a scale model of the building and set it up in a snowdrift in the back yard. There was no substitute for seeing the behaviour of the actual light and shade on three-dimensional forms."

COVER ILLUSTRATION, HARDCOVER
DON MAITZ
Magician: Apprentice
Cover for the novel by Raymond E. Feist (Bantam)
Oils on masonite
22.5in x 30in (57cm x 76cm)
"Several years after completing this work, I was congratulated by someone for my cleverness in painting the central rocky outcrop to resemble the silhouette of the head of The Thinker, the famous sculpture by Rodin. Of course, I agreed. In fact, the similarity was unconscious, and I was quite surprised to discover the shape when it was pointed out to me. The costumes were rented from a local theatrical costume warehouse. One of the models was an air-conditioning repairman who kindly donned the apparel for a photo shoot."

BELOW:
COVER ILLUSTRATION, MAGAZINE
MICHAEL WHELAN
Monument
Cover for *Asimov's*, November 1992
Acrylics on watercolour board
18in x 30in (46cm x 76cm)
"Commissioned by Asimov's for the commemorative issue following the passing of Isaac Asimov."

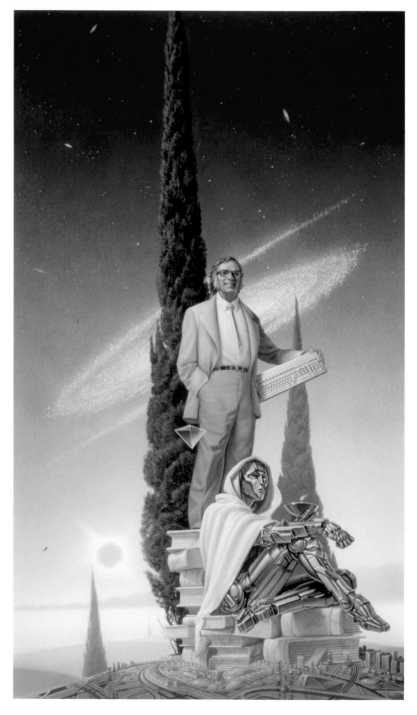

COVER ILLUSTRATION, PAPERBACK
DAVID A. CHERRY
Bladeswoman
Cover for the anthology *Sword & Sorceress IX*, edited by Marion Zimmer Bradley (DAW)
Acrylics on board
c15in x 24in (38cm x 61cm)
"DAW Books wanted me to come up with a female Errol Flynn for this one, someone who looked like she could kill you in a heartbeat but who was obviously one of the good guys. I must have hit the mark fairly well because I received no end of fan mail from women thanking me for coming up with a heroine who was not a bimbo in abbreviated chainmail and a rabbitskin bikini."

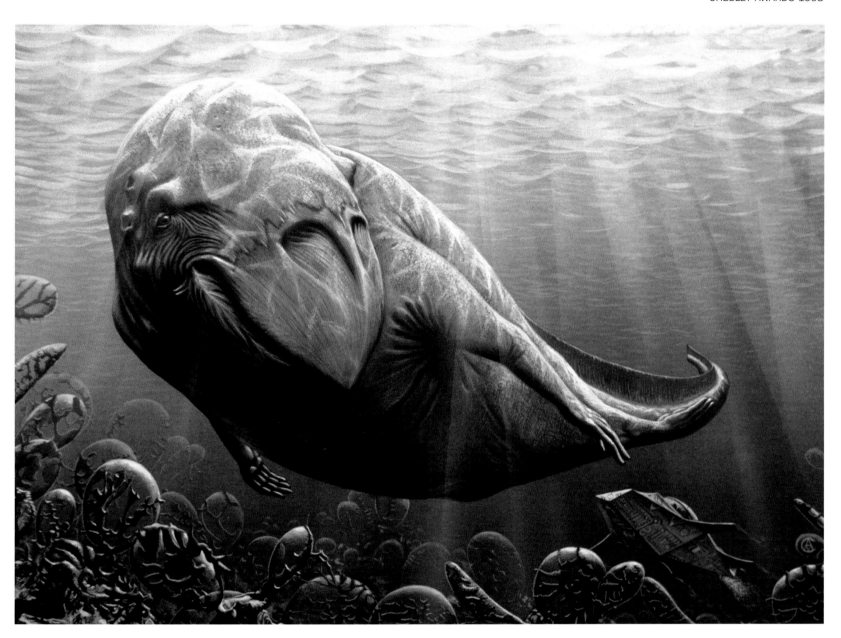

INTERIOR ILLUSTRATION
ALAN M. CLARK
Poles Apart
Analog, mid-December 1992, illustrating the story by G. David Nordley
Acrylics on board
Under 12in (30cm)

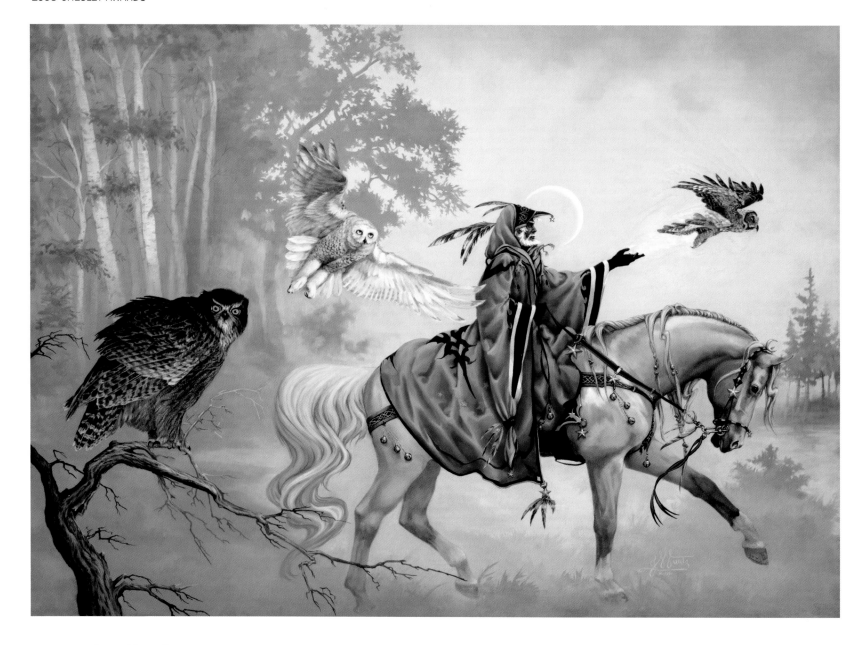

Colour Work, Unpublished
Janny Wurts
The Wizard of Owls
Personal work
Oils with copal resin concentrate on untempered masonite, with an acrylic ground
30in x 22.5in (76cm x 57cm)
"This painting was done for the sheer enjoyment of making a beautiful image that would attempt to capture the essence of a wild creature that lies outside the reach of either words or pictures. Birds of prey are more alert than we are. Their perception of their environment is more focused, and their senses more finely honed, which opens the fascinating question – what might an owl see that we do not? Legend holds that owls can cross the veil between the seen and the unseen, and move at will between worlds. The fascination of dissolving the borders into other realms was the idea I wished to portray, with the owls being creatures of magic, coming and going as a wizard's silent messengers. The wizard is earth-coloured, signifying our human ties with the natural world and the mystical world of imagination, so often neglected in our rushed, modern times of artificial lighting, acrylic carpets, and cement.

"A peculiar irony arose with this piece. For once in my career, I'd done a painting just for the sake of creating a pleasing image. Shortly afterwards, Marion Zimmer Bradley saw the original in a convention art show and wanted it as a cover for her magazine. This meant it had to illustrate a story, so I had to spin a tale to match the piece after the fact. Hence my short fiction 'Dreambridge' was born."

Art Director
Jamie Warren Youll

Contribution to ASFA
Ingrid Neilson

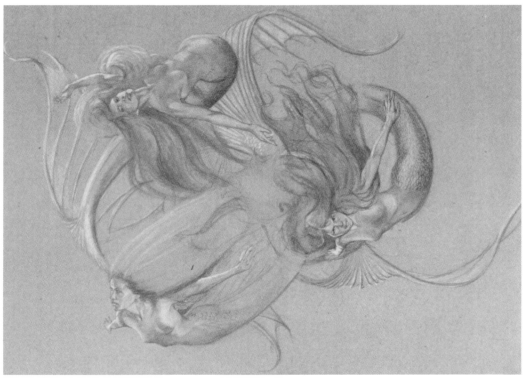

MONOCHROME WORK, UNPUBLISHED
DAVID A. CHERRY
Tag, You're It
Personal work
Pencil
Dimensions unknown
*"Done just for fun and because my
wife loves mermaids."*

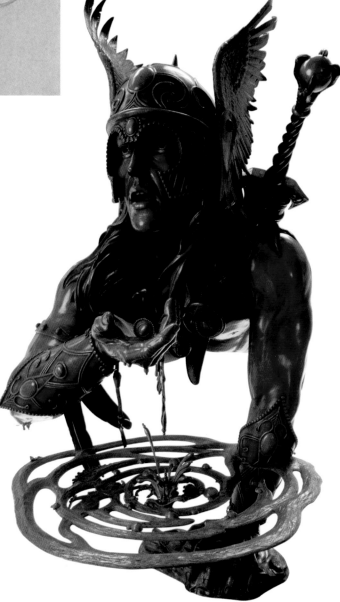

THREE-DIMENSIONAL WORK
GARY PERSELLO
Reflection
Personal work
Hand cast and patinated bronze
48in x 26in x 32in (122cm x 66cm x 81cm)
Reproduced by permission of The Frank Collection

ARTISTIC ACHIEVEMENT 1993
JAMES GURNEY

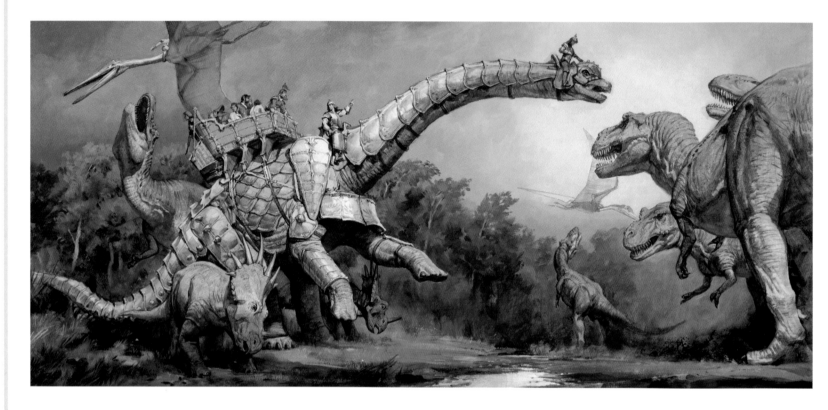

ABOVE:
Attack on a Convoy
1994
Oils on canvas
16in x 22in (41cm x 56cm)
"Not all dinosaurs in Dinotopia live harmoniously with their neighbours. It's not safe to travel unprotected through Tyrannosaurus territory. A custom-designed suit of armour protects this brachiosaur bus, which is escorted by two styracosaurs with spiked frills. I consciously limited the range of colours to a warm monochromatic design with a few touches of red, eliminating blues and greens to give a stark drama to the scene."

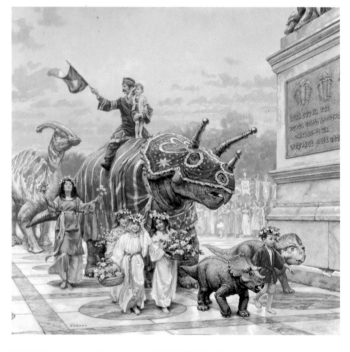

Birthday Pageant
1993
Oils on canvas
23in x 23in (58cm x 58cm)
"In Dinotopia, birthdays – or Hatchdays, as they are sometimes called – are times of flowers and flags, of dances and songs. Here a group of children and adults join a costumed Triceratops and its hatchling in a procession in honour of the birthday of a fellow Dinotopian."

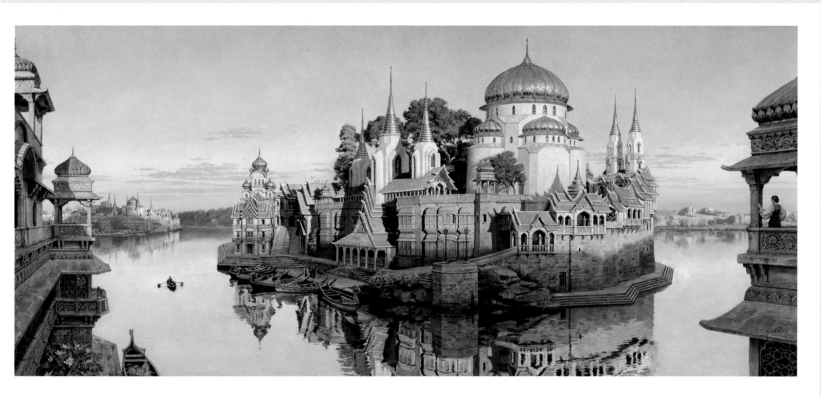

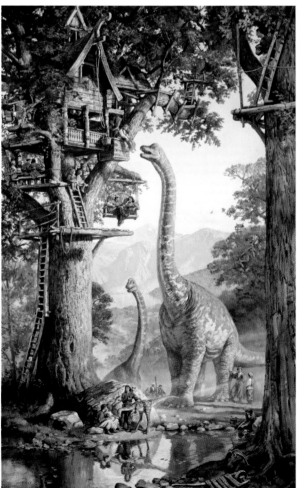

ABOVE:
Chandara
2002
From the *Recent Works* CD
Oils on canvas
24in x 52in (61cm x 132cm)
"The first light of sunrise touches the golden domes of Chandara, the centre of art and science in eastern Dinotopia. The city is made up of a cluster of neighbouring islands laid out like jewels in Silver Bay. As the city wakes up, dinosaurs will climb into the ferry boats now tied up in the harbour and, using their powerful sweeping tails, propel the boats from place to place."

LEFT:
Morning in Treetown
1990
Oils on canvas
20in x 40in (51cm x 102cm)

RIGHT:
Timestone Pirates
2001
Oils on canvas
10in x 24in (25cm x 61cm)

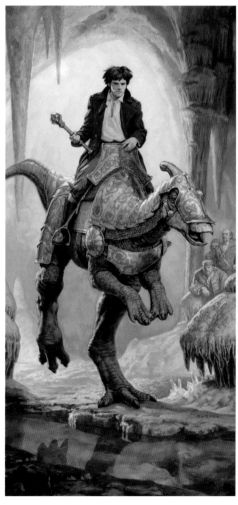

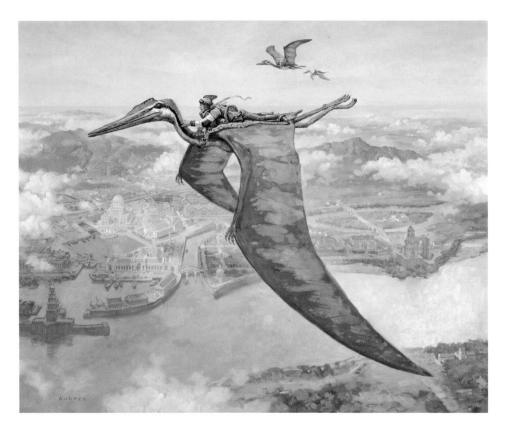

LEFT:
Skybax Rider
1990
Oils on canvas
20in x 24in (51cm x 61cm)
"The largest creatures ever to fly over the Earth, Quetzalcoatlus – or 'skybax', as they are known in Dinotopia – carry young pilots high into the air. Like all creatures in Dinotopia, these pterosaurs are based on actual creatures from the fossil record."

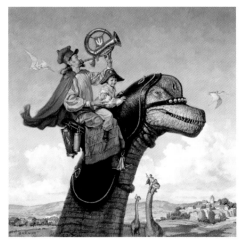

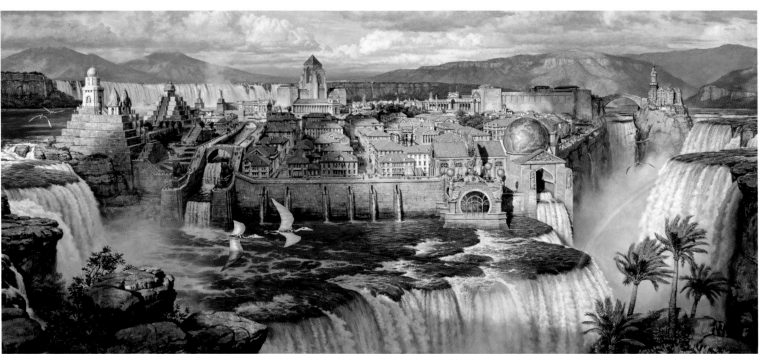

Waterfall City Afternoon Light
2001
Oils on canvas
24in x 52in (61cm x 132cm)

ABOVE:
Up High
1991
Oils on canvas
23in x 23in (58cm x 58cm)

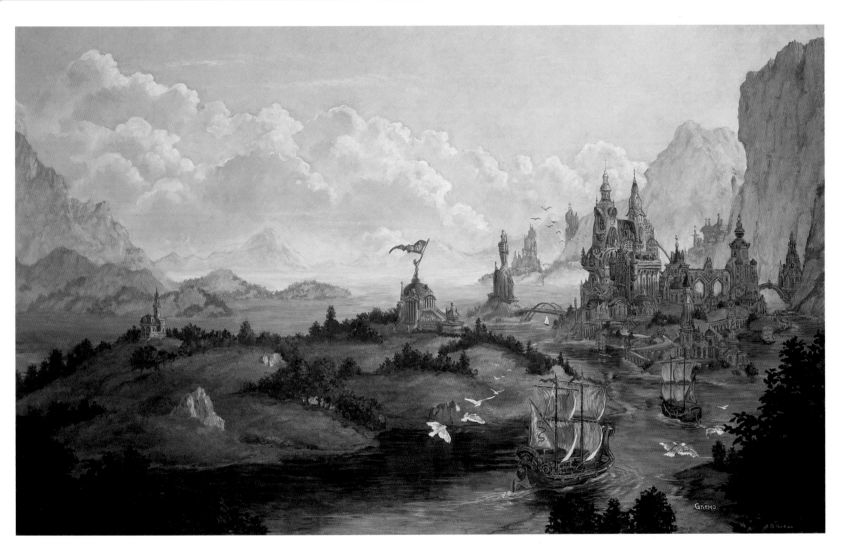

COVER ILLUSTRATION, HARDCOVER
TOM KIDD
The Far Kingdoms
Cover for the novel by Allan Cole and Chris Bunch
(Legend/Del Rey)
Oils
22in x 36in (56cm x 91cm)
*"This painting was done under my pseudonym Gnemo.
I have since done a modified version of it, called* Dunne
Estates.*"*

COVER ILLUSTRATION, PAPERBACK
BOB EGGLETON
Dragons!
Cover for the anthology edited by Jack Dann and Gardner Dozois
(Ace)
Acrylics on board
24in x 30in (61cm x 76cm)
"Done as a lark. I wanted to break the reputation I had as only a space painter. I have lost a great deal of interest in doing astronomical art, partly because astronomical art is best done digitally, I think, but mostly because . . . well, how could artists compete with the images produced by the Hubble?"

COVER ILLUSTRATION, MAGAZINE
WOJTEK SIUDMAK
Idylle
Cover for *Asimov's* December 1993
Acrylics on canvas
31.5in x 31.5in (80cm x 80cm)
"This painting was originally done in 1981, making its Asimov's appearance much later"

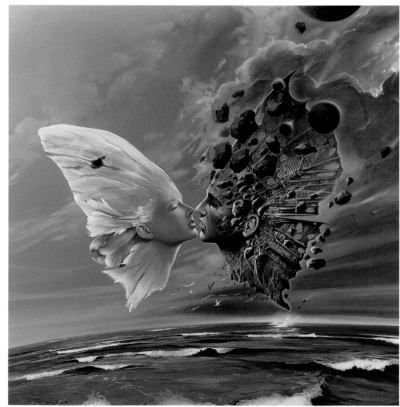

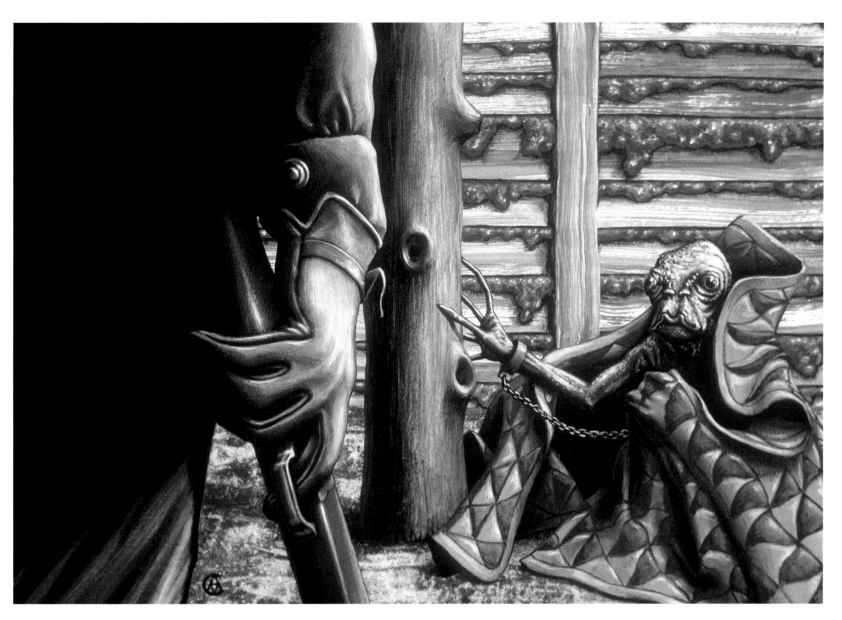

INTERIOR ILLUSTRATION
ALAN M. CLARK
The Toad of Heaven
Asimov's, June 1993, illustrating the story by Robert Reed
Acrylics on board
Under 12in (30cm)

THREE-DIMENSIONAL WORK
JENNIFER WEYLAND
Flying Pegasus and Rider

ART DIRECTOR
JAMIE WARREN YOULL

CONTRIBUTION TO ASFA (TIE)
TERESA PATTERSON AND PEGASUS MANAGEMENT CREW
DAVID LEE PANCAKE

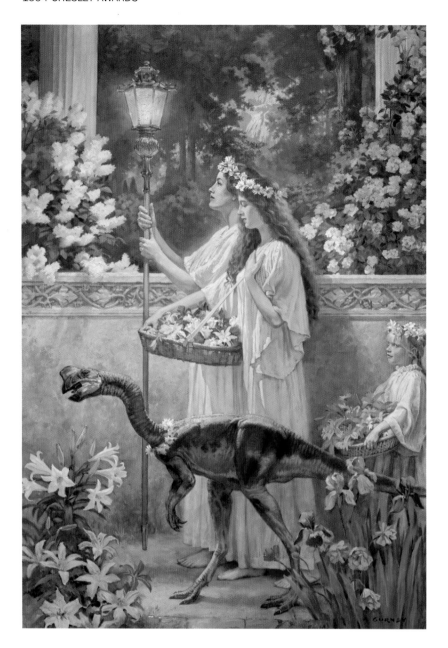

COLOUR WORK, UNPUBLISHED
JAMES GURNEY
Garden of Hope
Done for the book *Dinotopia: The World Beneath*
Oils on canvas
28in x 18.5in (71cm x 47cm)

MONOCHROME WORK, UNPUBLISHED
CARL LUNDGREN
Impudence
Personal work
Oils/mixed media on hardboard
60in x 36in (152cm x 91cm)

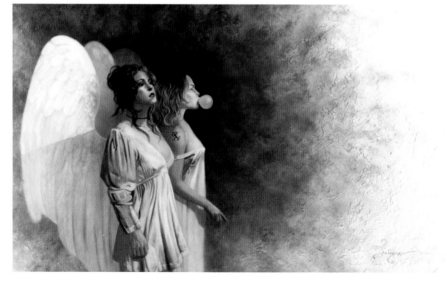

ARTISTIC ACHIEVEMENT 1994
FRANK KELLY FREAS

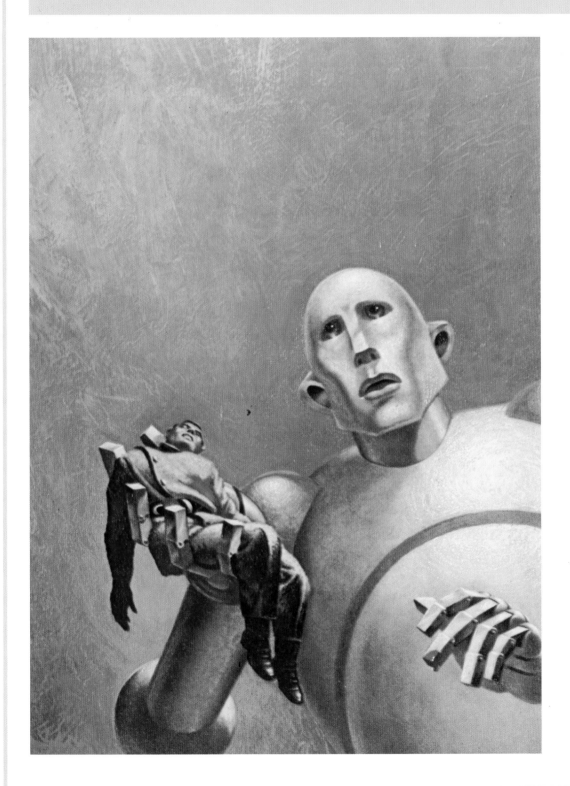

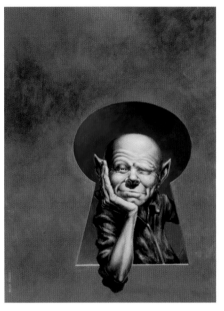

ABOVE:
Martians, Go Home
1954
Cover for *Astounding*, March 1954,
illustrating the serial by Fredric Brown
Acrylics on board
15in x 20in (38cm x 51cm)

The Gulf Between
1953
Cover for *Astounding*, October 1953,
illustrating the story by Tom Godwin
Acrylics on board
15in x 20in (38cm x 51cm)

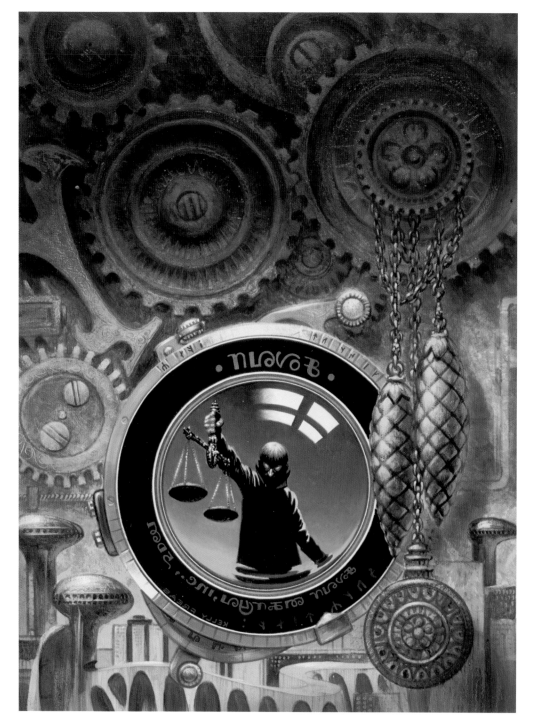

Mister Justice
1972
Cover for the novel by Doris Piserchia
(Ace)
Acrylics on board
15in x 20in (38cm x 51cm)

Call Me Joe
1957
Cover for *Astounding*, April
1957, illustrating the story by
Poul Anderson
Acrylics on board
15in x 20in (38cm x 51cm)

BELOW:
Conscience Interplanetary
1975
Cover for the novel by Joseph Green (DAW)
Acrylics on board
15in x 20in (38cm x 51cm)

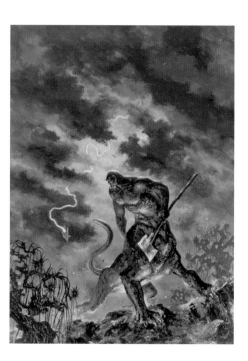

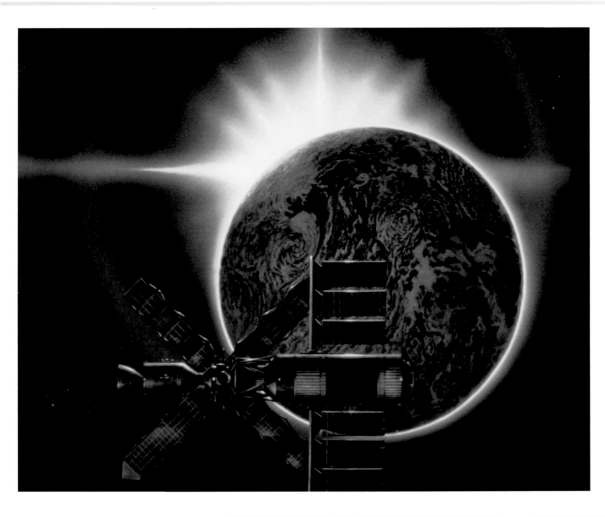

Skylab
1973
Cover for *Analog*, June 1973
Acrylics on board
15in x 20in (38cm x 51cm)

BELOW:
The Custodians
1968
Cover for *Analog*, December 1968,
illustrating the story by James H.
Schmitz
Acrylics on board
15in x 20in (38cm x 51cm)

Double Star
1956
Cover for *Astounding*, April
1956, illustrating the serial
by Robert A. Heinlein
Acrylics on board
15in x 20in (38cm x 51cm)

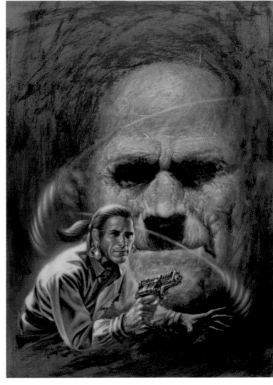

The Green Hills of Earth
1979
Cover for the audio version of the
novel by Robert A. Heinlein
(Caedmon Records)
Acrylics on board
15in x 20in (38cm x 51cm)

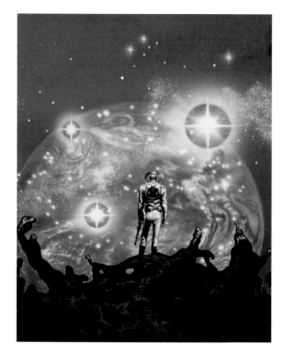

Medea
1985
Fold-out print for the anthology *Harlan's
World* edited by Harlan Ellison (Phantasia)
Acrylics on board
20in x 15in (51cm x 38cm)

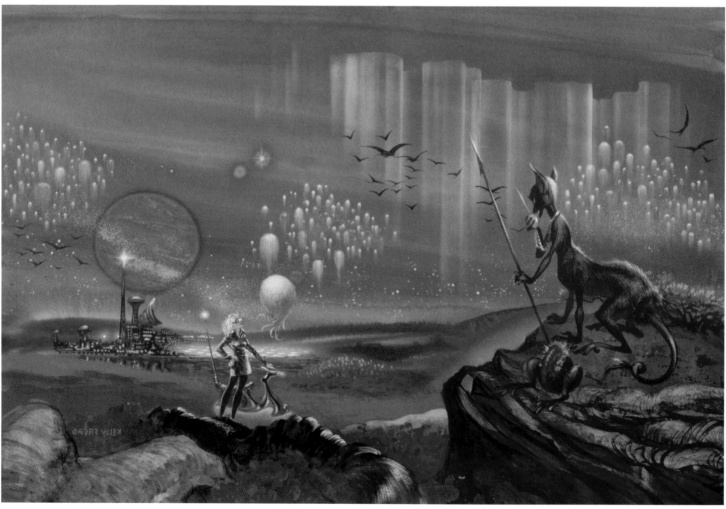

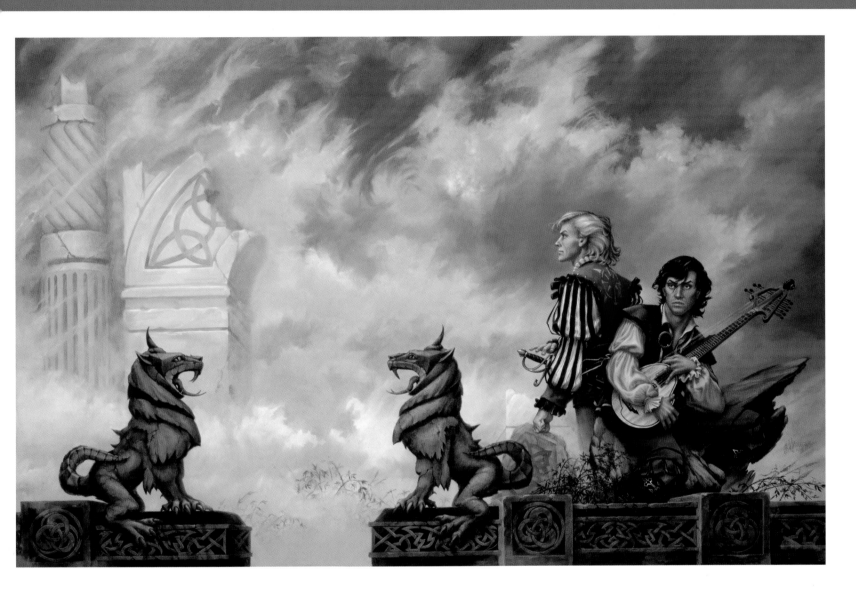

COVER ILLUSTRATION, HARDCOVER
JANNY WURTS
The Curse of the Mistwraith
Cover for the novel by Janny Wurts (Penguin/Roc)
Oils and copal resin on untempered masonite with an acrylic ground
36in x 23.5in (91cm x 60cm)
"The Curse of the Mistwraith *was the first novel in my* Wars of Light and Shadow *series, and this painting depicted the main characters in it. The story involves two half-brothers whose powers of Light and Shadow banish the mists that have covered a world for five centuries. The mistwraith they defeat curses them to destroy each other, and as each of the brothers pursues his fate the world becomes divided by violence. The story does not endorse the symbolism whereby 'dark' is evil and 'light' is right, but explores the anguish of wars as told from both sides. The blond brother was born a prince and a charismatic statesman, and his gift for just rule leads him to make a grand cause and self-righteous mission of his plight. The dark brother whom he is curse-bound to oppose struggles to maintain his self-honesty in the face of the escalating violence of war; since killing is abhorrent to his basic nature, he wrestles his inner demons with the sensitivity and insight of a mage-trained musician."*

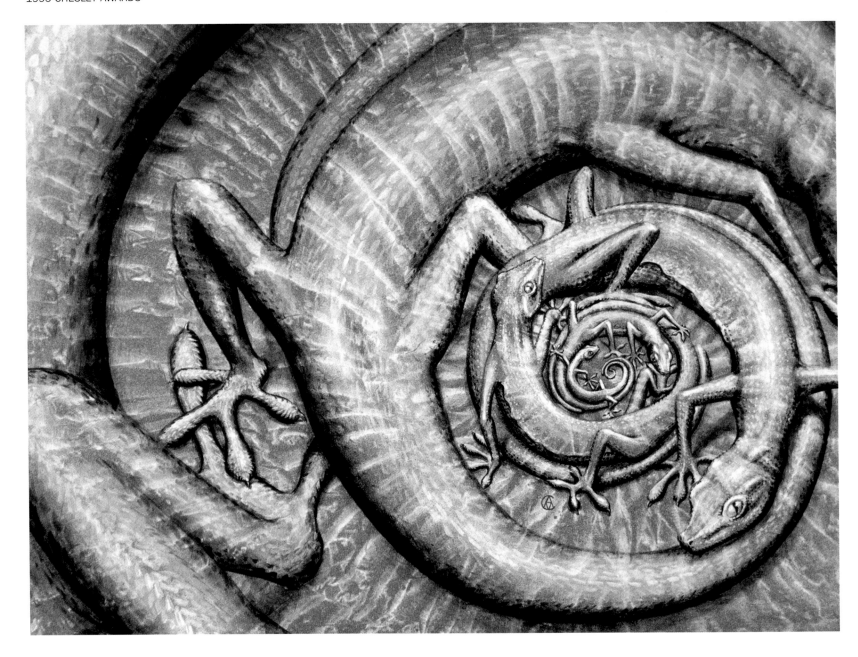

COVER ILLUSTRATION, PAPERBACK
ALAN M. CLARK
Geckos
Cover for the novel by Carrie Richerson (Roadkill)
Acrylics on board
12in x 18in (30cm x 46cm)

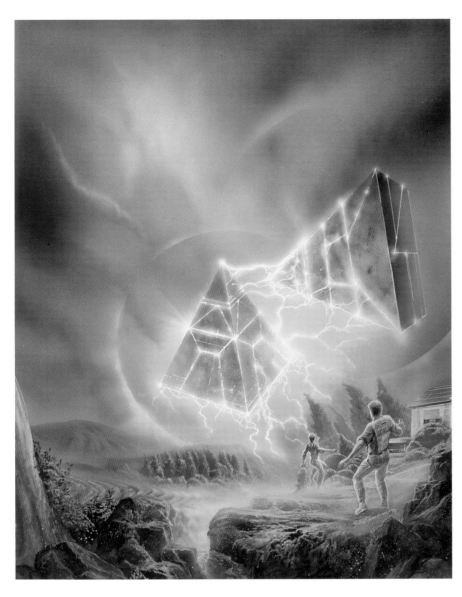

COVER ILLUSTRATION, MAGAZINE (TIE)
WOJTEK SIUDMAK
Eclosions
Cover for *Analog,* December 1994
Acrylics on canvas
19.5in x 25.5in (50cm x 65cm)

COVER ILLUSTRATION, MAGAZINE (TIE)
BOB EGGLETON
Soon Comes Night
Asimov's, August 1994, illustrating the story by Gregory
Benford
Acrylics on board
16in x 20in (41cm x 51cm)
*"Benford's story was set on his mecha-world at the
Galactic Centre. The mecha things looked like two
huge pyramids."*

INTERIOR ILLUSTRATION
BRIAN FROUD
Lady Cottington's Pressed Fairy Book
Illustrated book by Brian Froud & Terry Jones (Turner)

Watercolours and acrylics with coloured pencil
Each 12in x 16in (30cm x 41cm)

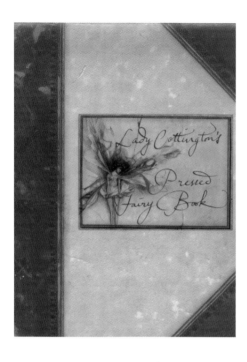

Colour Work, Unpublished
Alan M. Clark
The Pain Doctors of Suture Self General
Acrylics on board
24in x 36in (61cm x 91cm)
*"This was in response to my seven-week
hospital stay for brain abscesses."*

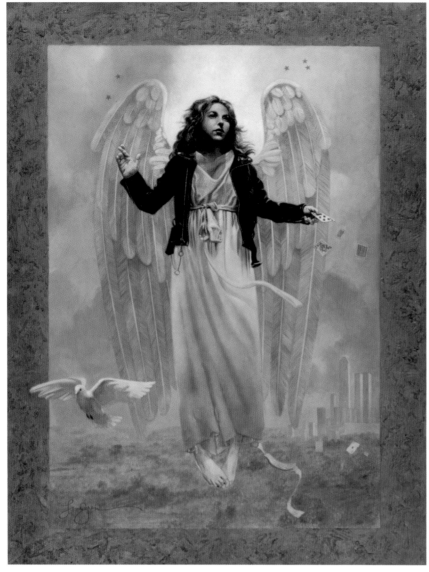

MONOCHROME WORK, UNPUBLISHED
CARL LUNDGREN
Promise
Personal work
Oils/mixed media on hardboard
40in x 60in (102cm x 152cm)

THREE-DIMENSIONAL WORK
CLAYBURN MOORE
Pitt
Licensed piece (from Dale Keown)
Super Sculpey
Height 12.25in (31cm), including 2.25in (6cm) base
"This was marketed by Moore Creations as both a cold-cast porcelain and a bronze edition."

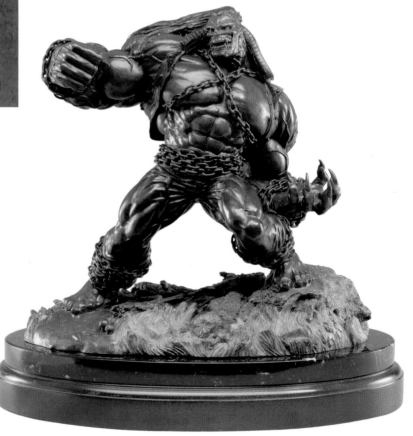

ART DIRECTOR
CATHY BURNETT & ARNIE FENNER

CONTRIBUTION TO ASFA
DAVID LEE PANCAKE

ARTISTIC ACHIEVEMENT 1995
FRANK FRAZETTA

Fire & Ice
1983
Sculptures done for artist renderings for the animated
movie produced by Ralph Bakshi and Frank Frazetta

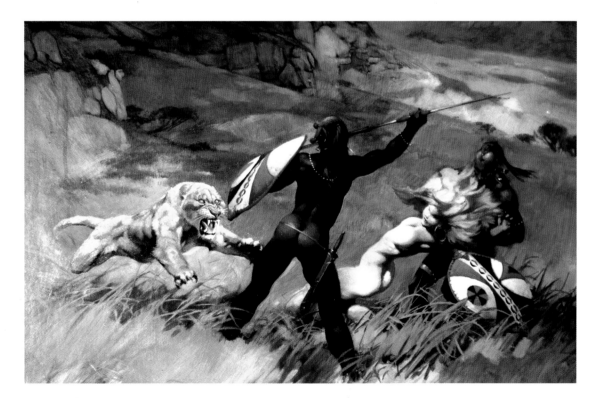

African Scene
1985
Oils on
hardboard
12in x 14in
(30cm x 36cm)

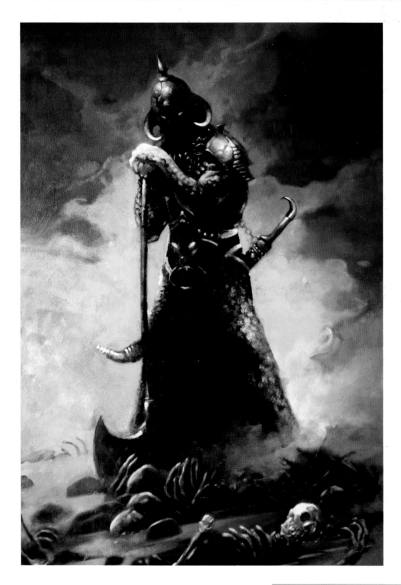

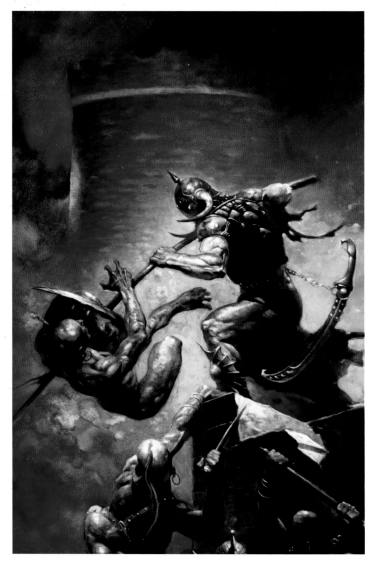

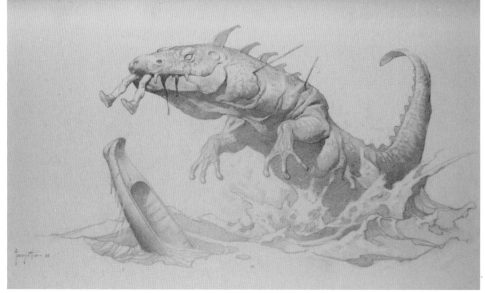

ABOVE:
Death Dealer 3
1987
Oils on hardboard
15in x 24in (38cm x 61cm)

RIGHT:
Serpent
1994
Pencil on paper
11in x 14in (28cm x 36cm)

ABOVE RIGHT:
Death Dealer 5
1988
Oils on hardboard
14in x 24in (36cm x 61cm)

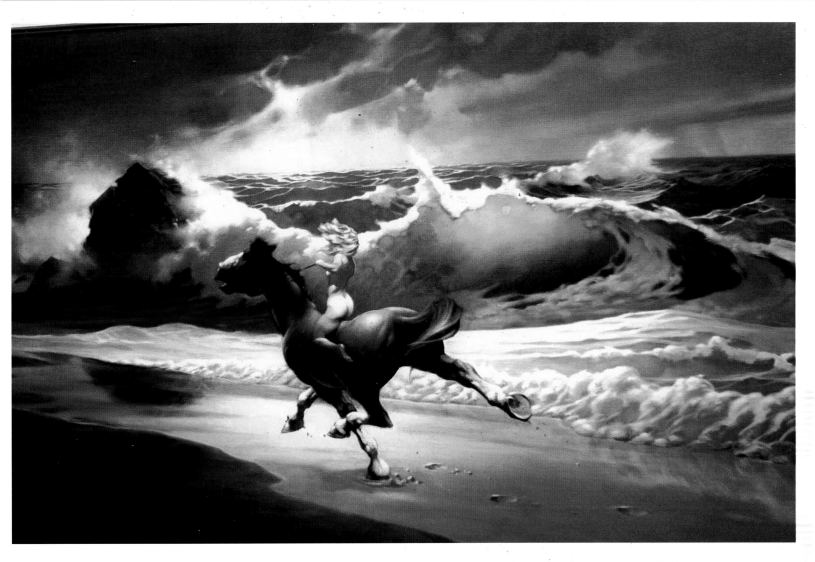

LEFT:
Sketch
1994
Pencil on paper
Size unknown

Wildride
1990
Oils on canvas
16in x 24in (41cm x 61cm)

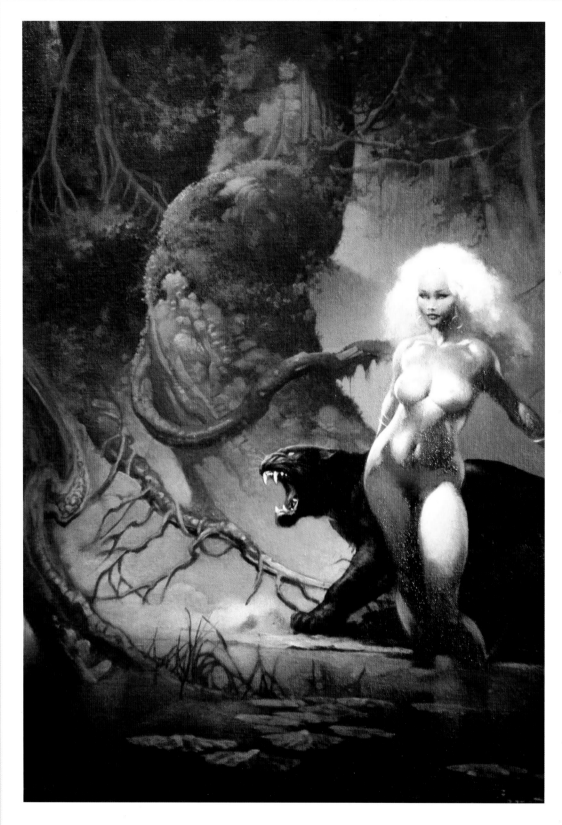

Princess and the Panther
1990
Oils on hardboard
17in x 23in (43cm x 58cm)

BELOW:
Sketch
1994
Pencil on paper
Size unknown

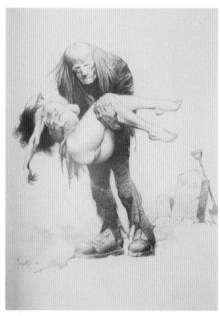

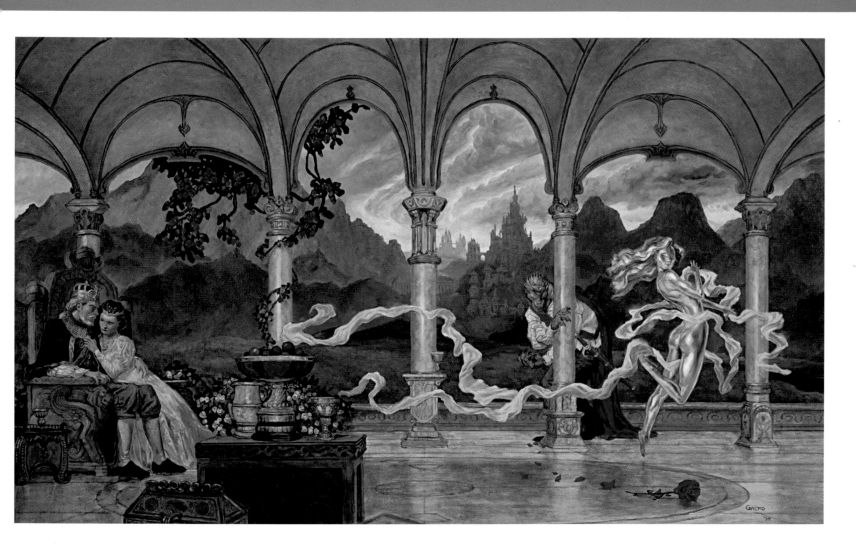

COVER ILLUSTRATION, HARDCOVER
TOM KIDD
Kingdoms of the Night
Cover for the novel by Chris Bunch & Allan Cole (Del Rey)
Oils
22in x 36in (56cm x 91cm)
"I did this under my pseudonym Gnemo."

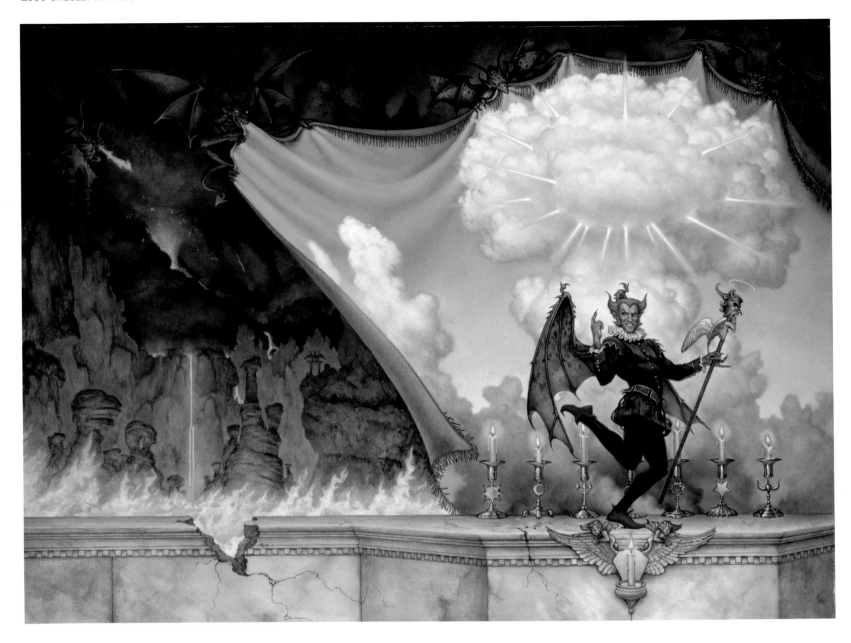

COVER ILLUSTRATION, PAPERBACK
DON MAITZ
A Farce to Be Reckoned With
Cover for the novel by Roger Zelazny & Robert Sheckley
(Bantam Spectra)
Oils on masonite
20in x 27in (51cm x 69cm)
"The manuscript came to me from the publisher with an uninspired provisional title. After reading the text, I suggested the title that was actually used. I later met Zelazny at a gathering (OK, it was in a bar) and he thanked me for it. A theatrical warehouse that supplies costumes for Shakespearean plays was helpful."

RIGHT:
COVER ILLUSTRATION, MAGAZINE
BOB EGGLETON
Tide of Stars
Analog, January 1995, illustrating the story by Julia Ecklar
Acrylics on board
16in x 20in (41cm x 51cm)
"After doing this cover I realized how awful my airbrushing was looking – in fact, airbrushing was making me physically sick. The airbrush is a seductive tool that can strip you of your sensitivity towards your own work. That's what was happening with me, and this piece represented one of the last straws so far as my romance with the airbrush was concerned. Looking back, I cringe – to be honest, when I look at most airbrush artwork today I cringe."

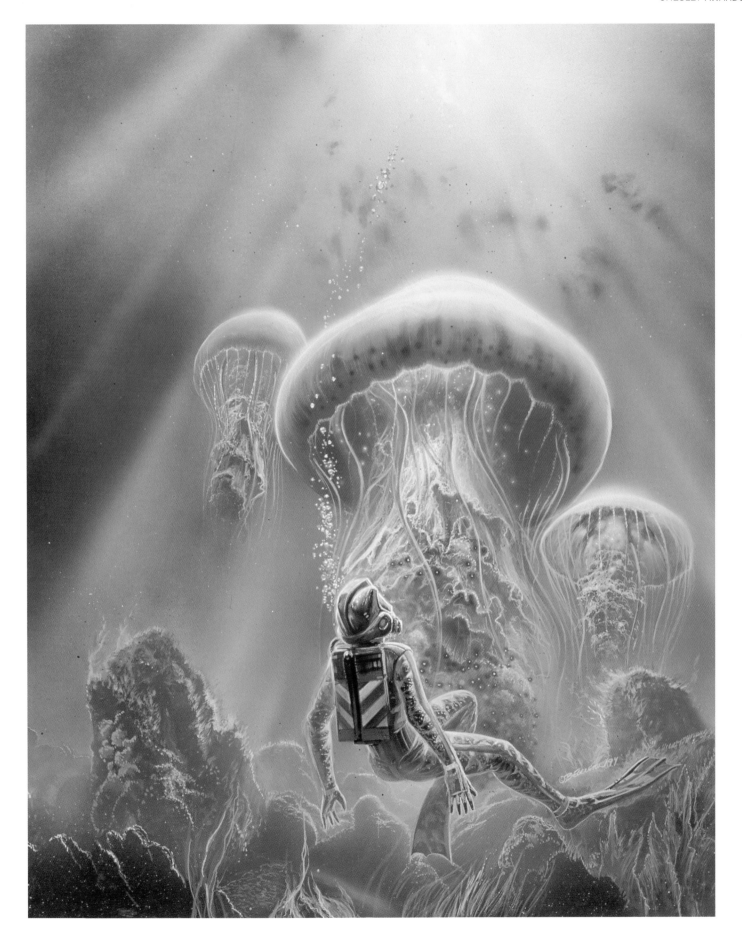

INTERIOR ILLUSTRATION
JAMES GURNEY
Dinotopia: The World Beneath
(Turner)

Map of Dinotopia

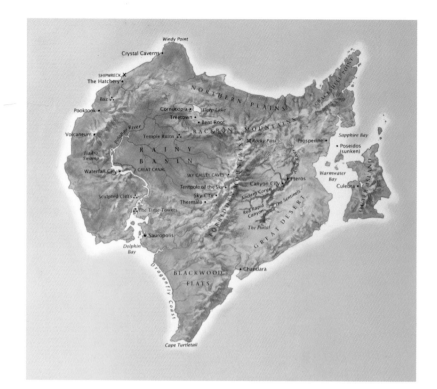

Rumble and Mist
Oils on canvas
11.5in x 33in (29cm x 84cm)

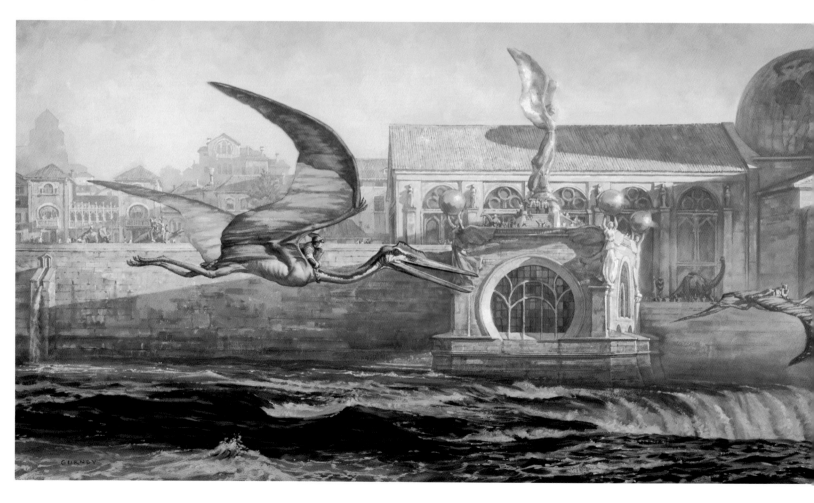

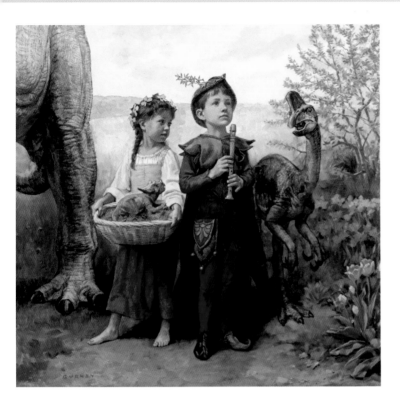

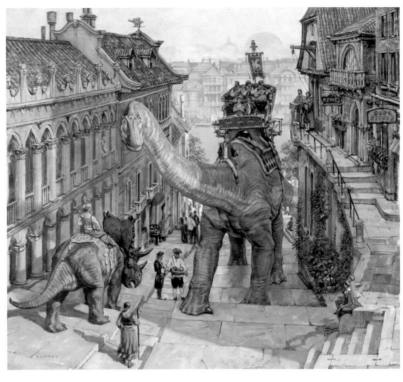

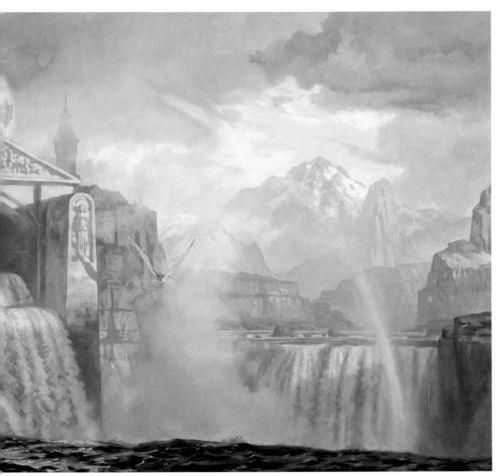

TOP LEFT:

Small Wonder
Oils on canvas
13in x 14in (33cm x 36cm)
"This painting shows two young people at a springtime festival. The boy is dressed to represent the plant kingdom and the girl carries a small Triceratops hatchling. To create this painting, I dug down to the most basic feelings: the nurturing of a new life, the enjoyment of companionship, music and the outdoors, and most of all the feeling of wonder that was the daily bread of our youth. So much that I had earlier painted as a fantasy artist explored themes of terror and darkness, but as I travelled farther into Dinotopia I felt there were sunlit realms to discover as well."

ABOVE:

Steep Street
Oils on canvas
13in x 14in (33cm x 36cm)
"Streets are narrow in Waterfall City, and they're steep enough to require stairs: big ones for the dinosaurs and little ones for the people. I was inspired by my memories of Venice, where the streets are crooked, having grown organically over the centuries. Then I gave them a Dinotopian spin."

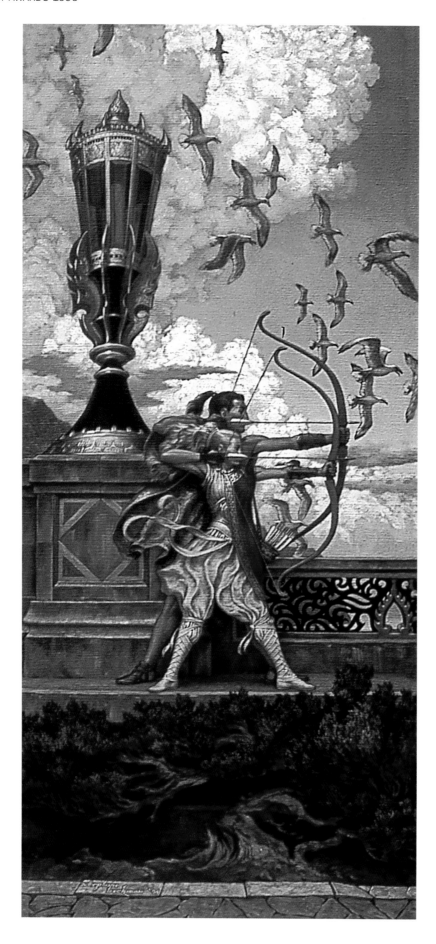

COLOUR WORK, UNPUBLISHED
STEPHEN HICKMAN
The Archers
Oils on canvas
22in x 50in (56cm x 127cm)
"One of the ideas I did to try and interest The Greenwich Workshop in producing prints. I painted this on heavy double-weave Belgian linen, with the glue sizing and all the rest of the ancient rigamarole. The monochrome painting was in Mars violet."

ART DIRECTOR
JAMIE WARREN YOULL

CONTRIBUTION TO ASFA
INGRID NEILSON

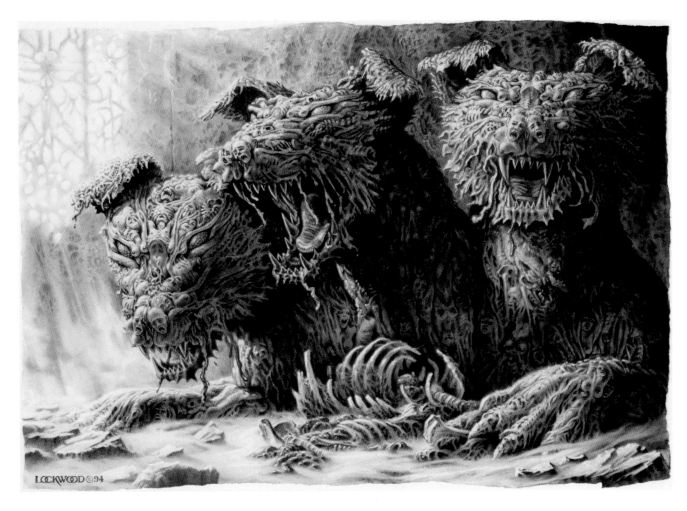

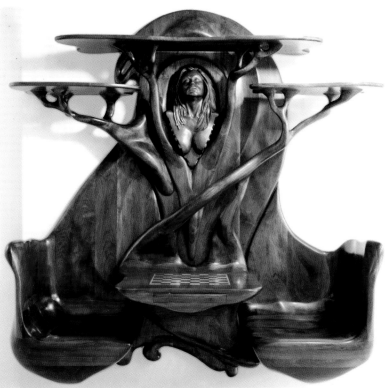

Monochrome Work, Unpublished
Todd Lockwood
Cerberus
Personal work
Pencil on board
11in x 15in (28cm x 38cm)
"This was a personal piece intended as a visual aid for my Dungeons & Dragons group. One of my players had changed deities, which of course required that the supplicant perform a quest. They were all high-level by this point and not afraid of much in the game world, so I wanted to scare the bejasus out of them. I ended up scaring myself, too."

Three-Dimensional Work
Barclay Shaw
Ellison Wonderland Chess Table
Private commission for Harlan Ellison
Walnut, clay, plaster and bronze
72in x 80in x 36in (183cm x 203cm x 91cm)
"The block laminated walnut rough was carved by chainsaw, then finished by hand and power tools. The figure was modelled in clay and finished in plaster and bronze cast. This piece was inspired by and created as a companion piece to a noncommissioned carved fantasy desk that Ellison had purchased at the 1980 World Science Fiction Convention."

ARTISTIC ACHIEVEMENT 1996
THOMAS CANTY

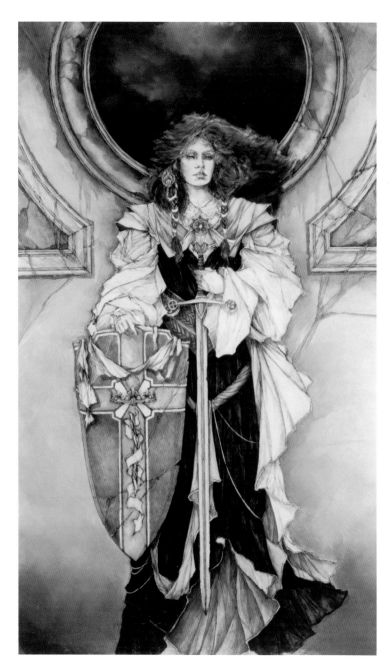

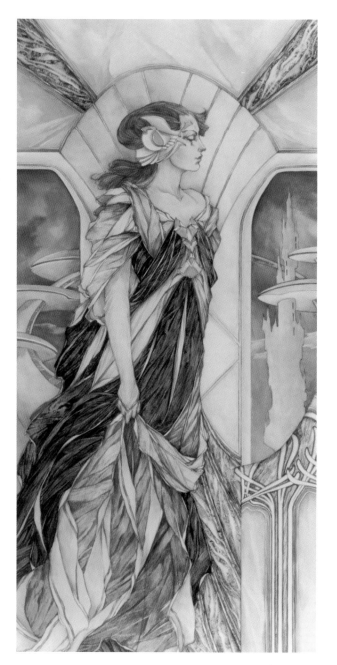

The Silver Branch
1988
Cover for the novel by Patricia Kennealy
(New American Library)
Oils on paper, mounted on board
11.5in x 19in (29cm x 48cm)

Forerunner Foray
1992
Cover for the novel by Andre Norton
(Penguin)
Oils on paper, mounted on board
8.5in x 15in (22cm x 38cm)

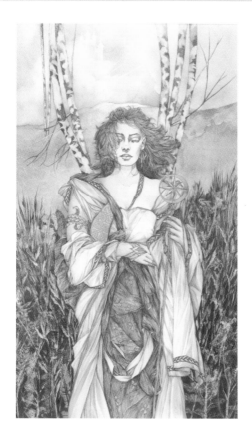

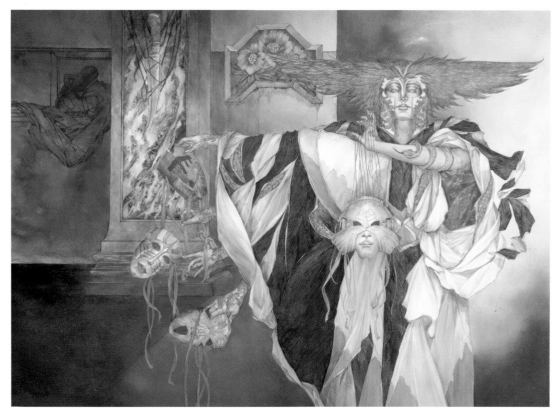

ABOVE:
Spires of Spirit
1996
Cover for the collection *Spires of Spirit: Early Stories in the World of Strands of Starlight* by Gael Baudino (New American Library)
Oils on paper, mounted on board
8.5in x 15in (22cm x 38cm)

TOP RIGHT:
The Year's Best Fantasy and Horror: Fifteenth Annual Collection
2002
Cover for the anthology edited by Terri Windling and Ellen Datlow (St Martin's Press)
Oils on paper, mounted on board
21in x 15.5in (53cm x 39cm)

RIGHT:
Stories for an Enchanted Afternoon
2001
Cover for the collection by Kristine Kathryn Rusch (Golden Gryphon)
Oils on paper, mounted on board
18.5in x 16in (47cm x 41cm)

White Raven
1989
Cover for the novel by Diana L. Paxson
(Morrow)
Oils on paper, mounted on board
13in x 18in (33cm x 46cm)

Dandelion Wine
1989
Cover for the novel by Ray Bradbury
(Bantam Spectra)
Oils on paper, mounted on board
20in x 12.5in (51cm x 32cm)

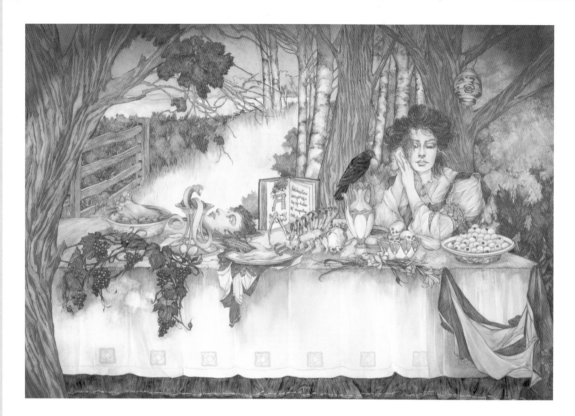

The Year's Best Fantasy and Horror: Tenth Annual Collection
1997
Cover for the anthology edited by
Terri Windling and Ellen Datlow
(St Martin's Press)
Oils on paper, mounted on board
21in x 15in (53cm x 38cm)

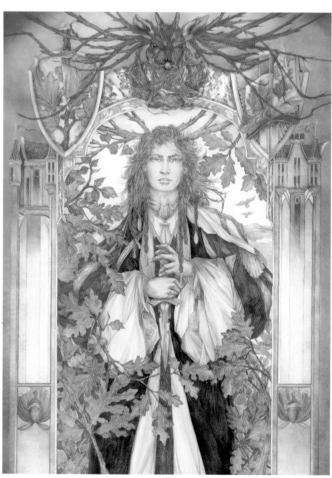

The Fall of the Kings
2002
Cover for the novel by Ellen Kushner
and Delia Sherman (Bantam Spectra)
Oils on paper, mounted on board
14in x 20in (36cm x 51cm)

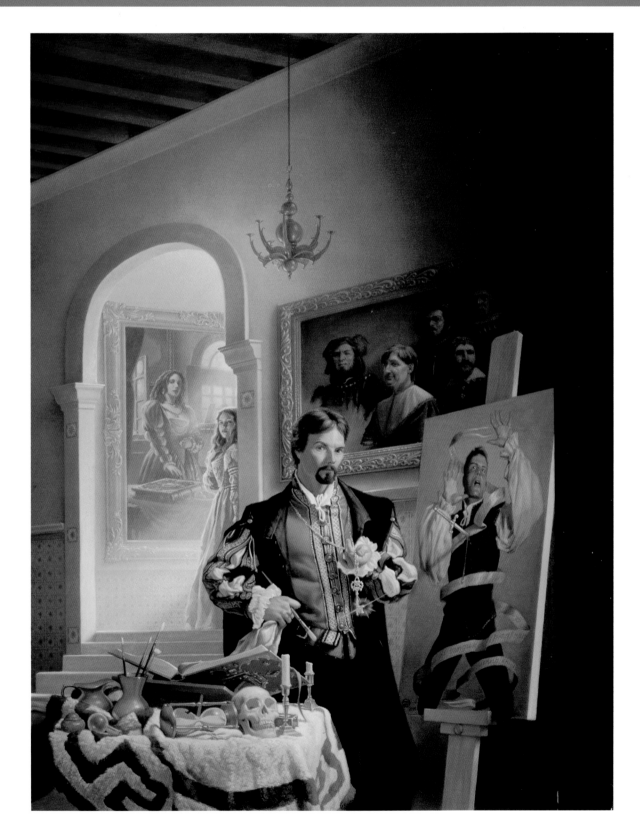

COVER ILLUSTRATION,
HARDCOVER
MICHAEL WHELAN
The Golden Key
Cover for the novel by
Melanie Rawn, Jennifer
Roberson & Kate Elliott
(DAW)
Oils on canvas
36in x 24in (91cm x 61cm)

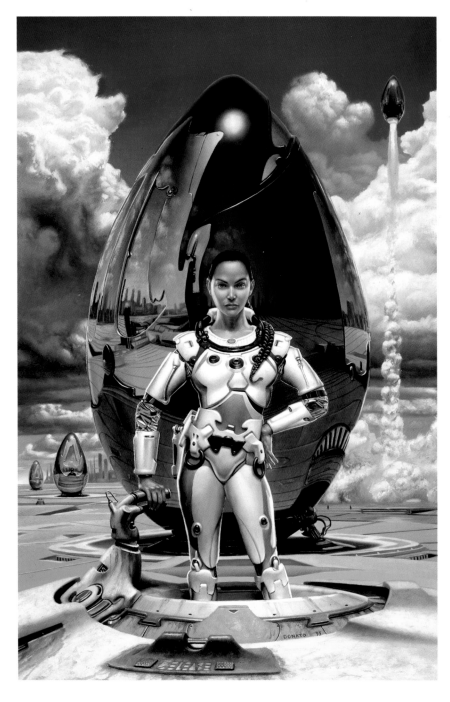

COVER ILLUSTRATION, MAGAZINE
BOB EGGLETON
Airborn
The Magazine of Fantasy & Science Fiction, May 1996, illustrating the story by Nina Kiriki Hoffman
Acrylics on board
20in x 24in (51cm x 61cm)
"I'd had it with airbrushing: I hated it, and was determined I would work in other ways. Ed Ferman of F&SF gave me the chance. Instead of directly illustrating Hoffman's story, I used it as a springboard to go off in my own direction to create an image that deals with psychological imprisonment, which of course relates to my own painting at the time. A model friend posed for the picture. Airborn was a joy to do because at last I'd forsaken that airbrush!"

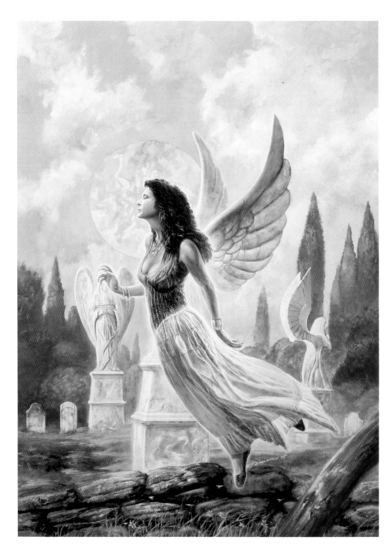

COVER ILLUSTRATION, PAPERBACK
DONATO GIANCOLA
An
Cover for the novel *Eggheads* by Emily Devenport (Penguin/Roc)
Oil on acid-free Strathmore drawing paper mounted on masonite
15in x 24in (38cm x 61cm)
"This story was so eclectic I decided, rather than portray a direct narrative from the novel, I would paint a portrait of the main female character, An. My principal inspiration for the painting came from Donatello's stunning sculpture of the young David standing in victory over the decapitated head of Goliath. The power, seduction, and self-confidence radiating from that statue were the focus I wanted this woman to have."

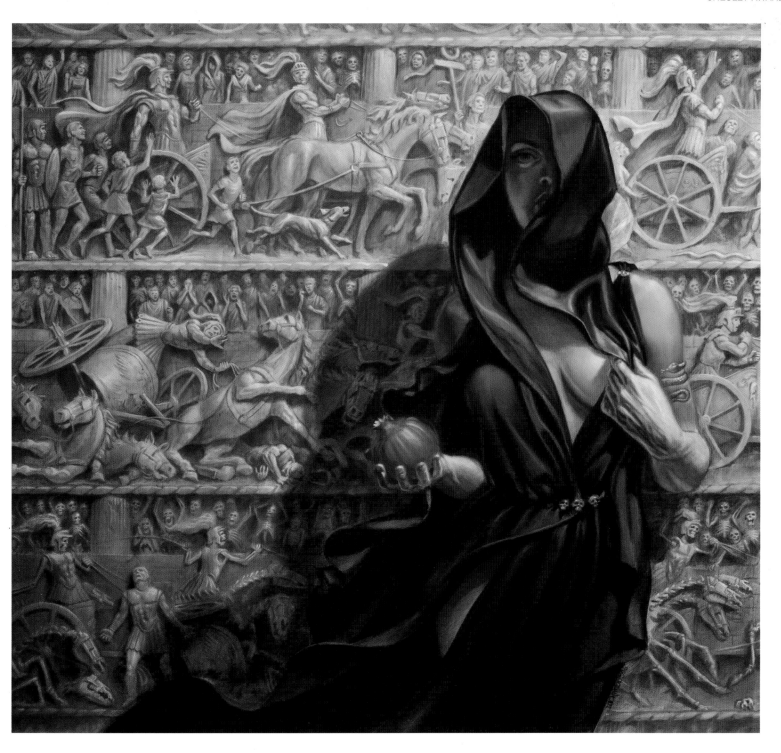

INTERIOR ILLUSTRATION
TODD LOCKWOOD
Death Loves Me
Realms of Fantasy, August 1996, illustrating the story by Tanith Lee
Acrylics on board
17in x 16in (43cm x 41cm)
*"The story involved a charioteer who was convinced he was seeing
Death, in the form of Persephone, watching him from the stands.
He knew that, on the day she stood upon the racetrack and exposed
herself to him fully, he would die . . ."*

113

Colour Work, Unpublished
Rob Alexander
Sinja's World
Watercolour and body colour on watercolour paper
14in x 18in (36cm x 46cm)
*"This was originally done as a proposal for a children's book by
Cooper Edens. No one really liked the story, but I got the best
rejection letters I will ever get: everyone loved the painting. Finally
the project seemed dead in the water, so I showed it at the World
SF Convention in Anaheim, where it took Best of Show. Later it
won the Chesley and ended up in Spectrum. Currently I have found
a New York publisher who is interested in the project, so it may see
the light of day as a children's book after all."*

Art Director
Jamie Warren Youll

Contribution to ASFA
Don Maitz

MONOCHROME WORK, UNPUBLISHED
DAVETTE SHANDS
Waiting for Antony
1996
Personal work
Pencil and white acrylic on paper
14in x 11.5in (36cm x 29cm)
"I did this for fun as an exercise in shading."

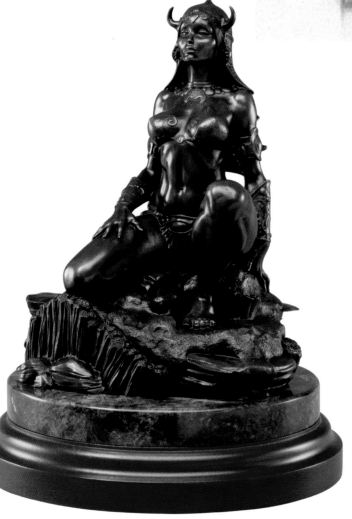

THREE-DIMENSIONAL WORK
CLAYBURN MOORE & FRANK FRAZETTA
Princess
Licensed piece (from Frank Frazetta)
Super Sculpey
Height 10.5in (27cm), including base
"This was produced as both a cold-cast porcelain and a bronze edition by Moore Creations. Mr Frazetta was closely involved in the process, and art direction was a joint effort by both him and Clayburn Moore."

115

ARTISTIC ACHIEVEMENT 1997
DON MAITZ

The Wind Witch
1994
Cover for the novel by Susan Dexter (Ballantine Del Rey)
Oils on masonite
30in x 20in (76cm x 51cm)
"In the Dark Ages, a girl finds she has inherited the ability to literally whistle up a storm. Her magical steed allows her to patrol the shoreline and defend villages from sea raiders."

ABOVE:
Silver Lining
1994
Personal work
Oils on canvas
40in x 30in (102cm x 76cm)
"An optimistic and uplifting image imploring one to look beyond stormy conditions and strive towards a bright future. The tropic bird's distinctive facial markings are reminiscent of a blindfold, and this gives them symbolic significance as a guiding influence for one's hopes through blind faith. This personal painting relates to an air spirit, at one with nature's creatures, finding life's silver lining. It received a World Fantasy Convention Award."

Abracatabra
1994
Personal work
Oils on masonite
14in x 10in (36cm x 25cm)

White Unicorn
1995
Guardians game card and screen saver
Oils on masonite
14in x 11in (36cm x 28cm)
"The secrets of unicorns are locked within standing stones and, of course, unicorns likewise hold the secrets to standing stones. This painting was stolen from a delivery truck en route to its first showing. If you see the original, contact me through http://www.paravia.com."

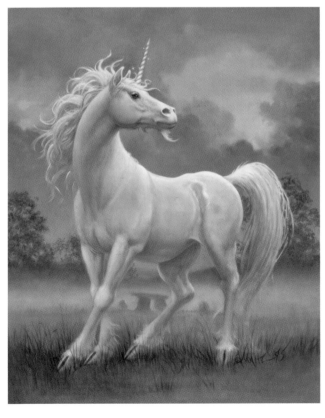

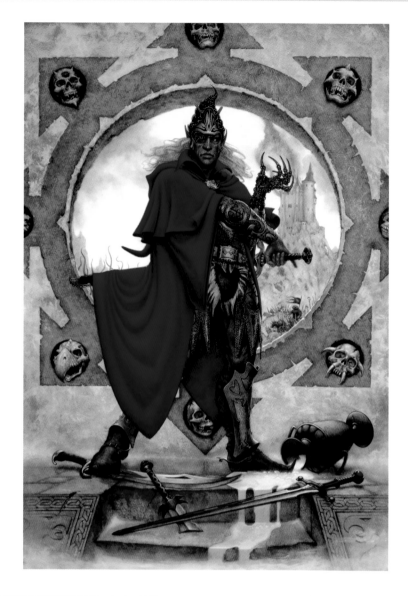

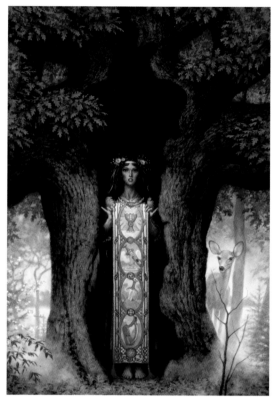

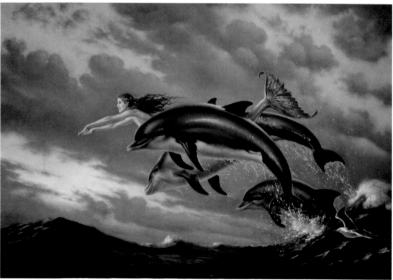

ABOVE:

Merlin's Harp

1996

Cover for the novel by Anne Eliot Crompton (Roc)

Oils on masonite

30in x 20in (76cm x 51cm)

"The legend of King Arthur told from the perspective of Merlin's apprentice, the daughter of the Lady of the Lake. A woven tapestry displays the elements of the legend as she stands before Merlin's final resting place. I was hiking in the woods and came across an oak tree that had been struck by lightning sometime earlier. Luckily I had a camera with me, as the stricken oak has been an inspiration for several paintings."

TOP LEFT:

Corum

1996

Cover for the omnibus *The Swords Trilogy* by Michael Moorcock (White Wolf)

Oils on masonite

30in x 20in (76cm x 51cm)

"It is rare to have the opportunity to paint a book cover with a heroic figure filling the entire space, including the upper one-third usually reserved for typography. Moorcock creates characters so distinctive that they appear fully fleshed in one's mind's eye. This painting received the Best in Show Award at Sunquest 98, Orlando, Florida."

LEFT:

Chasing the Wind

1996

Personal work

Oils on canvas

25.5in x 35.5in (65cm x 90cm)

"This work was inspired by dolphins and their willingness to interact with humans. While I was sailboarding on an inland waterway, a school of dolphins came within two feet of my board to see what I was doing. They had a good look and swam alongside me. It was a remarkable exerience and an inspiration."

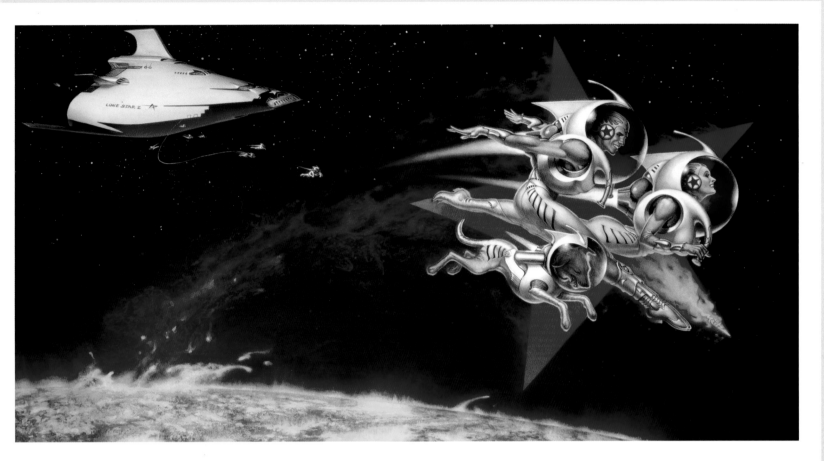

Lonestar 2
1997
Cover for 1997 World Science Fiction Convention
Program Book
Acrylics on masonite
18in x 30in (46cm x 76cm)
*"Since the event for which this work was created
was to be held in San Antonio, Texas, in August,
the surface of a star came to mind as somewhere
nearly as hot. I used it as the background for this
recreational space walk, acknowledging the Lone
Star State by incorporating a shooting-star design."*

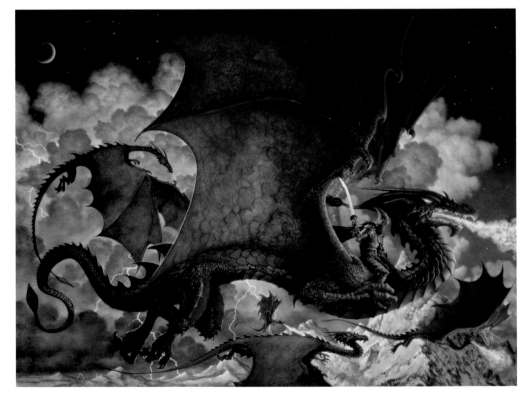

Dragons on the Sea of Night
1996
Cover for the novel by Eric Lustbader (HarperCollins
UK)
Oils on masonite
22.5in x 30in (57cm x 76cm)
*"The novel is part of Eric Lustbader's continuing
Sunset Warrior series. The lyrical title inspired this
visual, as did Florida thunderheads. This painting
was reproduced on the cover of Dick Jude's book
Fantasy Art Masters (1999), in which ten fantasy/sf
artists describe how they work."*

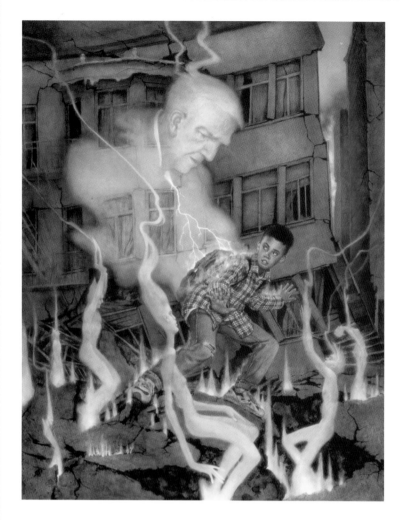

Fault Lines
1997
Cover for the omnibus by Tim Powers (Science Fiction Book Club)
Oils on masonite
24in x 18in (61cm x 46cm)
"The SFBC gave purchasers of the book a free poster of the cover illustration. Doubleday Direct received a Certificate of Merit at the 56th Annual Graphic Arts Awards Exhibition in 1998 for this piece."

BELOW:
Redemption
1997
Interior art for the anthology *The Crow: Shattered Lives And Broken Dreams*, edited by J. O'Barr and Ed Kramer (Donald M. Grant), illustrating the story "Triad" by Janny Wurts
Oils on masonite
20in x 14in (51cm x 36cm)
"This portrays the culminating moment in a moving short story written by my favourite author (and wife), Janny Wurts. Janny writes stories that are a pleasure to illustrate, and I always jump at the opportunity to create images interpreting her work."

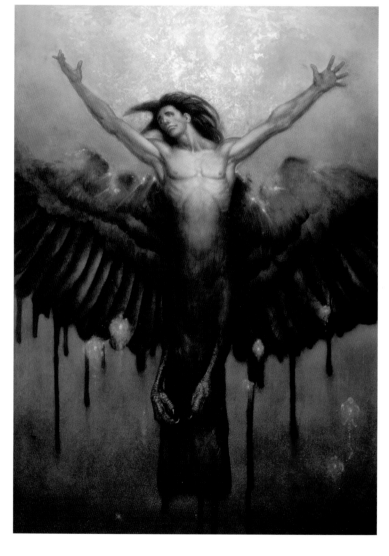

COVER ILLUSTRATION, HARDCOVER
BOB EGGLETON
The Howling Stones
Cover for the novel by Alan Dean Foster
(Ballantine Del Rey)
Acrylics on board
15in x 28in (38cm x 71cm)
"Despite my resolve to abandon the airbrush, I did use some airbrushing for this piece – only a bit! – and even some coloured pencil."

Cover Illustration, Paperback
Michael Dashow
The Rhinoceros Who Quoted Nietzsche
Cover for the story collection *The Rhinoceros Who Quoted Nietzsche and Other Odd Acquaintances* by Peter S. Beagle (Tachyon)
Pencil and Photoshop
10.3in x 14.5in (26cm x 37cm)
"I had wanted to illustrate the title character from the story 'Come Lady Death'. Editor Jacob Weisman convinced me otherwise, claiming that I could always draw an attractive woman but it's not very often that one gets to do a rhino for a book cover. He was right.

"The illustration was first drawn entirely in pencil. It was then scanned into the computer and painted in Adobe Photoshop. There are a lot of small details in the illustration that are hard to see without viewing the full-scale image. All of the books on the shelves are genuine philosophy books and collections, as Professor Gottesman and the rhinoceros are debating philosophy. A couple on the shelf are collections previously published by Tachyon. The two on the floor to the left of the now-demolished couch are recognizable by Beagle fans as two of his earlier works, The Folk of the Air *and* The Innkeeper's Song.*"

COVER ILLUSTRATION, MAGAZINE
TODD LOCKWOOD
Black Dragon
Cover for *Dragon*, August 1997
Oils on masonite
18in x 24in (46cm x 61cm)

INTERIOR ILLUSTRATION
ALAN LEE
The Hobbit
Novel by J.R.R. Tolkien
(HarperCollins UK)

"... *a dozen bundles
hanging in a row from a
dry branch.*"
Watercolours on board
30in x 45in (76cm x
114cm)

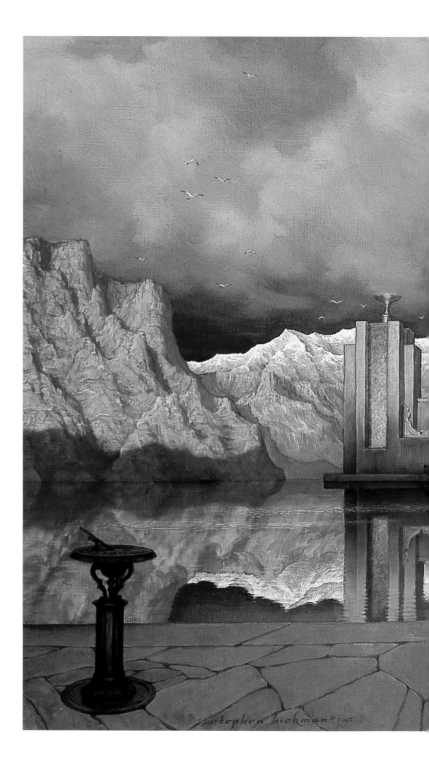

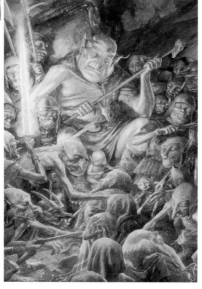

"... *a tremendous goblin
with a huge head* ..."
Watercolours on board
30in x 45in (76cm x
114cm)

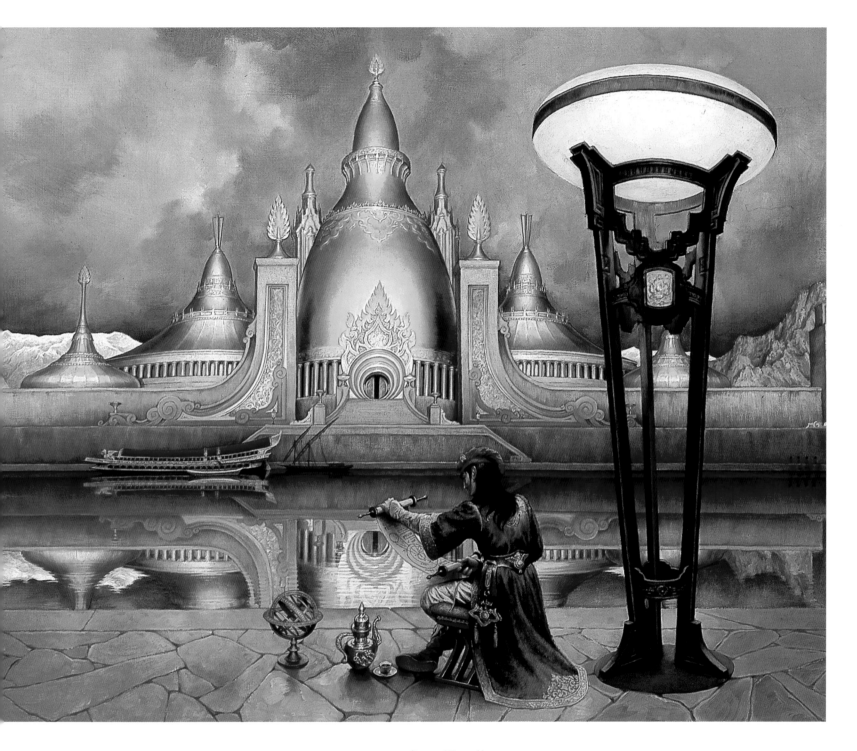

COLOUR WORK, UNPUBLISHED
STEPHEN HICKMAN
The Astronomer Prince
Oils on canvas
25in x 30in (64cm x 76cm)
"This private commission is a scene of the mythical continent from my fantasy novel The Lemurian Stone. I actually saw this cloud formation in the Hudson Valley, where a dark cloudmass hung suspended in front of a bright cumulus formation, in defiance of any logic. The most difficult bit for me was the rippled reflection in the water just to the left of the figure. I found the tea urn at a yard sale within a block of my house."

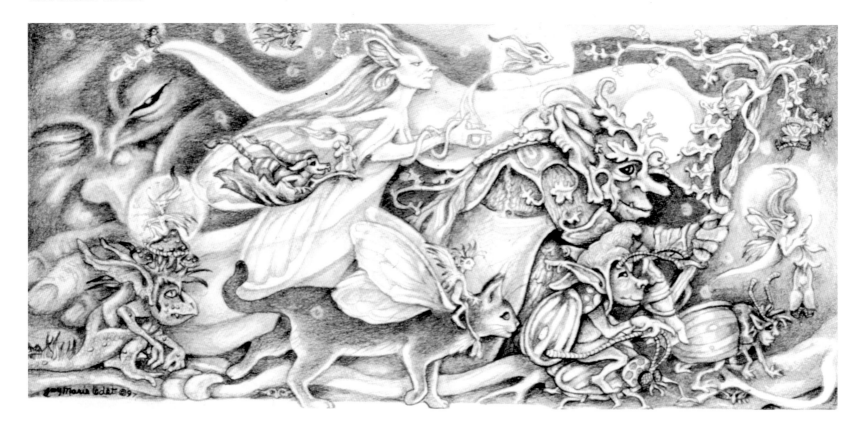

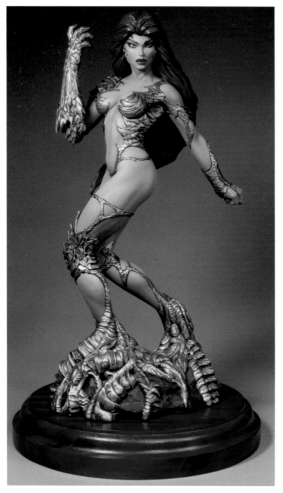

MONOCHROME WORK, UNPUBLISHED
JOY MARIE LEDET
The Silently Moving People
Personal work
Graphite pencil on Bristol board
4.5in x 9.5in (11cm x 24cm)
"I have always enjoyed drawing the lesser fairies instead of the High Court variety. They seem to have more personality! The longer I worked on the drawing the more fairies seemed to want to be included in the 'lesser' category."

THREE-DIMENSIONAL WORK
CLAYBURN MOORE
Witchblade
Licensed piece (from Top Cow Productions)
Super Sculpey
12.5in (32cm), including base
"This was produced as a cold-cast porcelain limited edition statue."

ART DIRECTOR
JAMIE WARREN YOULL

CONTRIBUTION TO ASFA
JANNY WURTS

ARTISTIC ACHIEVEMENT 1998
VINCENT DI FATE

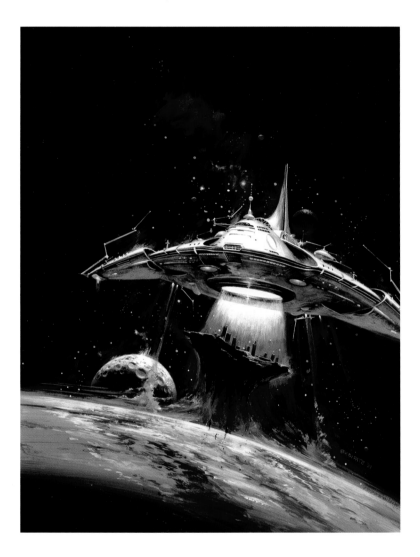

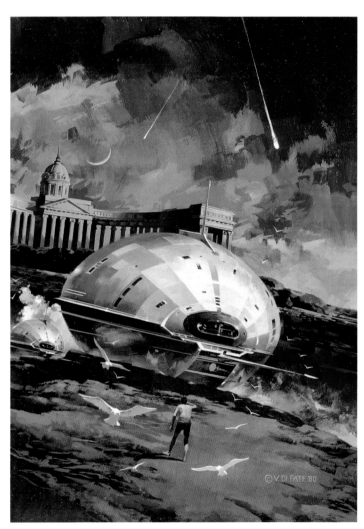

The Good Stuff
1999
Cover for the anthology edited by Gardner Dozois
(Science Fiction Book Club)
Acrylics on hardboard
12in x 18in (30cm x 46cm)

Out of the Deeps
1980
Cover for the novel by John Wyndham (Workman)
Acrylics on hardboard
9in x 12.75in (23cm x 32cm)

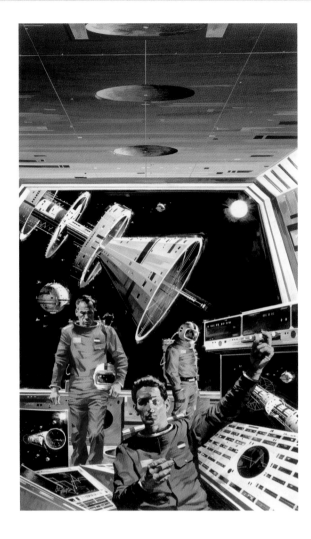

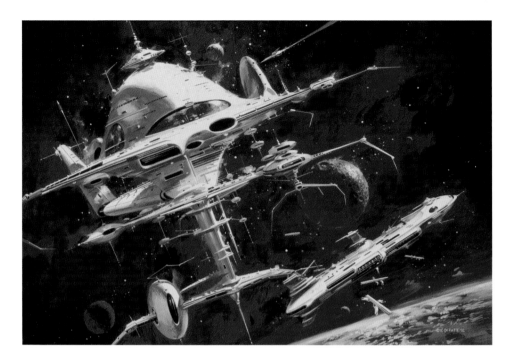

ABOVE:
The Chaos Weapon
1977
Cover for the novel by Colin Kapp (Ballantine Del Rey)
Acrylics on hardboard
9.25in x 16in (23cm x 41cm)

ABOVE RIGHT:
Going for Infinity
2002
Cover for the novel by Poul Anderson (Tor)
Acrylics on hardboard
16in x 24in (41cm x 61cm)

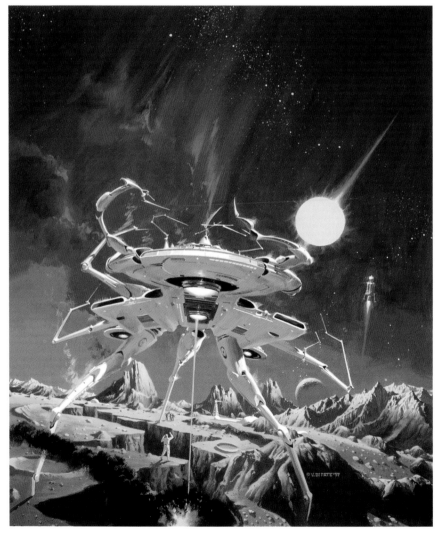

RIGHT:
Putting Up Roots
1997
Cover for the novel by Charles Sheffield (Tor)
Acrylics on hardboard
16in x 24in (41cm x 61cm)

FAR LEFT:
The Best of Philip K. Dick
1977
Cover for the story collection by
Philip K. Dick (Ballantine Del
Rey)
Acrylics on hardboard
10in x 17in (25cm x 43cm)

LEFT:
Star Fire
1987
Cover for the novel by Paul
Preuss (Tor)
Acrylics on hardboard
15in x 20in (38cm x 51cm)

BELOW:
Saturn from Iapetus
1990
Study for proposed mural
Acrylics on wood
24in x 12in (61cm x 30cm)

LEFT:
Bellerophon
1979
Cover for the anthology *Destinies 6*, edited by James Baen (Ace)
Acrylics on hardboard
14.5in x 14.75in (37cm x 37cm)

To Bring in the Steel
1978
Cover for *Analog* illustrating the story by Donald R. Kingsbury
Acrylics on hardboard
9in x 12.75in (23cm x 32cm)

Broke Down Engine and Other Troubles with Machines
1970
Cover for the story collection by Ron Goulart (Macmillan)
Acrylics and collage on illustration board
8.5in x 12.5in (22cm x 32cm)

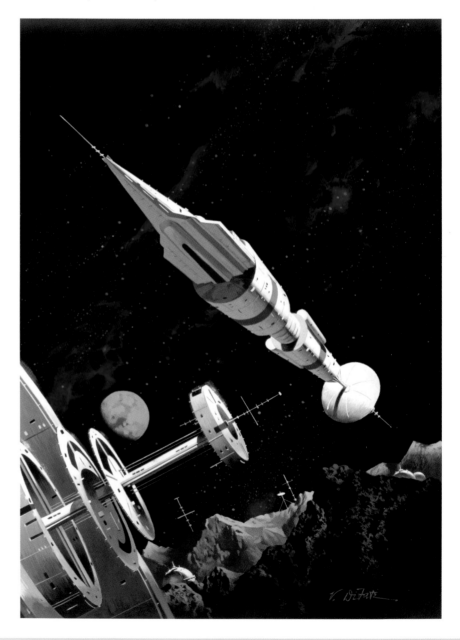

COVER ILLUSTRATION, HARDCOVER
KINUKO Y. CRAFT
Song for the Basilisk
Cover for the novel by Patricia A. McKillip (Ace)
Oils over a watercolour underpainting on Strathmore illustration board
11.5in x 17.5in (29cm x 44cm)
"This was a simple book-jacket assignment which required reading the manuscript and developing an image independently."

COVER ILLUSTRATION, PAPERBACK
JOHN JUDE PALENCAR
Tales of the Cthulhu Mythos
Cover for the anthology edited by Anonymous (Ballantine
Del Rey)
Acrylics on board
18in x 40in (46cm x 102cm)

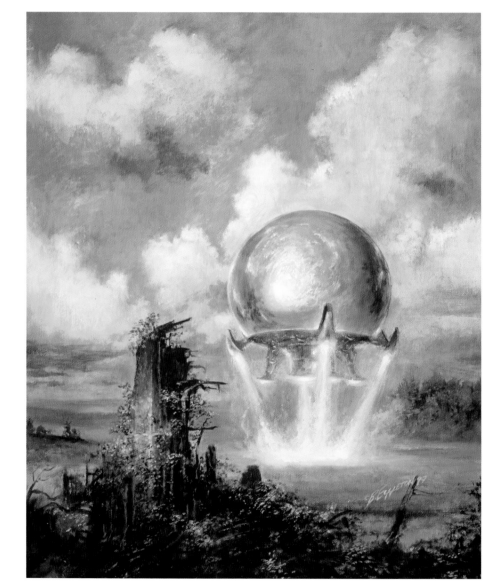

COVER ILLUSTRATION, MAGAZINE
BOB EGGLETON
The Allies
Cover for *The Magazine of Fantasy & Science Fiction*,
May 1998, illustrating the story by Mark Geston
Acrylics on board
16in x 20in (41cm x 51cm)
*"The story deals with a spaceship that returns home to
Earth many years after an alien invasion has come and
gone. I wanted a sort of a futuristic Thomas Cole look to
the painting – Cole was a 19th-century landscape painter
I greatly admire."*

INTERIOR ILLUSTRATION
BRIAN FROUD
Good Faeries/Bad Faeries
(illustrated book by Brian Froud & Terri Windling; Simon & Schuster)

Healing Goddess
Watercolours and acrylics with coloured pencil
22.5in x 18in (57cm x 46cm)

The Dressing of a Salad
Watercolours and acrylics with coloured pencil
22.5in x 18in (57cm x 46cm)

LEFT:
Queen of the Bad Faeries
Watercolours and acrylics with
coloured pencil
22.5in x 18in (57cm x 46cm)

RIGHT:
Melancholic Faery
Watercolours and acrylics with
coloured pencil
22.5in x 18in (57cm x 46cm)

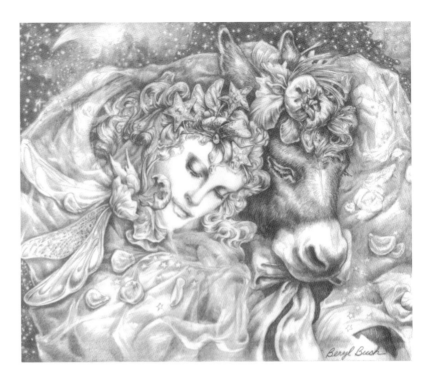

Colour Work, Unpublished
Marc Fishman
Salvation
Personal work
Oils on canvas
36in x 54in (91cm x 137cm)

Monochrome Work, Unpublished
Beryl Bush
Bottom & Titania
Personal work
Black chalk on paper
17.25in x 20in (44cm x 51cm)

"I created this work to experiment with a medium I had not yet tried. The theme is of course from Shakespeare's A Midsummer Night's Dream. *I was able to work with two of my favourite subjects: fanciful beings and animals. I began the drawing at its current size, without doing any smaller preliminaries; I felt I could better relate to the faces if they were closer to lifesize.*

"Though I also work in colour, I have always been especially fond of black-and-white. The chalk allowed for a combination of clarity and softness that appealed to me. It also challenged me, because the combination of chalk and paper I'd chosen didn't allow for much erasure and most of the drawing was being improvised. When I decided to exhibit the piece I was honoured by the positive comments and awards it received, culminating in the Chesley."

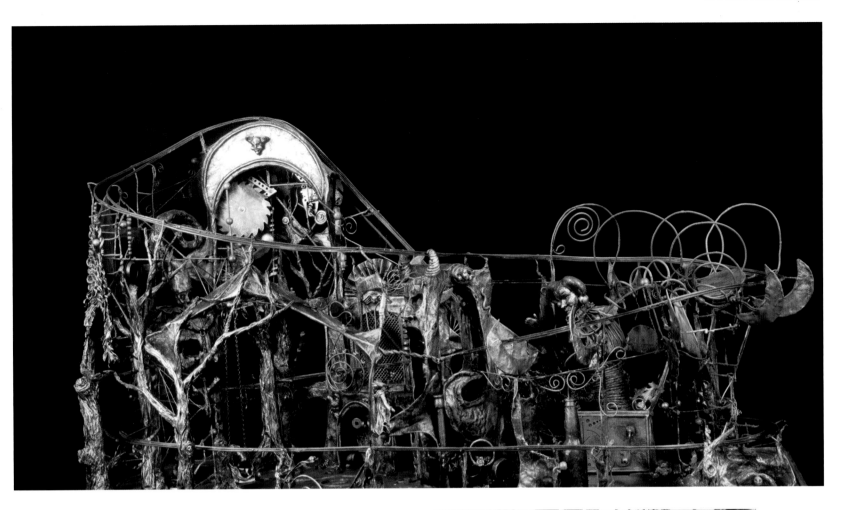

THREE-DIMENSIONAL WORK
LISA SNELLINGS
Short Trip to October
Sculpture #4 in the *Dark Caravan* series of kinetic sculptures
commissioned by Howard and Jane Frank
Frame mostly wood, steel, papier mâché; tracks copper;
cars and riders mixed media
c4ft high x 6ft long x 3ft wide (1.2m x 1.8m x 0.9m)
*"I've exhibited the coaster at two World Science Fiction Conventions.
Both times the copper tracks gave me a little trouble as they shifted
from being transported and also with the room's temperature and
the slant of the floor or tables. Still, people didn't seem to mind my
husband and I tinkering and talking. We felt a bit like carneys and it
became fun.*

*"The train of cars clatters up the first hill very slowly, which I
thought would annoy people but ended up giving everybody a chance
to get a good look at the details and sort of enjoy the suspense with
the riders. The cars hang at the top, then suddenly drop to fly in and
out of equally odd figures around the tracks. (Some of these figures
I'd like to sculpt again, alone, and some I already have.) This sculpture
took five months to finish, and was the last piece I built before leaving
Georgia for the California desert. For me, Short Trip to October will
always carry the scent of childhood autumns in the deep South, where
each carnival swept away the leaves before and trailed chilly winds
behind, just in time for Hallowe'en."*

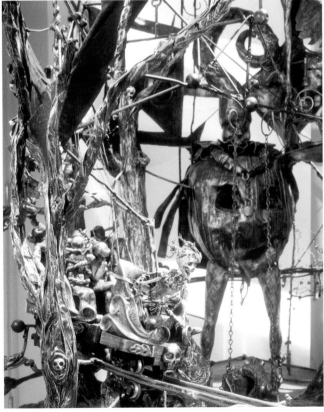

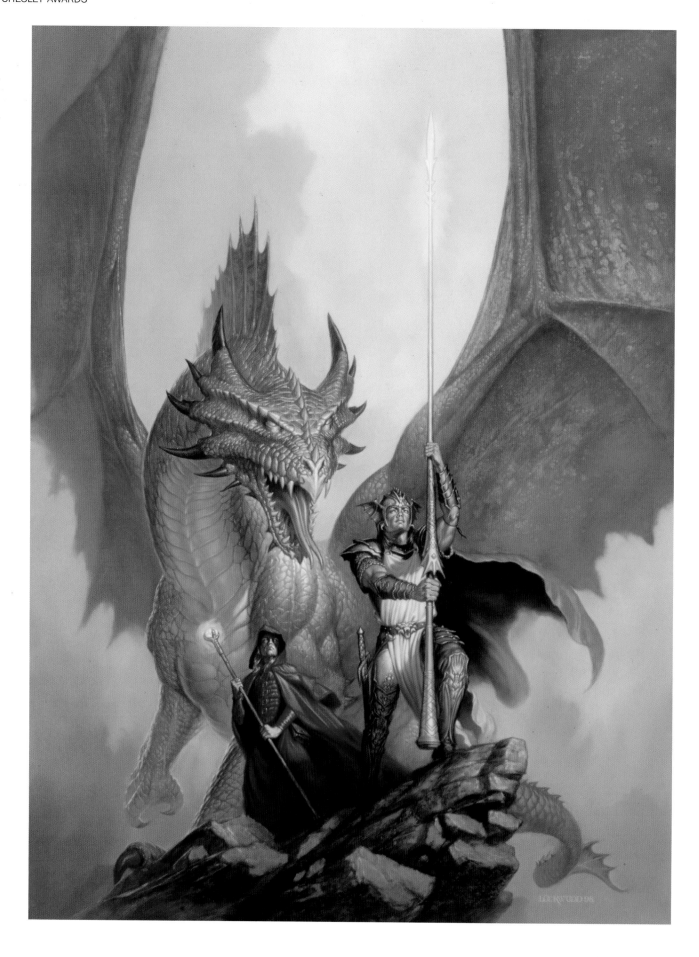

LEFT:
GAMING-RELATED ILLUSTRATION
TODD LOCKWOOD
The Dragonlance
Cover for *DragonLance Classics
15th Annual Game Module*
Oils on watercolour paper
20in x 30in (51cm x 76cm)
*"This was the cover of the Silver
Anniversary release of the Dragonlance
game setting product, and was quickly
adopted by the Wizards of the Coast
book department as well for the
release of Dragonlance: The Annotated
Chronicles by Margaret Weis and Tracy
Hickman."*

RIGHT:
PRODUCT ILLUSTRATION
DONATO GIANCOLA
Archangel
Packaging art for the collectible
card game *Magic: The Gathering*,
6th edition
Oil on acid-free Strathmore drawing
paper mounted on masonite
13in x 20in (33cm x 51cm)
*"Always wanting to challenge myself
in my commissions, I decided that,
since this was to be a 'white' card,
I would attempt to control my palette
in both colour and value. The result
was a wonderfully atmospheric image
that radiates light from within."*

ART DIRECTOR
ARNIE FENNER & CATHY FENNER

CONTRIBUTION TO ASFA
JEFF WATSON

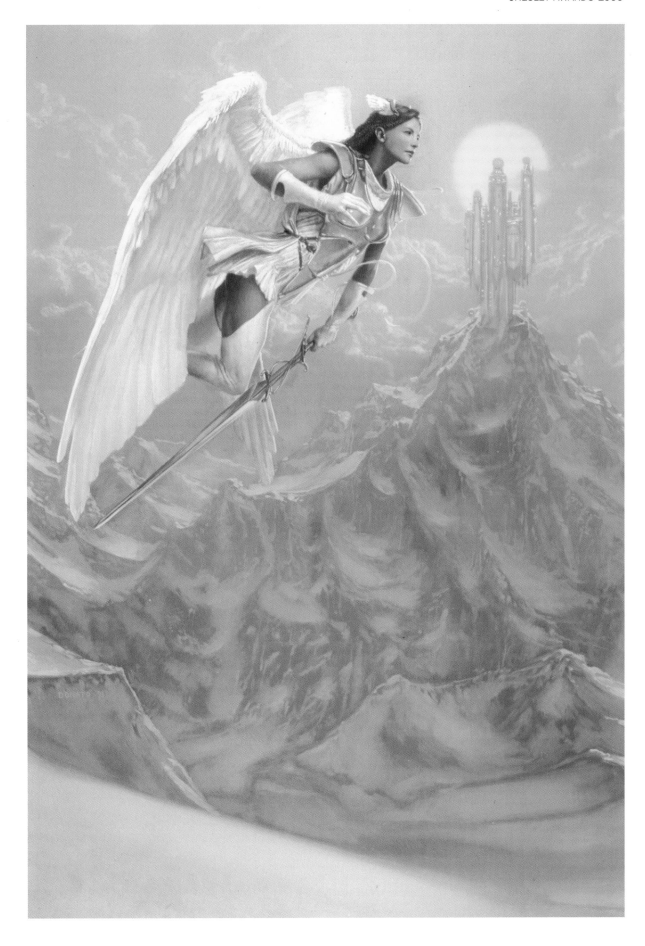

ARTISTIC ACHIEVEMENT AWARD 1999
BOB EGGLETON

When one receives the Chesley for Artistic Achievement, one can hope that it refers not just to a single year but to a protracted period of work in the field of fantastical illustration.

Art is a kind of journey. Artists should never be stereotyped or pigeonholed; and, when this does happen, it is the duty of the artist to fight tooth and nail to escape the straitjacket. As I look back over the years at the work I have done, I must confess that I wince at a lot of the earlier stuff; on the other hand, it takes practice to get better, and I've had so much practice that I must be getting better at *something*! Part of being an artist is always expecting that your best work will be the *next* one. It never is, of course, because there's always the painting after *that* . . .

One goes through stages – evolution and exploration – in this strange quest with no end. It's a way of life like no other, which is why perhaps artists have an excuse when they show difficulty obeying the rules that apply to the rest of life. The quest is a matter of constantly taking the risk of total failure – but so what? What's the worst that can happen? Just slop some paint over it . . .

I'm not an intellectual – no rocket scientist, me. In fact, I'm suspicious of pretentiousness in the arts, of whatever form. I just make pictures. I try to make it fun for myself while I'm doing them, and I try to work fast because there's nothing worse than getting bored and bogged down in something. The most fun is exploring a new medium, whether it's oil paints or torn-paper collage.

I've often said: "Artists never retire. They just draw their lives to a close." It's true for me, certainly. The day I stop painting will be the day they have to pry the brush from my cold fingers.

Cosmic Dragon
2002
Interior illustration and cover for *Dragonhenge*, written by John Grant (Paper Tiger)
China marker, mixed media
22in x 28in (56cm x 71cm)

ABOVE:
The Dragon Society
2001
Cover for the novel by Lawrence Watt-Evans (Tor)
Acrylics
24in x 36in (61cm x 91cm)

Floating Dragon
2002
Interior illustration for *Dragonhenge*,
written by John Grant (Paper Tiger)
Watercolours
9in x 12in (23cm x 30cm)

ABOVE:
Skywings of Nador
2002
Cover for *Hayakawa SF* magazine (Japan)
Acrylics
16in x 20in (41cm x 51cm)

RIGHT:
Gamera 1999
2002
Personal work
Acrylics on canvas
11in x 14in (28cm x 36cm)
Copyright (c) Daiei Motion Pictures

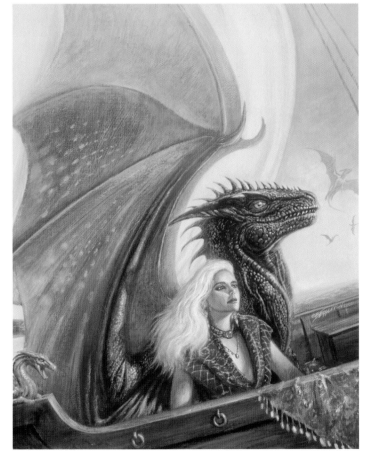

Fountains of Fire
2001
Personal work
Acrylics
15in x 36in (38cm x 91cm)

LEFT:
Sailing with Dragons
2000
Personal work
Acrylics
16in x 20in (41cm x 51cm)

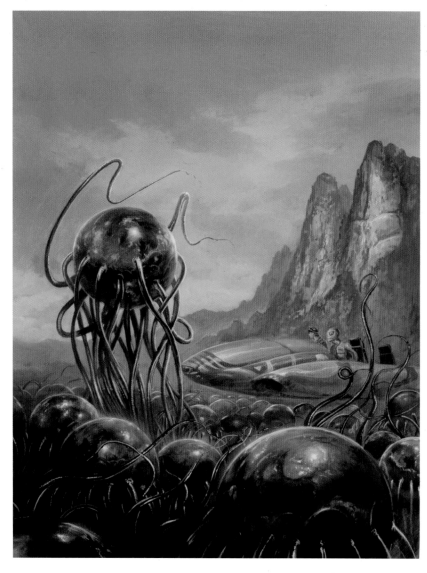

Over the Rainbow
1999
Personal work
Oils and human ashes
40in x 24in (102cm x 61cm)

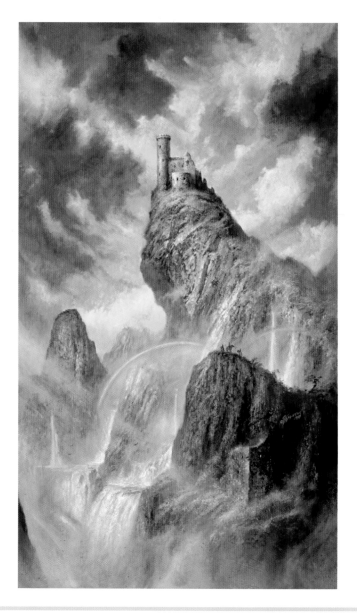

ABOVE:
The Funeral March of the Marionettes
1997
Cover for *The Magazine of Fantasy & Science Fiction*,
July 1997, illustrating the story by Adam-Troy Castro
Acrylics
12in x 18in (30cm x 46cm)

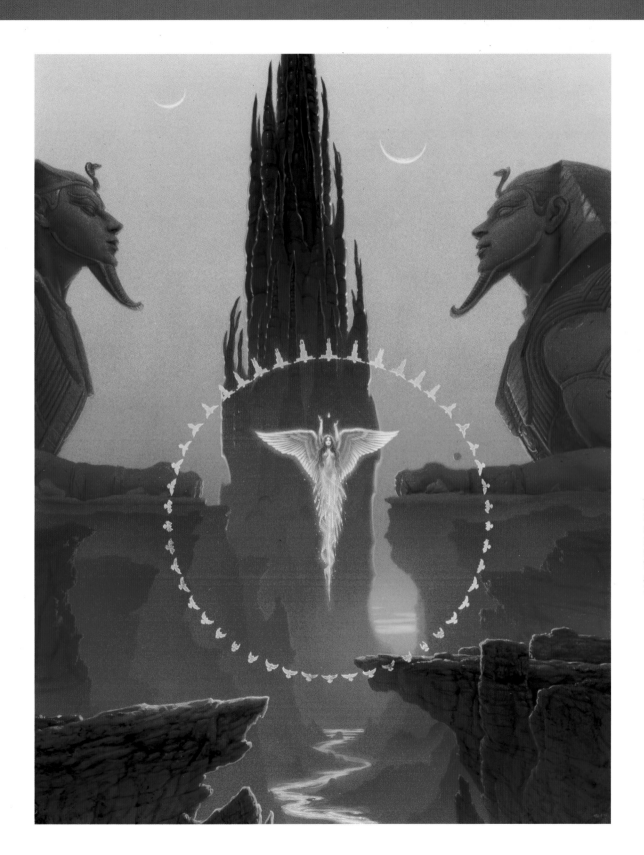

COVER ILLUSTRATION, HARDBACK
MICHAEL WHELAN
Otherland: Mountain of Black Glass
Cover for the novel by Tad Williams (DAW)
Acrylics on watercolour board
24in x 18in (61cm x 46cm)

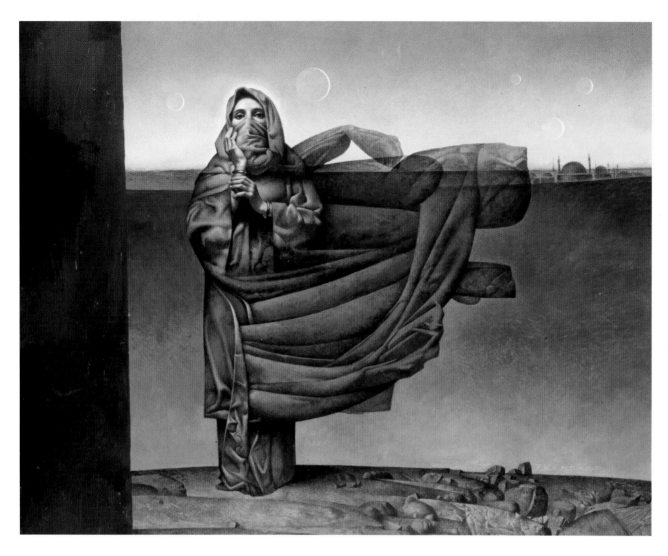

COVER ILLUSTRATION, PAPERBACK
JOHN JUDE PALENCAR
The Terrorists of Irustan
Cover for the novel by Louise Marley (Berkley Putnam)
Acrylics on board
28in x 31in (71cm x 79cm)

COVER ILLUSTRATION, MAGAZINE
BOB EGGLETON
Strongbow
Cover for *The Magazine of Fantasy & Science Fiction*, August 1999, illustrating the story by R. Garcia y Robertson
Oils on canvas
11in x 14in (28cm x 36cm)
"This was a tough assignment. The story dealt with some subject matter I personally would have found offensive to illustrate. Instead of doing so directly, I created a painting (done in oils) which really plugged into my interest in landscape work. The publisher confessed to me that he disliked this cover, but ironically it turned out to be one of F&SF's most popular covers among the readership. It was nice to be proved right, and it's nice to look back at something I did and still like it."

INTERIOR ILLUSTRATION
JAMES GURNEY
Dinotopia: First Flight (HarperCollins)

Arrival on the Shores
Oils on canvas
14in x 24in (36cm x 61cm)
"The towering rock forms are based on actual limestone formations in Thailand. Every painting in First Flight *was created as part of the overall story, and I designed this painting to be a relief from the oppressive feeling of the entire first-act sequence. For the first time, we see direct sunlight and the shimmering turquoise colour of shallow tropical waters."*

Rainbow Bridge
Oils on canvas
14in x 24in (36cm x 61cm)
"On an arch of rock, the young hero Gideon Altaire rests before climbing to Highest, the pterosaur rookery where he and his friends will seek to begin their defence of the island. I chose this moment in the story for a lyrical scene as the flying creatures swoop over the arch, and the afternoon sunlight touches one part of the distant formation. Painting the background had to be done all in one sitting, keeping the oil paint all wet together."

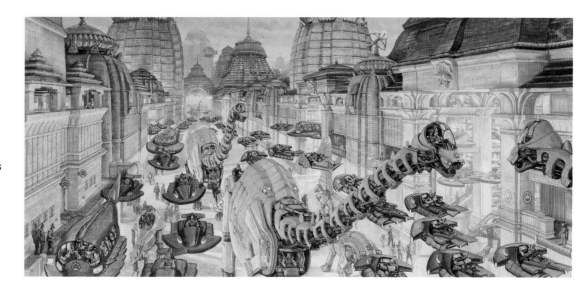

Poseidos Overview
16in x 30in (41cm x 76cm)
"Dinotopia's history reaches back to a futuristic past where advanced machines threatened to take over the island. In this establishing painting for First Flight, *a vast and unsettling scene unfolds itself. The architecture draws from southern Indian temples, and the scene is lit with the weird yellow-green of fluorescent illumination, which casts the skylight into an even stranger red violet. My goal was to use these colours to impart an unnatural feeling to the scene, so setting the stage for Gideon's entrance to the natural world later in the story."*

At-the-Entmoot

COLOUR WORK, UNPUBLISHED
STEPHEN HICKMAN
At the Entmoot
Personal work
Oils on canvas
34in x 34in (86cm x 86cm)
"This was a private commission for a Tolkien scene that I would have hesitated to attempt on my own, because there had been so many previous versions to which it could be compared. So I worked hard to imbue the Ents with their own personalities and tree-related character. The texture in Treebeard's face is the happy accident of the random texturing of the canvas prior to painting."

MONOCHROME WORK, UNPUBLISHED
RICK BERRY
Artemis
Personal work
Graphite
4in x 5.5in (10cm x 14cm)

THREE-DIMENSIONAL WORK
JOHNNA KLUKAS
From the Astrologer's Anteroom
Personal work
Red oak, Indian slate, wrought iron, cloth
Chairs c48in x 18in x 18in (122cm x 46cm x 46cm); table c18in x 18in x 18in
(46cm x 46cm x 46cm)
*"Many of my pieces combine different levels of sanding on different components
to add both tactile and visual texture. Here the oak was sanded with a very rough
sandpaper (60 grit) using a random orbital sander, then finished with linseed oil
and wax. The tactile result is something like the feel of stiff leather, not what most
people expect when they see wood! Though I'm not a furniture-maker primarily,
I like imagining what kinds of furnishings a room in a story would have. From the
Astrologer's Anteroom was inspired by such an imagining."*

GAMING-RELATED ILLUSTRATION
BROM
Heaven and Hell
Cover for TSR game booklets *Warriors of Heaven* and
Guide to Hell
Oils on board
Each panel 18in x 23in (46cm x 58cm)

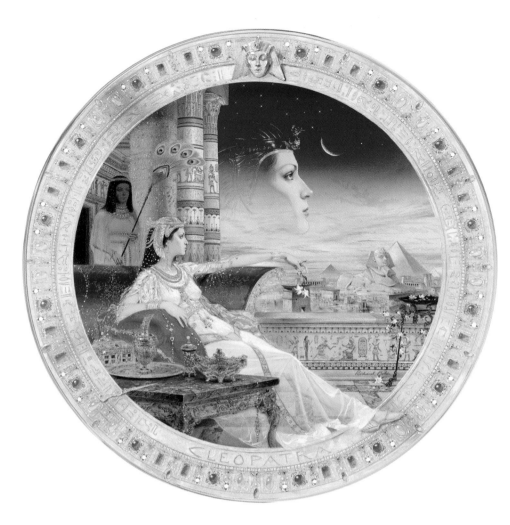

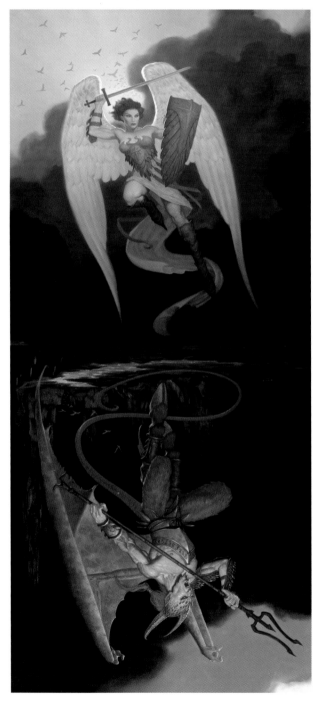

PRODUCT ILLUSTRATION
RICHARD BOBER
Cleopatra
Design for collectible plate, The Bradford Exchange, 1999
Acrylic underpainting and oil glazes on illustration board
c16in (41cm) diameter
*"I was working on a painting of Cleopatra commissioned by Jane and
Howard Frank for their H. Rider Haggard project when Bradford called
and told me I would be perfect for a concept they had for a new
collectible plate. The subject would be . . . Cleopatra."*

ART DIRECTOR
RON SPEARS

CONTRIBUTION TO ASFA
WIZARDS OF THE COAST

ARTISTIC ACHIEVEMENT 2000
STEPHEN HICKMAN

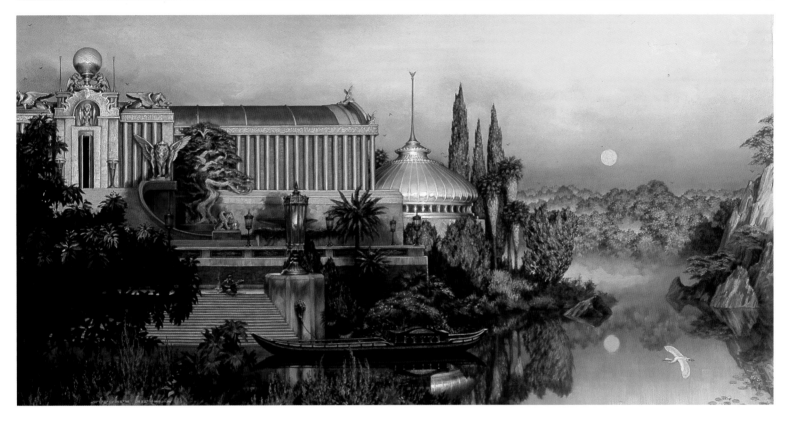

As I write these words it's Hallowe'en, so I can talk about the Magic of Art.

The world is full of magic, and an interesting definition of art could be: practical magic. Those who can see the magic in the beauty and mystery of creation are artists, whether they follow the Muse of music (the most powerful artistic magic), the Muse of painting, or of writing, or of theoretical physics . . .

Everyone's heard the old saw about "nothing new under the sun". I see an element of truth there, but I'm left with the feeling that whoever first wrote it down had never fallen in love . . . or, as Mark Twain put it better, "History may not repeat itself, but it does rhyme." Magic is the miracle that makes all the old things new and fresh. "The artist's job is the mythologizing of the world," according to Joseph Campbell, and he saw the myth as that power which comes from the realization of the mystery of life, expressed by the symbols man invents for himself to deal with that mystery. Practical magic, in other words.

Though magic is literally everywhere we look, to find the particular bit of the magic that is significant to the artist as an individual sometimes requires a lot of the artist. And, just as each of von Eschenbach's knights had to enter the Dark Forest in a different place in search of the Grail, every artist must find their own direction and travel as far as necessary to find the

The Lion Pavilion
1995
Portfolio piece
Oils on canvas
24in x 46in (61cm x 117cm)
"A picture I developed with The Greenwich Workshop in mind, and one of my best pictures – it ought to be, after two months of solid work! I was using lead white, and the sky picked up so many brushmarks it looked like suede. In removing the excess paint with a palette knife, I remembered that Jim Gurney had blended a sky with a knife, and tried it. To my delight, it worked. This is the only picture of mine I can remember that used a yellow ochre underpainting."

inspiration for the particular work they have set themselves to accomplish. Talent can be thought of as the key to the realm of the Grail, but it takes more than talent to accomplish the Quest. The difficulties artists face in the Quest show in their work, and the way they are dealt with says a lot about who the artists are. "The three essentials of Genius are," according to the Celtic Triads, "an Eye that can see Nature, a Heart that can feel Nature, and the Courage that dares follow it."

Most of my life has been devoted to the devising of charms intended to persuade people to buy books. It was in fact charms I saw on the covers of books that made me want to become someone who made charms like that. Probably the most difficult thing I had to do early on was to create charms that were not like the ones that had so entranced me, and to go off and make my own, different ones. That meant the next hardest thing was to come up with ideas. I seemed to have a lot of time and not a clue what to do with it. Now I seem to have no time to do all the ideas I want to do. Evidently I see a lot more of the magic in life now than I did at the start . . .

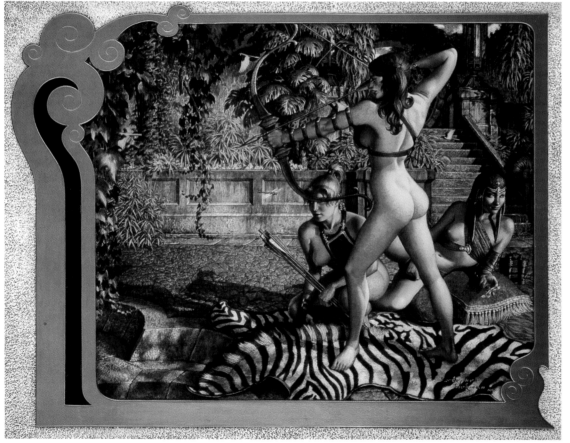

ABOVE:
Gaffer Gamgee and the Black Rider
1980
Personal work
Oils on canvas
30in x 30in (76cm x 76cm)
"I did this in oil colour over a raw umber underpainting, which I did in turn over a pen-and-ink drawing (!). The mane and tail of the black horse are done in texture black, so they generate their own high-lights. The autumn of 1980 was truly wonderful, and I caught an echo of it in the trees of the background."

The Archers of Lhune
1990
Private commission
Oils on canvas
27in x 36in (69cm x 91cm)
"A scene inspired by a fantasy novel I wrote. The image is done, following classical procedure, over a raw umber monochrome painting. I used lead white to generate a light impasto (the tropical scene seemed to call for lots of visual and physical texture). The raised border treatment on this makes it distinctive – the ornamental inner border is made from a single piece of rag matboard and glued to the surface of the canvas. The dark area inset into this border is black snakeskin."

ABOVE:
Lemurian Princess
Begun 1980
Personal work
Oils on canvas
23in x 30in (58cm x 76cm)
"This was a scene I did for myself, and I then wrote an entire novel around it (the stone is a trans-dimensional portal). It was the first picture in which I attempted the raised inner-border treatment, a thing I had only ever seen in Maxfield Parrish pictures. The canvas is textured with Sani-Flat (a trick from the Golden Age illustrators – they've discontinued the product now, though), and the painting is built up in bas-relief in places using the same method. I recently finished this painting after working on it now and then for twenty years."

LEFT:
Pharazar
1999
Personal work
Oils on canvas
20in x 36in (51cm x 91cm)
"This is an ornamental scene from the mythical continent of that name, where exist all the things I love to paint and think about. In fact, when I conceived this series of paintings I sat down and made a list of the stuff I was interested in, just to give me ideas for pictures. Notice the water level in the lily pond has sunk below the usual levels – surprisingly, this type of lily is supported as much by its stalk as by the water."

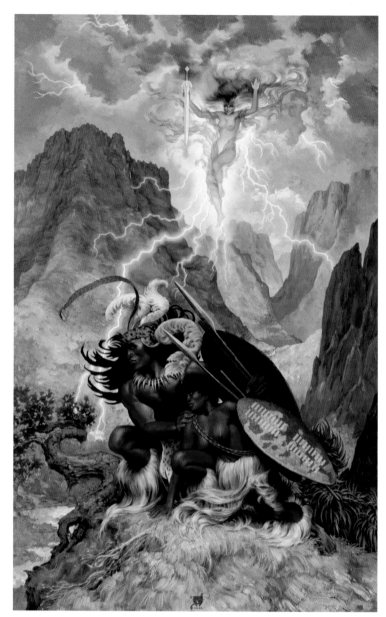

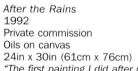

After the Rains
1992
Private commission
Oils on canvas
24in x 30in (61cm x 76cm)
*"The first painting I did after moving to New York State,
before I had any lighting put in, crammed up to the window
to try to see what I was doing. I did this for a dear friend
of mine I went to Art School with in Richmond, Virginia.
One of my subtropical Utopian fantasy-scapes."*

Nada the Lily
2002
Private commission
Oils on canvas
28in x 50in (71cm x 127cm)
*"From the book of that title by H. Rider Haggard, this is
undoubtedly the most challenging private commission I've
accepted so far. Possibly Haggard's best novel, Nada is the
grand tale of the epic tragedy of the Zulu Empire. This is the
first painting I've done using the palette knife to any great
extent, as the African subject seemed to call for a distinctive,
forceful treatment."*

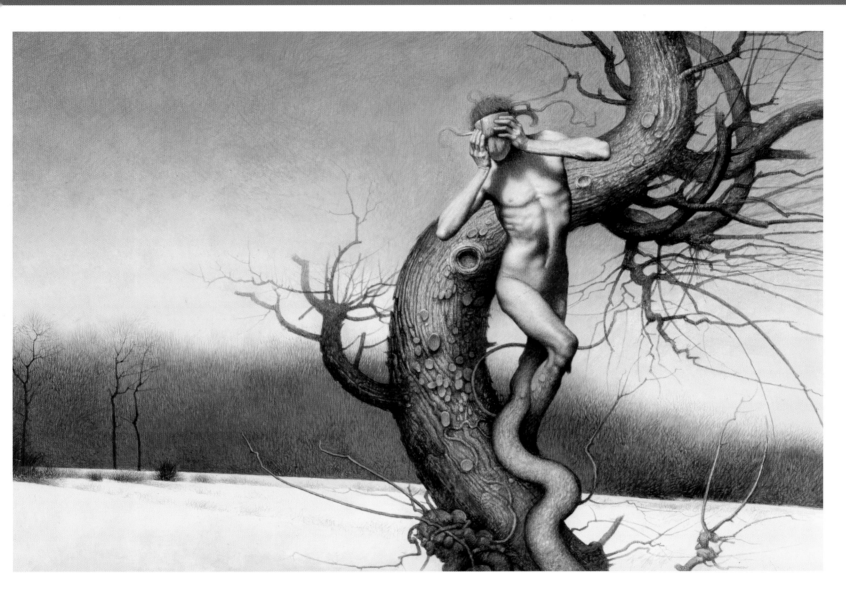

COVER ILLUSTRATION, HARDCOVER
JOHN JUDE PALENCAR
Forests of the Heart
Cover for the novel by Charles de Lint (Tor)
Acrylics on board
30in x 14in (76cm x 36cm)

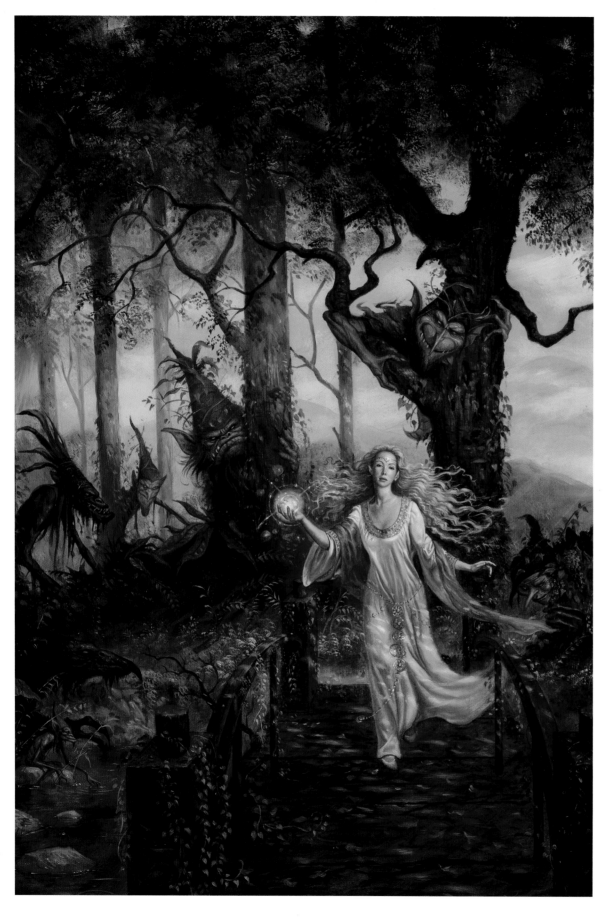

LEFT:
COVER ILLUSTRATION, PAPERBACK
JEAN PIERRE TARGETE
Circle at Center
Cover for the novel by Douglas Niles (Ace)
Oils on illustration board
20in x 30in (51cm x 76cm)
*"I used illustration board for this, although
I prefer masonite or fibreboard. The piece
was inspired by nature in general and also
by my move back to Florida after living in
New York and New Jersey for fifteen years.
The golden tone in the piece represents a
rebirth of my love of art and nature – a
turning point in my career."*

RIGHT:
COVER ILLUSTRATION, MAGAZINE
TODD LOCKWOOD
Swashbuckler
Cover for *Dragon*, July 2000
Oils on watercolour paper
18in x 24in (46cm x 61cm)
*"One of the nice things about working for
Dragon magazine was always the freedom
allowed me to explore the theme in any way I
wanted to. The theme of this particular issue
was 'swashbucklers'; someone suggested an
Errol Flynn type, but I said, 'No, a babe . . .'"*

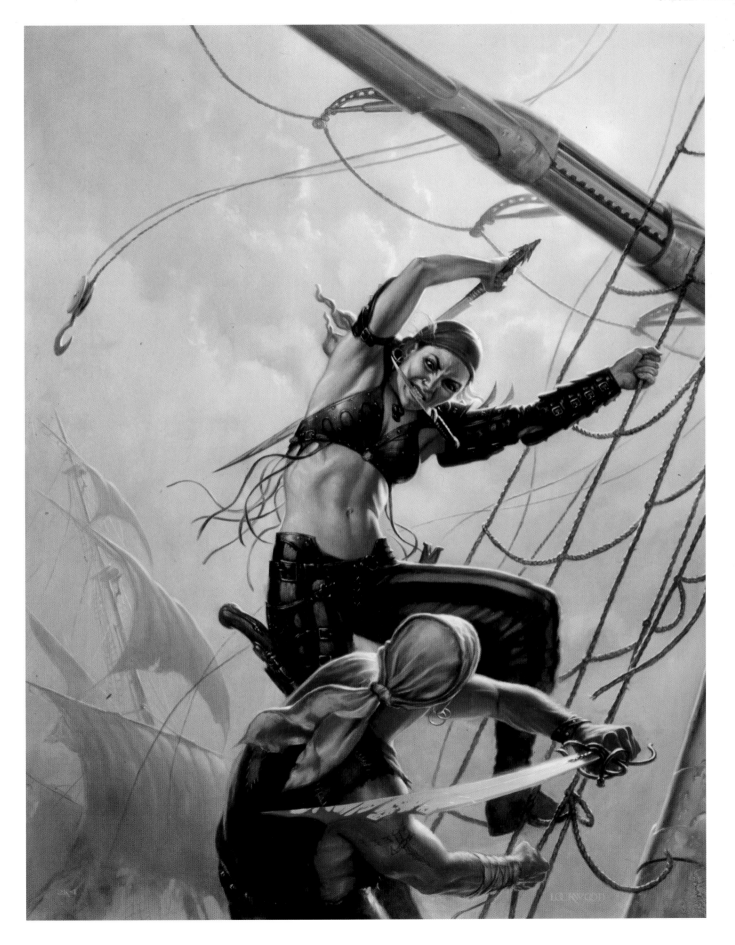

COLOUR WORK, UNPUBLISHED
MICHAEL WHELAN
Reach
Personal work
Acrylics on panel
45in x 25in (114cm x 64cm)

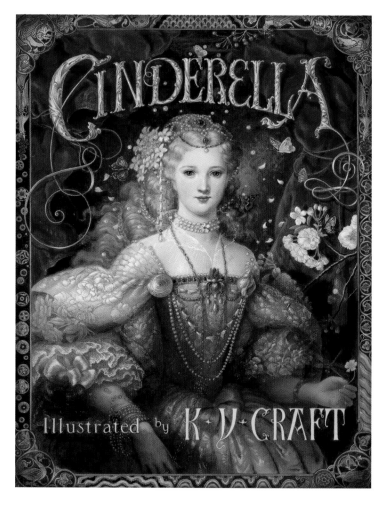

INTERIOR ILLUSTRATION
KINUKO Y. CRAFT
Cinderella
Children's book by Kinuko Y. Craft (SeaStar)
Oils over a watercolour underpainting on Strathmore illustration board
15.5in x 11.75in (39cm x 30cm)
"It was both difficult and very enjoyable to try to execute my own ideas for the scenes in a story that so many masters have painted so beautifully in the past."

MONOCHROME WORK, UNPUBLISHED
DREW WILLIS
A Wizard of Earthsea
Personal work
Pencil on Strathmore 500 series Bristol paper
18in x 20in (46cm x 51cm)
"I was really inspired by a scene from Ursula K. LeGuin's A Wizard of Earthsea where Ged the Wizard first meets a dragon. I wanted to catch the moment before Ged reveals that he knows the dragon's name, because that moment has a lot of tension to it. I was intrigued by that strange balance of confidence and terror that we see in the main character. I tried to capture it by showing Ged's courage in coming so close to the dragon, and yet showing his fear through his failure quite to meet the dragon's intent gaze and his refusal to meet the dragon on dry land where the dragon would have the advantage."

THREE-DIMENSIONAL WORK
SANDRA LIRA
Millennium Angel
Personal work
Produced in resin or bronze
44in x 33in x 6in (112cm x 84cm x 15cm)
"The original piece was made in oil-based clay, then a mould was taken, which allowed it to be cast in resin. For a bronze casting, there are a few extra steps. A wax model is first taken from the mould. The wax is then encased in a different type of mould, which is able to withstand high temperatures. The wax is burnt out, leaving a negative impression in the second mould. Finally, bronze is poured into the mould, filling the spaces where the wax was. (This process is known as lost-wax casting.)

"The original inspiration for this piece was to create a protective spirit for the new millennium. As I worked on it, though, I realized that it was a memorial to my mom, who passed away in 1999."

GAMING-RELATED ILLUSTRATION
IAN MILLER
Crucible: Conquest of the Final Realm
Interior double-page illustration (FASA)
Pen and ink, technical pens, watercolours and pencil on line board
16in x 8in (41cm x 20cm)
*"FASA always granted me a great deal of working freedom. This made
for a very positive interaction, which I feel is clearly reflected in the
quality of this image. Conquest of the Final Realm was an extremely
fertile and vivid source from which to draw visual inspiration."*

ART DIRECTOR
IRENE GALLO

CONTRIBUTION TO ASFA
**TODD LOCKWOOD, JON SCHINDEHETTE &
WIZARDS OF THE COAST**

PRODUCT ILLUSTRATION
DONATO GIANCOLA
Dracopaleontology
Advertising art for the Science Fiction Book Club
Oil on acid-free Strathmore drawing paper mounted on masonite
22in x 21in (56cm x 53cm)
"When presented with the theme 'dragons and books', I decided to take a unique angle, away from the clichés of the fantasy genre. The Art Director at the SFBC, Toby Schwartz, has always supported creative problem-solving, and I knew she would appreciate an indirect approach: that of melding my love of true science with fiction. The result was the creation of a palaeontological research laboratory, filled with tomes of science I love, and a fossilized dragon attached to the back wall for study. Art doesn't get any more fun than this!"

AWARD OF DISTINCTION
ESTATE OF CHESLEY BONESTALL

120 Miles Over Pennsylvania
1947
Preliminary study for the *Pic* magazine pictorial
"Coast to Coast in 40 Minutes"
Oils on board
c6in x 6in (15cm x 15cm)

Aftermath of a Meteor Impact on Manhattan
1947
Study for an illustration for the *Coronet* article
"The End of the World"
Oils on board
c6in x 6in (15cm x 15cm)
*"The crater is the same size as the famous
Meteor Crater in Arizona."*

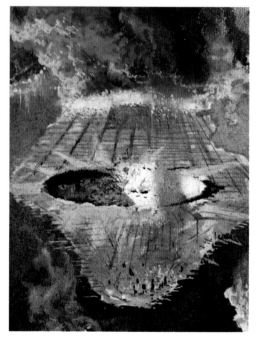

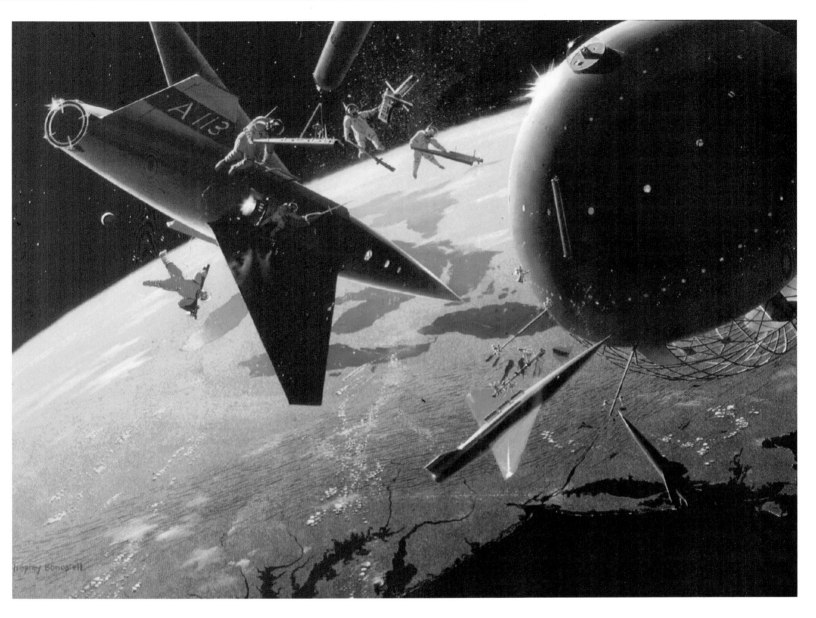

Space Station under Construction
1949
Oils on board
c18in x 27in (46cm x 69cm)

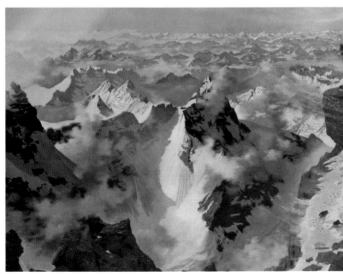

Mount Everest
1948
Interior illustration for *Esquire* magazine
Media and size unknown

ARTISTIC ACHIEVEMENT 2001
FRANK KELLY FREAS

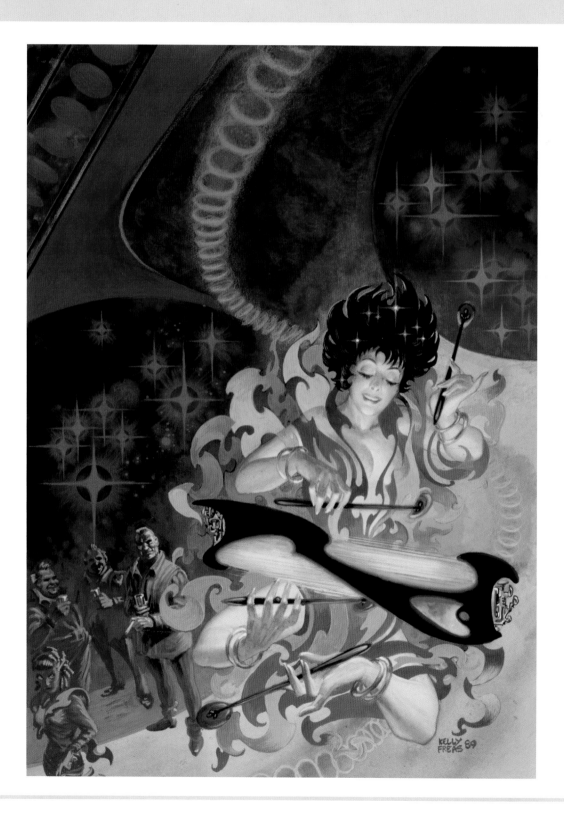

Quaddie
1989
Cover for *Analog*, August 1989, illustrating
the story "Labyrinth" by Lois McMaster
Bujold
Acrylics on board
15in x 20in (38cm x 51cm)

Time Keeper
1990
Cover for *The Magazine of Fantasy & Science Fiction*, November 1990, illustrating the story by John Morressy
Acrylics on board
15in x 20in (38cm x 51cm)

Sucker Bet
1990
Cover for *Dragon*, January 1990
Acrylics on board
15in x 20in (38cm x 51cm)

The Listeners
1990
Frontispiece for the novel by James Gunn
(Easton)
Acrylics on board
15in x 20in (38cm x 51cm)

The Wishing Season
1993
Cover for the novel by Esther Friesner
(Atheneum)
Acrylics on board
15in x 20in (38cm x 51cm)

ABOVE:
Transition
1993
Cover for the anthology *Thinking on the Edge* edited by Aidan
Kelly (Agamemnon)
Acrylics on board
15in x 20in (38cm x 51cm)

TOP RIGHT:
Thinking Beyond the Edge
1993
Cover for the anthology edited by Aidan Kelly (Agamemnon)
Acrylics on board
30in x 30in (76cm x 76cm)

RIGHT:
Research Station
1993
Cover for *Amazing*, November 1993
Acrylics on board
15in x 20in (38cm x 51cm)

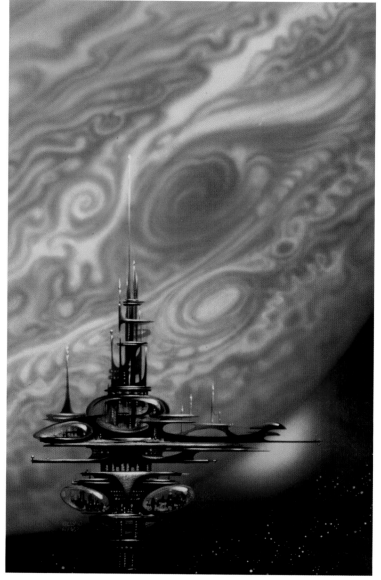

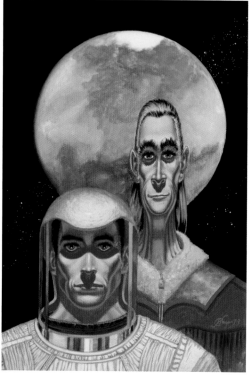

ABOVE:
Jupiter Station
2001
Cover for the anthology *Writers of the Future Volume XVII* (Bridge)
Acrylics on board
15in x 20in (38cm x 51cm)

TOP LEFT:
He Says He's from WHERE??!!
1997
Cover for *Science Fiction Writers of America Membership Directory*
1993–4
Acrylics on board
15in x 20in (38cm x 51cm)

LEFT:
The Martians
2000
Frontispiece for the story collection by Kim Stanley Robinson (Easton)
Acrylics on board
15in x 20in (38cm x 51cm)

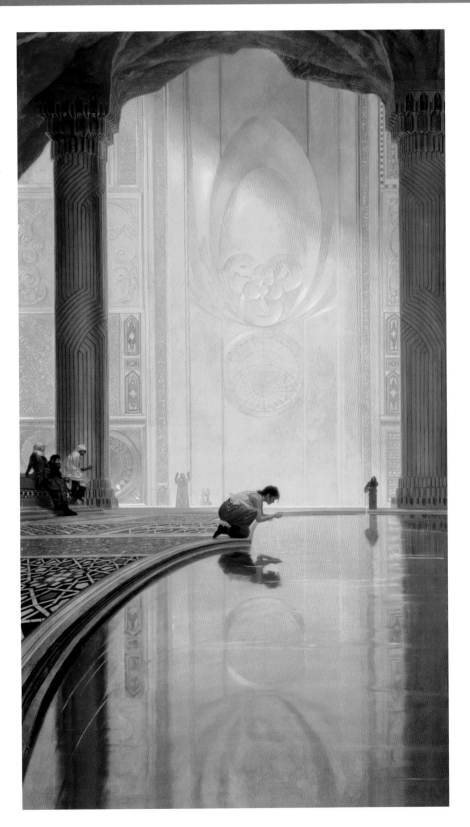

COVER ILLUSTRATION, HARDCOVER
DONATO GIANCOLA
Ashling
Cover for the novel by Isobelle
Carmody (Tor)
Oil on acid-free Strathmore drawing
paper mounted on masonite
20in x 36in (51cm x 91cm)
*"When you read a series of novels
as brilliant as Carmody's, the stress
of creating covers to do them justice
overshadows all other concerns of
time, money and design. You want
it to be perfect, both as a cover
illustration and as an independent
painting."*

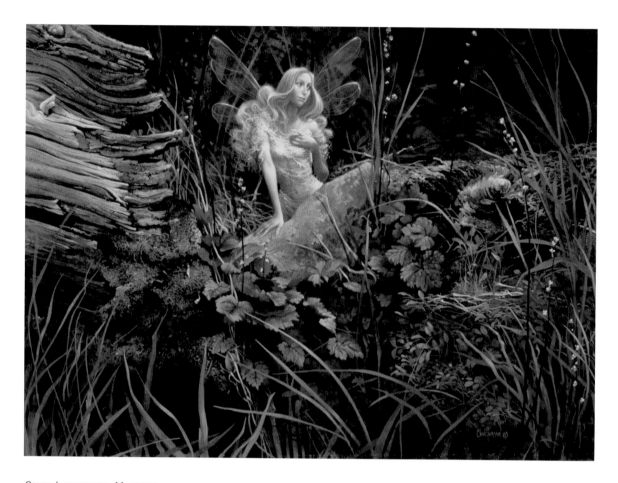

Cover Illustration, Magazine
James C. Christensen
Waiting for Oberon
Cover for *The Leading Edge #41*, April 2001
Acrylics on board
24in x 16in (61cm x 41cm)

COVER ILLUSTRATION, PAPERBACK
DONATO GIANCOLA
The Hobbit: Expulsion
Cover for the graphic novel *The Hobbit* by David
Wensel, based on the novel by J.R.R. Tolkien (Del Rey)
Oil on Acid-free Strathmore drawing paper mounted
on panel
68in x 38in (173cm x 97cm)
*"The attendees at the World Science Fiction
Convention in Philadelphia 2001 had the chance to
see one of my raison d'être paintings in person: The
Hobbit: Expulsion. It represents everything I aspire to
and am passionate about in my career as a fantasy
illustrator and realist painter: illustrating Tolkien's
work; depicting the humanity of characters in epic
conflict; and creating large, emotionally charged
paintings. The inspirations accumulated on trips to
museums around the world finally found expression
in a work like this."*

INTERIOR ILLUSTRATION
TOM KIDD
The War of the Worlds
Novel by H.G. Wells (Books of Wonder)
Oils
Each image 20in x 28in (51cm x 71cm)
*"Altogether I did 18 paintings for this
edition of Wells's classic novel – I even
did two different endpapers for the book."*

Colour Work, Unpublished
Anne Sudworth
The Snow Tree
Personal work
Pastels
25in x 27in (64cm x 69cm)

MONOCHROME WORK, UNPUBLISHED
TOM KIDD
The Faeries of Spellcaster
Pencil
14in x 18in (36cm x 46cm)
"I did this to advertise my print business, Spellcaster Press. I later turned it into a full-colour painting (above)."

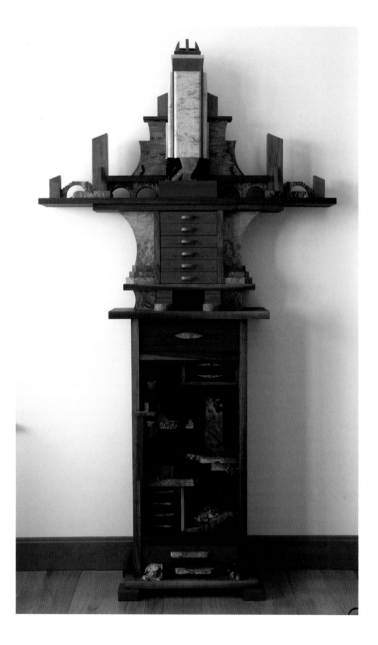

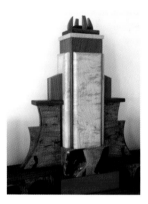

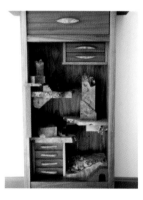

THREE-DIMENSIONAL WORK
JOHNNA KLUKAS
Hall Table of the Mountain King
Personal work
Walnut, mahogany, burl maple, figured maple
c68in x 36in x 10in (173cm x 91cm x 25cm)
"I chose a limited palette of walnut, mahogany, burl maple and figured maple to echo the limited range of materials that would likely be available for such a building. Walnut is for the original matrix of rock. The mahogany lies in layers, like sedimentary rock, bedding in cracks and gaps. Burl maple appears in chunks and lenses, cobbles of older material trapped in the sediments as they harden. Finally, figured maple enters like an igneous intrusion into previous layers.
"Chesley Bonestell was an architect, so I'm especially pleased that Hall Table of the Mountain King, with its obvious architectural overtones, received the Chesley Award."

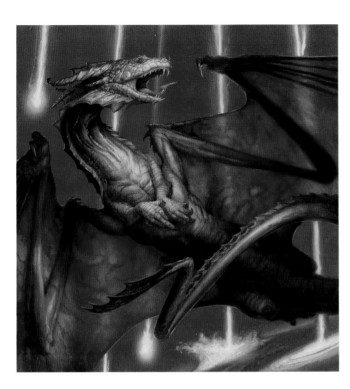

GAMING-RELATED ILLUSTRATION
DONATO GIANCOLA
Shivan Dragon
Packaging and card art for *Magic: The Gathering*, 7th edition
Oil on acid-free Strathmore drawing paper mounted on masonite
18in x 19in (46cm x 48cm)
"What better way to begin an assignment than to be told to create the coolest-looking red dragon you can? Then have that illustration selected to appear on one of the most popular cards in Magic, *and on packaging for the set, and on advertising for the game worldwide. You couldn't ask for a more public exposure of your illustration!"*

RIGHT:
PRODUCT ILLUSTRATION
KINUKO Y. CRAFT
Die Valküre (poster; Dallas Opera)
Poster for the Dallas Opera Company, 2001 Season
Oils over a watercolour underpainting on Strathmore illustration board
19.5in x 26in (50cm x 66cm)
"It's always amazing to me that the complicated border design I created for each of the four posters in this series – one for reach of the four Wagner operas the Dallas Opera Company presented that year – consumed more than one-third of the time I spent working on the paintings! Two new wonderful Windsor & Newton Series 7 #0 brushes were completely worn out finishing this painting; usually one brush lasts long enough to finish two paintings."

| ART DIRECTOR |
| **PAUL BARNETT** |
| |
| CONTRIBUTION TO ASFA |
| **GEOFFREY SURRETTE** |

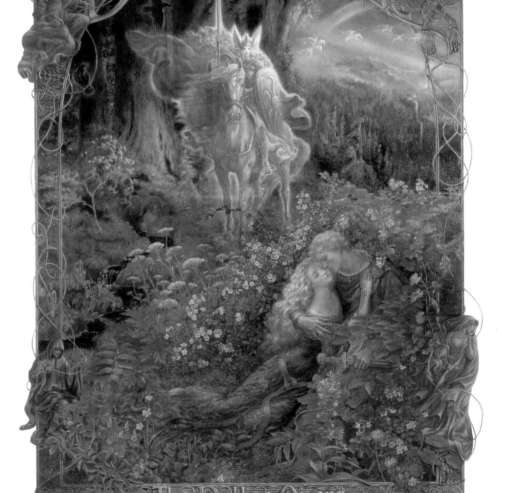

ARTISTIC ACHIEVEMENT 2002
DONATO GIANCOLA

ABOVE:
Sisay's Ring
1996
Illustration for *Magic: The Gathering*
Oils on acid-free Strathmore paper mounted onto masonite
9in x 7.5in (23cm x 19cm)
© 1996 Wizards of the Coast

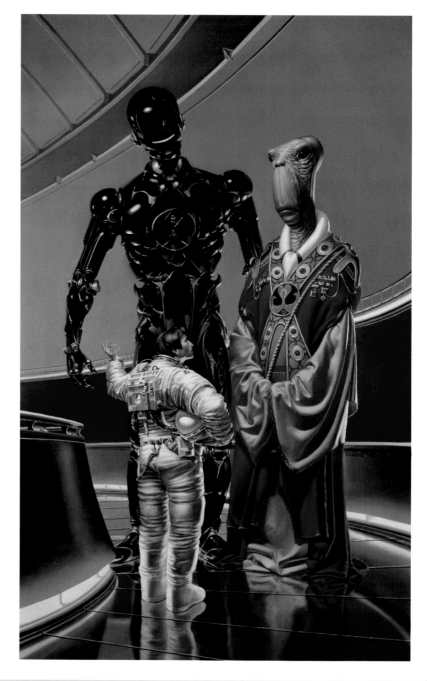

Otherness
1994
Cover for the story collection by David Brin (Bantam
Spectra)
Oils on acid-free Strathmore paper mounted onto masonite
14in x 30in (36cm x 76cm)

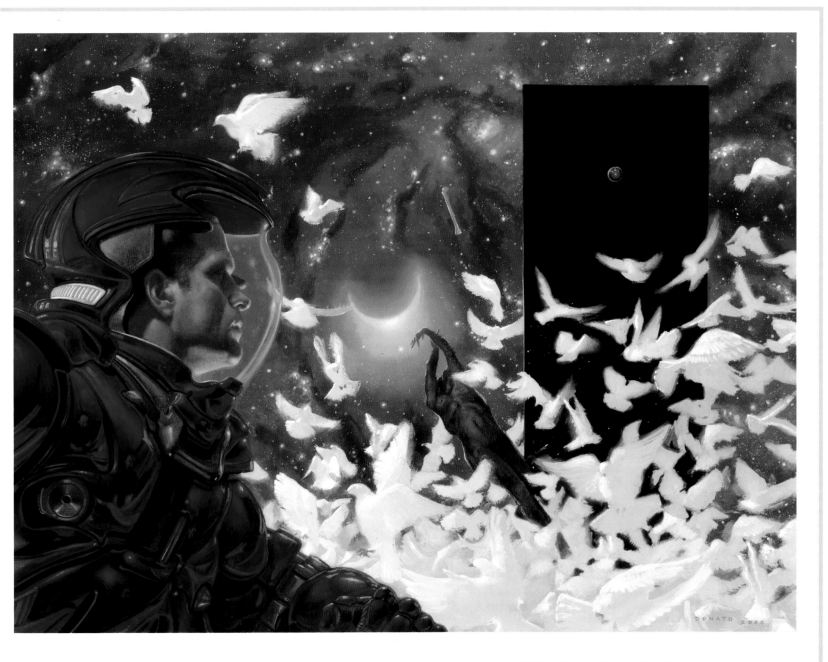

2001: A Space Odyssey Revisited
2000
Illustration for *Playboy*, January 2001
Oils on acid-free Strathmore paper mounted
onto masonite
22in x 18in (56cm x 46cm)
© 2000 Playboy Enterprises

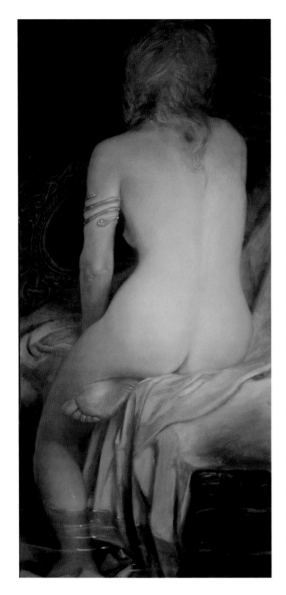

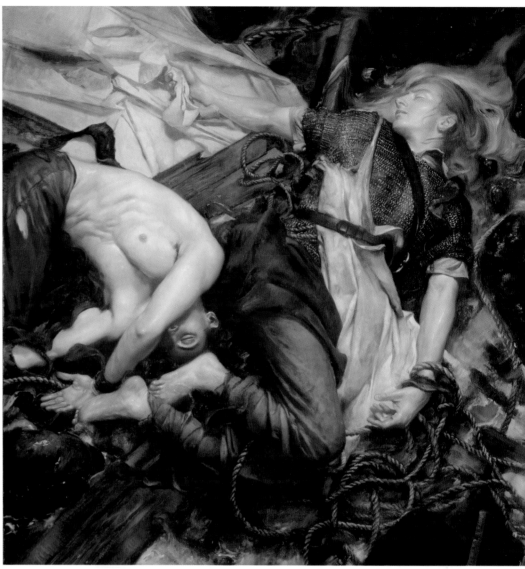

Eric Brighteyes: Triptych
2001
Private commission
Oils on acid-free Strathmore paper mounted onto panel
68in x 34in (173cm x 86cm)

RIGHT:
Psychohistorical Crisis
1999
Cover for the novel by Donald Kingsbury (Tor)
Oils on acid-free Strathmore paper mounted onto masonite
36in x 22in (91cm x 56cm)

ABOVE:
Highrises
1999
Illustration for *Playboy*,
January 2000
Oils on acid-free Strathmore
paper mounted onto masonite
17in x 19in (43cm x 48cm)
© 1999 Playboy Enterprises

LEFT:
Godheads
1997
Cover for the novel by Emily
Devenport (Roc)
Oils on acid-free Strathmore
paper mounted onto masonite
15in x 22in (38cm x 56cm)

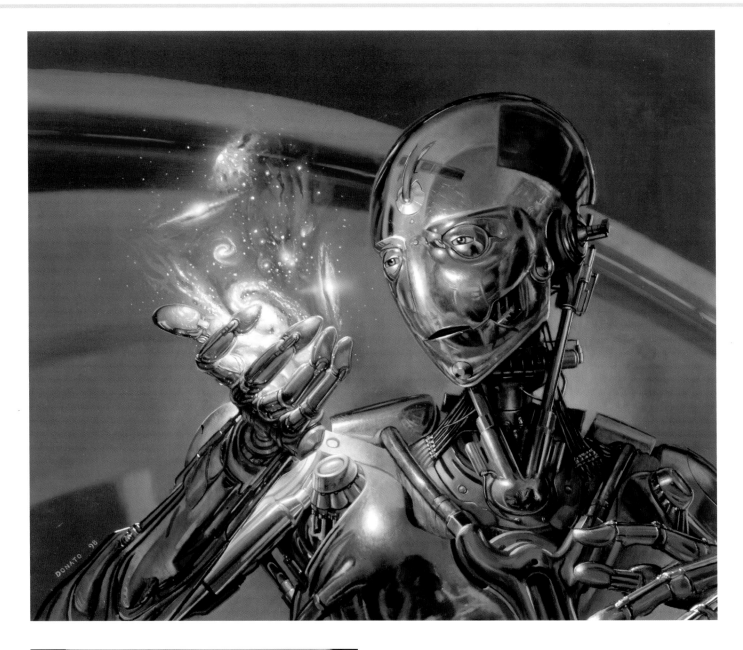

Earth to Universe
1998
Illustration for *Playboy*, January 1999
Oils on acid-free Strathmore paper mounted onto masonite
20in x 18in (51cm x 46cm)
© 1998 Playboy Enterprises

Cartographer
2001
Illustration for *Magic: The Gathering*
Oils on acid-free Strathmore paper mounted onto masonite
22in x 17in (56cm x 43cm)
(c) 2001 Wizards of the Coast

BIOGRAPHICAL SKETCHES OF ARTISTS REPRESENTED IN THIS BOOK

Alexander, Rob

Rob Alexander is a Canadian-born watercolour artist who has spent the past ten years working in the publishing and gaming industries. His paintings have appeared on book covers for Tor, HarperCollins, Del Rey, Berkley, Donald M. Grant, Old Earth Books, Shadowlands Publishers and Tachyon Publications. He has done magazine cover and interior art for *Amazing Stories*, *The Magazine of Fantasy & Science Fiction*, *Dragon*, *Inquest*, *The Duelist* and *Marion Zimmer Bradley's Fantasy Magazine*, as well as the cover to the French release of the multi-user computer game *Dark Age of Camelot*. One of the artists for the popular trading card game *Magic: The Gathering* since its inception, he has also worked on ten other card games, including roughly 45 pieces for the *Lord of the Rings* card game from Iron Crown Enterprises. Lately he has been doing conceptual and promotional work creating new fantasy worlds for Wizards of the Coast and working on his backlog of private commissions . . . while fitting in the occasional cover. Visit his website at http://www.robalexander.com.

Aulisio, Janet

Janet Aulisio was born in New Jersey and currently lives in Minnesota; she has been married for 24 years to the artist John Dannheiser. She has been illustrating professionally for over twenty years, mainly in the field of fantasy/sf; clients have included *Asimov's*, *Analog*, *Science Fiction Age*, *Realms of Fantasy*, *Weird Tales*, *Amazing*, *Galaxy*, Arkham House, Cricket and Cicada. Among the awards she has won, besides the Chesley, are two Readers' Awards for *Asimov's*, in 1989 and 1990.

Berry, Rick

Born in California in 1953, Rick Berry attended a variety of schools before going on the road. He finally hitch-hiked to Boston in the late 1970s with the aim of making a career in illustration; his first commission was for a 1978 edition of *Twenty Thousand Leagues Under the Sea*. His 1984 cover for William Gibson's *Neuromancer* heralded his adoption of digital techniques, which he combines with traditional work in oils. His work has been exhibited across the USA, and he has taught at the University of Tennessee, Adams State University and Tufts University, Boston. His concept art for the screen includes work for *Johnny Mnemonic* (1995). With Phil Hale he created the art book *Double Memory: Art and Collaboration* (1995). Visit his website at http://www.braid.com.

Bober, Richard

Born in 1943, Richard Bober studied with Lee Gaskins and in 1961 won a scholarship to the Pratt Institute. There he studied with "a series of tenth-rate DeKooning and Jackson Pollock clones" and flunked gym for four consecutive years before being expelled, proudly holding the Pratt's record for cutting classes. He has worked as a medical illustrator and an sf/fantasy artist for the past thirty years. He is now accepting portrait commissions through his agent, Jane Frank (http://www.wow-art.com).

Bonestell, Chesley

Born on January 1, 1888, in San Francisco, Chesley Bonestell was the doyen of space illustrators. He had also careers in architecture – he worked on the Golden Gate Bridge and on New York's Chrysler Building, among many others – and as a motion-picture matte painter: movies on which he worked include *War of the Worlds* (1953), *When Worlds Collide* (1951), *Destination Moon* (1950), *The Conquest of Space* (1955) and *This Island Earth* (1955). In the early 1950s he was asked by *Collier's* magazine to illustrate a series of articles to be written by, among others, Wernher von Braun and Fred Whipple; these articles, with their positive attitude towards space exploration, so affected US popular opinion that they spurred the US space program. Bonestell's many books include *The Conquest of Space* (1950) and *Beyond the Solar System* (1964), both with Willy Ley, *Conquest of the Moon* (1953), with Ley, von Braun *et al.*, and *Beyond Jupiter* (1972), with Arthur C. Clarke. Chesley Bonestell died at the age of 98 on June 11, 1986, at his home in Carmel, California; he was still painting almost until the last.

Brom

Born in 1965 in Albany, Georgia, as the son of an Army aviator, Brom spent his entire school-age years on the move, living in such places as Japan, Alabama and Hawaii; he graduated from high school in Frankfurt, Germany. At the age of 20 he started working full-time as a commercial illustrator, and by age 21 he had two national art representatives and was doing work for such clients as Coca Cola, IBM, Columbia Pictures and CNN. Three years later he entered the fantasy field that he'd loved all his life: TSR hired him full-time. He spent the next three years creating the highly dramatic look and feel of the bestselling *Dark Sun* world.

In 1994 he returned to the freelance market, this time to pursue his love of the bizarre and fantastic. Since that time he has been working feverishly on hundreds of paintings for every facet of the genre: novels, role-playing, comics, games and film, including Tim Burton's *Sleepy Hollow* (1999), *Galaxy Quest* (1999), *Bless the Child* (2000), *Ghosts of Mars* (2001) and *Scooby Doo* (2002). He has also created a line of Brom fetish toys for Fewture and a series of bronzes for Franklin Mint.

Bush, Beryl

Beryl Bush was born in the South and reared in the Midwest, and currently lives with her husband in New York City. She earned her BFA from Western Kentucky University, where she also studied theatre design, and her MFA from the Pratt Institute. Since arriving in New York she has worked at advertising photography studios, *Harper's Bazaar* magazine, a SoHo art gallery, and Christie's Fine Art Auctioneers. She creates works for private sale and she contributes regularly to sf and fantasy publications.

Canty, Thomas

Thomas Canty is a very private person. Rather than offer a biography, he prefers to let his art speak for itself.

Cherry, David A.

David A. Cherry is a former attorney who turned to art at the instigation of his sister, Hugo Award-winning author C.J. Cherryh, and never looked back. He spent twenty-plus years as one of the premier freelance illustrators of sf and fantasy, doing many book and magazine covers, and currently works as Marketing Artist for Ensemble Studios and Microsoft (makers of the PC strategy games *Age of Empires* and *Age of Mythology*). He has been a member of ASFA since 1983, and served as its President 1988–90. He was instrumental in drafting the first set of Chesley Award rules and, in association with the World Science Fiction Society, arranging for the Chesley Awards ceremony to have a permanent place as an event at the annual World Science Fiction Convention.

Christensen, James C.

Inspired by the world's myths, fables and tales of imagination, James C. Christensen wants his paintings of floating fish, "puffy guys" in ornate costumes, angels, faeries, magical realms and more to add up to more than a beautiful if sometimes "curious" work of art. Recently retired after over twenty years as a professor of art at Brigham Young University, he continues as, in his own phrase, "a professor of imagination". His commissions include for the Utah Shakespeare Festival, the LDS Church, Time-Life Books and *Omni*.

Clark, Alan M.

Alan M. Clark has illustrated the writings of such authors as Ray Bradbury, Robert Bloch, Stephen King, George Orwell, Manly Wade Wellman, Greg Bear and Spider Robinson – and his own. His work has appeared in fiction, nonfiction, textbooks, young adult fiction and children's books. He has received the World Fantasy Award, four Chesleys, the Deathrealm Award and the International Horror Guild Critic's Award. Scorpius Digital Publishing released a collection of his fiction, *Hemogoblins: Stories to Chill the Blood,* in May 2001. *Pain and Other Petty Plots to Keep You in Stitches*, a collection of stories set in the "Facility" environment of the "Pain Doctors", was released early in 2003.

Craft, Kinuko Y.

Born in Japan, Kinuko Y. Craft first took an interest in drawing and painting while a small child. She gained her BFA from the Kanazawa Municipal College of Fine and Industrial Art in 1962. She came to the USA in the early 1960s and studied at the school of the Chicago Art Institute for a year and a half. After brief periods at various art studios in Chicago, she devoted herself fulltime to freelance illustration. Her work has been recognized repeatedly by professional art and design publications, competitions and shows, garnering her numerous awards. Her paintings are in the permanent collections of the National Geographic Society, Time Incorporated, the Museum of American Illustration and other corporate and private collections. She has won well over 100 awards, including five Gold Medals from the Society of Illustrators' annual exhibitions, the Hamilton King Award (1987), the *Spectrum* 7 Gold Award (2000), the *Spectrum* 8 Gold Award (2001) and

the *Spectrum 9* Grand Master Award (2002). Her children's books to date include *The Twelve Dancing Princesses* (1989; with Marianna Mayer), *Baba Yaga and Vasilisa the Brave* (1994; with Mayer), *Cupid and Psyche* (1996; with M. Charlotte Craft), *Pegasus* (1998; with Mayer), *King Midas and the Golden Touch* (1999; with Craft), *Cinderella* (2000) and *The Adventures of Tom Thumb* (2001; with Mayer). Her illustration clients have included *Time*, *Newsweek*, *The National Geographic Magazine*, *Forbes Magazine*, *Sports Illustrated*, the *New York Times*, AT&T, *Atlantic Monthly*, *US News and World Report* and *Playboy*, and she has done cover art for many book publishers and advertising art for major ad agencies. Her work has also graced posters for the Washington Opera and Dallas Opera. Visit her website at http://www.kycraft.com.

Dashow, Michael

Michael Dashow writes: "I traditionally rely upon my status as a Chesley-winning artist as the cornerstone of my bio. However, as that distinction is shared by everyone else in this book, I would have you know other relevant facts about myself." He is an art director and artist at the well known computer game company Blizzard North, makers of the game *Diablo II*. He does occasional illustration work for sf and fantasy publishers and has been the illustrator and designer of most of Tachyon Publications' book covers. He was also awarded ASFA's first ever Web Site Award for best artist website: http://www.michaeldashow.com.

Di Fate, Vincent

Vincent Di Fate attended the Phoenix (later renamed the Pratt-Manhattan Center) in New York City for his undergraduate studies and received his Masters degree from Syracuse University. In his prolific career he has produced art on sf, astronomical and aerospace subjects for such clients as IBM, Reader's Digest, the National Geographic Society and NASA. He has received many awards for his work, including the Chesley, the Frank R. Paul Award for Outstanding Achievement in Science Fiction Illustration, the Hugo for Best Professional Artist (1979), the Skylark Award for Imaginative Fiction (1987) and the Lensman Award for Lifetime Contribution to the Science Fiction Field (1990).

Di Fate has published three major books: *Di Fate's Catalog of Science Fiction Hardware* (1980), *Infinite Worlds: The Fantastic Visions of Science Fiction Art* (1997) – widely regarded as the first comprehensive history of sf art in the USA – and *The Science Fiction Art of Vincent Di Fate* (2002). He is now working on a fourth, and rather different book, this one on the subject of illustration and its connection to the US sf movie.

He has lectured extensively about the history, methods and meaning of his craft, and has been a consultant for MCA/Universal, 20th Century-Fox, Walt Disney Productions and MGM/United Artists. He is a Professor at the Fashion Institute of Technology (State University of New York) in New York City, where he teaches a course on the history of illustration and a studio course in sf and fantasy art. He served two terms as president of the Society of Illustrators (1995–7), an organization of which he is a Life Member, chaired the Permanent Collection Committee for the Museum of American Illustration from 1985-95, and has served on the Illustration Committee for the Sanford Low Collection of the New Britain Museum of American Art since 1993. He was a founding member and is a past President of ASFA.

Eggleton, Bob

Bob Eggleton, recipient of a string of Professional Artist Hugos (and one Hugo, with Nigel Suckling, in the Best Related Book category for *Greetings from Earth* [2000]), plus the 1999 Sylark Award and numerous Chesleys, first earned an international reputation as a painter in acrylics and airbrush of space and astronomical scenes. Towards the end of the 1990s he turned away from the airbrush to using oils on canvas and other traditional techniques, this being accompanied by a shift in subject matter from hard sf to fantasy – notably dragons and other large monsters. Books of his art are *Alien Horizons* (1995), *The Book of Sea Monsters* (1998) and *Greetings from Earth*, all with Nigel Suckling. His most recent book is the "fiction told in words and pictures" *Dragonhenge* (2002), done with John Grant; a companion volume, *The Stardragons*, is in preparation. He is married to the artist Marianne Plumridge. Visit his website at http://www.bobeggleton.com.

Fishman, Marc

Marc Fishman was born in Moldavia in 1971. He studied art at the University of Hartford Art School and then, briefly, in Florence. He has been working as a professional iullustrator for the past seven years, and has exhibited in group and solo shows in Italy, New York and Los Angeles. He is currently represented by Galerie Morpheus; visit their website at http://www.morpheusint.com.

Foster, Brad

Brad W. Foster was "born with a pen in my hand, causing no end of discomfort to my mother". A multiple award-winning artist, he enjoys working in a variety of fields as an illustrator, cartoonist and writer. He founded and continues to run the small press Jabberwocky Graphix, and has spent much of the past several years taking his work more directly to the public at art festivals across the country. Visit his website at http://www.jabberwockygraphix.com.

Frazetta, Frank

Frank Frazetta was born in 1928 in Brooklyn. He began his professional art career as a teenager, and worked in the comics industry throughout the 1940s and 1950s. He then worked for nine years with Al Capp, of *Lil Abner* fame. In 1964 he began painting paperback covers. For Ace Books he produced a series of Edgar Rice Burroughs covers, most notably for the *Tarzan* series. For Lancer he created the indelible image of Conan the Barbarian.

It was during this very successful period that he was able to negotiate more favourable contracts than the industry norm, becoming one of the first in the fantasy/sf art genre to retain ownership of his work and release only first printing rights to the publishers for whom he created covers. He went on to work with both publishers and movie companies through the 1970s and 1980s.

The 1990s saw a vigorous renewal of interest in his work. Several successful books dedicated to his art have appeared over the past couple of decades. He has won numerous awards including two Artistic Achievement Chesleys and the first *Spectrum* Grand Master Award. Currently he resides in East Stroudsburg, Pennsylvania, where the Frazetta Art Museum, constructed in 2000 as the new home for his paintings, draws visitors from all over the world. (Normal opening hours 11–4, Saturdays only, April through Christmas; schools and other art institutions welcome by appintment only. For more information, visit the official Frazetta website at http://www.frazettaartgallery.com.)

Freas, Frank Kelly

Frank Kelly Freas is universally recognized as one of the most prolific and popular sf and fantasy artists in the world. An eleven-time Hugo Award Winner (including a Retro Hugo in 2001), he has had a distinguished career that has so far spanned fifty years, from painting covers for *Astounding Science Fiction* and *Planet Stories* in the 1950s to his current work in sf illustration, gaming and motion-picture concepts. He has twice won the Readers' Poll Award from *Analog* magazine for Best Cover of the Year (1991 and 2000), received three Chesley Awards, and, in 1999, been honoured by the L. Ron Hubbard Lifetime Achievement Award for Outstanding Contribution to the Arts. In 2000 he was elected a Fellow of the International Association of Astronomical Artists.

Freas, Laura Brodian

Laura Brodian Freas, a Doctor of Music Education, has been a classical music radio programme host in San Francisco and Los Angeles. She has illustrated for *Analog*, *Marion Zimmer Bradley Fantasy Magazine*, *Weird Tales* and Easton Press, among others, and runs Kelly Freas Studios. She works in traditional media, computer graphics, webpage design and multimedia. She has served as President of the Southern California Early Music Society, and has been Western Regional Director of ASFA and Director at Large of the Costumers' Guild West. She is an L. Ron Hubbard Illustrators of the Future Contest judge and a founder of the Dark Shadows Festival's Collinsport Players.

Froud, Brian

Brian Froud was born in Winchester, UK, in 1947. He grew up in Kent and graduated with first-class honours from Maidstone College of Art. He began his career by illustrating book covers and quickly went on to illustrate books of his own, including *The Land of Froud* (1978; with David Larkin), the award-winning *Faeries* (1978; with Alan Lee and Larkin) and, more recently, *Lady Cottington's Pressed Fairy Book* (1994; with Terry Jones) and *Good Faeries/Bad Faeries* (1998; with Terri Windling). He has also designed the movies *The Dark Crystal* (1982) and *Labyrinth* (1986) for Jim Henson. His most recent books are *The Faeries' Oracle* (2001; with Jessica Macbeth) and *Lady Cottington's Fairy Album* (2002), a new Cottington book which he has both illustrated and written. He is currently working on a book of rune lore with author Ari Berk.

Giancola, Donato

Donato currently resides with his wife and daughter in Brooklyn, New York. Since the start of his professional career in 1993, his list of clients has continued to grow, including companies such as LucasArts, *National Geographic*, DC Comics, HarperCollins, *Playboy*, Penguin Books, Sony, Tor, The Franklin Mint, Milton-Bradley and Wizards of the Coast. His illustrations have won numerous awards, including four nominations for the Hugo, seven Chesleys, and Gold and Silver Awards from *Spectrum*. In addition, his work has been exhibited in dozens of shows at New York's Society of Illustrators and various galleries around the USA. Visit his website at http://www.donatoart.com.

Gurney, James

Author and illustrator of the bestselling *Dinotopia* books, James Gurney was born in California in 1958. He majored in anthropology at the University of California at Berkeley, then studied illustration at the Art Center College of Design in Pasadena. After a year-long odyssey across the USA, armed with a sketchbook, he painted the backgrounds for the animated

feature film *Fire and Ice* (1983) and became a frequent contributor to the *National Geographic*. Many of the original *Dinotopia* oil paintings were featured at a major exhibition at the Smithsonian in Washington in Summer 2002, and in Spring of that year ABC aired a six-hour, $86 million miniseries based on the books which broke ratings records and won an Emmy for Best Special Effects. A weekly tv series of *Dinotopia* premiered on ABC in Fall 2002. James Gurney lives with his family in New York's Hudson Valley

Henriksen, Hap
Having studied anthropology, Hap Henriksen became an artist, earning permanent places for his sculptures at major exhibitions and museums. After the rise in popularity of fantastic art during the mid-1970s, he moved into this new field, and by 1983 he was working on an Exhibition of Fantastic Art to celebrate 25 years of NASA. He spent ten years creating three ranges of figurines for Land of Legend; he has worked also for Rawcliffe Pewter, Warner Bros. Looney Tunes, Flambro, Monroe Collectibles and other companies. He lectures across the USA on the subject of fantastic art.

Hickman, Stephen
Stephen Hickman was born in Washington DC. The family was there because his father was in the Department of State; when his father was transferred to the Foreign Service the family began travelling around, so as a boy he spent time in the Philippines, Pakistan and Texas. The impressions he absorbed can be seen in his subtropical Utopian pictures like *After the Rains*, *The Lemurian Princess* and *The Archers of Lhune*.

The family settled in Alexandria, VA, where he attended high school and was fortunate enough to receive a first-rate artistic education: "A good thing for me, too, because I sure didn't get much that was of any use from the art school in Richmond, VA – a wonderfully hip and bohemian place I shared with such luminaries as Mike Kaluta, Phil Trumbo, and Charles Vess, but with a low taste for the stripe painting of that period in Art History." After an abortive foray into comics, he designed T-shirts while building up a painting portfolio. In due course Ace Books bought a piece from his portfolio, and then another, "and then my big moment – I got to do the cover for a reprint of Murray Leinster's *The Brain Stealers*! Hurray for me!" He says he has never looked back.

Honeck, Butch & Susan
Butch Honeck was born in 1940 in Ann Arbor, Michigan, and learned machining and welding from a neighbour during his youth. Dropping out of school, he joined the US Navy at age 17, receiving a medical discharge after two years and earning a living repairing automobiles. In 1968 he and Susan, a teacher, were married. While recuperating after breaking his leg in a skiing accident, he started making small welded sculptures, and discovered they were saleable; by 1975 he was supporting his family this way. Apart from welded steel sculptures for offices and the like, he has done touch exhibits for the blind: "Having my art 'viewed' by the blind is very inspiring." To make shapes impossible to achieve by welding, he learned how to cast bronze and aluminium and made his own foundry. He has recently started making custom parts for motorcycles. Visit his website at http://www.honeck.com.

Kidd, Tom
Tom Kidd obtained a scholarship to Syracuse University, but dropped out after two years, and even-

tually moved to New York City. He has worked for publishers including William Morrow, Random House, Warner Books, Doubleday, Marvel Comics, St Martin's Press and Tor. He has illustrated two books – *The Three Musketeers* (1998) and *The War of the Worlds* (2001) – and there is a book of his art, *The Tom Kidd Sketchbook* (1994). Trading cards and a screen saver have been based on his paintings. His book work has won him five Chesley Awards, an Anlab and a Golden Pagoda, and has garnered him four Hugo nominations. He has also done design work for film, theme parks and entertainment products, and figurines for such clients as Walt Disney Feature Animation, Rhythm and Hues, Franklin Mint, Danbury Mint, Buddy-L Toys, Mayfair Games and Second Nature Software. His work has been displayed in a wide array of venues, including the Delaware Art Museum, the Museum of American Illustration, the Canton Museum of Art and the NASA Future Art Expedition. He currently resides in New Milford, Connecticut, where he is working hard on a book called (provisionally) *Gnemo: Airships, Adventure, Exploration*. Visit his website at http://www.spellcaster.com/tomkidd.

Klukas, Johnna
Johnna Klukas was a computer scientist and electrical engineer before turning to art full-time in 1997. She and her husband, Jim Belfiore, divide their time between Maine and Massachusetts. Visit her website at http://www.jykboxes.com.

Ledet, Joy Marie
Joy Marie Ledet is proudly a Texas artist. Her illustrations have appeared in *Marion Zimmer Bradley Fantasy Magazine*, *Dreams of Decadence*, *Reality Escapes*, *Mythos*, *Women in Fur Comic Book*, *Sovereign Stone*, *Well of Darkness*, *Guardians of the Lost* and *Journeying into the Void of the Sovereign Stone Trilogy: The Lover's Knot*. She has done book covers including *The Essence of Stone* (2002) by Beverly A. Hale and *Tangled Webs* (2002) by Laura J. Underwood.

Lee, Alan
Alan Lee was born in 1947 in Middlesex, UK, and studied at the Ealing School of Art. For a time he shared commercial studio space in London with a group of artists including Brian Froud; in 1976 he and Froud moved to live near Exeter, Devon, UK, where they created the international bestseller *Faeries* (1978), with text by David Larkin. Since then he has illustrated editions of J.R.R. Tolkien's *The Lord of the Rings* (1991) and *The Hobbit* (1997), *The Mabinogion* (1982) and others, as well as original books like Peter Dickinson's *Merlin Dreams* (1988). He has also done much movie work – for *Legend* (1985), *Erik the Viking* (1989), *Merlin* (1998) and most recently Peter Jackson's *The Lord of the Rings* trilogy (2001, 2002, 2003).

Lee, Jody
Jody A. Lee was born in San Francisco, and graduated from the Academy of Art College with a BA in Illustration in 1980. Her fantasy and sf art has been shown at the Museum of Illustration and the Delaware Art Museum. Her work has centred primarily on illustrating book covers and game packages, and on interior book illustrations. Her clients have included the publishers DAW, Bantam Doubleday Dell, Tor and Warner. Visit her website at http://www.jodylee.net.

Lindahn, Val Lakey
Val Lakey Lindahn started her professional career as an illustrator at Screen Gems Columbia Music in

1972. By 1975 she was primarily illustrating sf, fantasy and horror. She was a finalist for the Hugo in 1984 and again in 1985 (one of few artists at the time to be nominated primarily for black-and-white interior illustrations). She went on to illustrate video and CD covers, movie posters and, done with husband Ron Lindahn, a series of her own children's books. Visit her website at http://www.valhallastudio.com.

Lira, Sandra
Sandra Lira took courses in foundry techniques at Syracuse University, in animation at Middlesex College and in anatomy with Deane Keller at Lyme Academy of Fine Art in Old Lyme, Connecticut. ("We were even taken to Yale for dissections on cadavers. It was amazing.") The medium she uses for original work is dictated by what material the final piece will be and its size. She generally uses an oil-based clay, Super Sculpey or wax, depending on whether the finished work will be in bronze, resin or precious metal. The original sculpture is often destroyed in the mould-making process. While primarily a sculptor, she is also drawn to painting, stop-motion animation and digital work, including visual FX and 3D animation. Her work has appeared in the *Spectrum* annuals numbers 5, 8 and 9. Visit her website at http://www.sculptor.net.

Lockwood, Todd
Todd Lockwood, a Colorado native and a 1981 graduate of the Colorado Intitute of Art, spent fifteen years in advertising before pursuing work in the sf and fantasy universe. He soon landed a choice job with TSR, in 1996, in Lake Geneva, Wisconsin, creating concept art and covers for the *Dungeons & Dragons* game. Shortly afterwards, he was rescued from the Midwest by Wizards of the Coast, this time moving to the Seattle area. During his fairly short fantasy/sf career to date he has won numerous awards, including five Chesleys and two World Fantasy Art Show awards. One of the highlights of his professional career has been the redesign of the look of *Dungeons & Dragons* for the Third Edition release of the game in 2000. Currently he is once more a freelance illustrator. The first book of his art, *Transitions*, was published in 2003 by Paper Tiger. Visit his website at http://www.toddlockwood.com.

Longendorfer, John
John Longendorfer is currently involved with the Golden Fish Gallery in Milford, Pennsylvania, where he exhibits his own work and that of other local artists. He is a painter, craftsman and sculptor whose subject matter leans towards medieval fantasy and the metaphysical. Having studied independently and at the Philadelphia College of Art and the Pennsylvania Academy of Fine Art, he has developed his own unique style which he incorporates into his stone, wood and copper sculptures. His intricate and detailed works on paper are achieved using pen, ink and watercolour. He can be reached via the Golden Fish Gallery, 307 Broad Street, Milford, PA 18337.

Lundgren, Carl
Born in Detroit in 1947, Carl Lundgren has been a professional artist of the fantastic for over twenty years. Although he briefly attended art school, he considers himself largely self-taught. His professional career began in the late 1960s when he was one of the premier contributors to the psychedelic generation; his early works are featured in *The Rock Concert Art of Carl Lundgren* (1994). His talents as an illustrator furthered his career in sf/fantasy: his paintings have been used on the covers of hundreds of books and magazines all over the world, and have regularly featured in

Spectrum. His work has also been marketed as greetings cards, puzzles, posters, T-shirts and jewellery. He today works as a fine artist. Many of his paintings have been exhibited at museums and galleries across the USA. *Carl Lundgren: Great Artist* (1994) is an autobiography. Visit his website at http://www.carllundgren.com.

Maitz, Don

Don Maitz has produced imaginative paintings throughout a career that has so far spanned twenty-five years. This career began and continues with book publishing, while expanding into other areas including exposure as the original and continuing artist of the Captain Morgan Spiced Rum character. His other clients include Joseph Seagrams & Sons, the National Geographic Society, Bantam Doubleday Dell, Warner Books, Random House Publishing, Watson-Guptill, Penguin, HarperCollins and Paramount Pictures. He has twice won the Hugo Award, and has received a World Fantasy Award, a Silver Medal and Certificates of Merit from New York's Society of Illustrators, and ten Chesleys. His paintings have been exhibited at NASA's 25th Anniversary Show, the Park Avenue Atrium, the Hayden Planetarium, the Museum of American Illustration, the New Britain Museum of American Art, the Delaware Art Museum, the Canton Art Museum, the Key West Museum of Art and History and the Florida International Museum.

His work has also enhanced magazines, cards, posters, limited-edition prints, puzzles, screen-saver programs and other merchandise. Two books of his work have been produced: *First Maitz* (1988) and *DreamQuests: The Art of Don Maitz* (1994), with a third tentatively scheduled for Fall 2003 publication. He is featured within Dick Jude's *Fantasy Art Masters* (1999) and as its cover artist. He has also worked as a conceptual artist on the animated feature film *Jimmy Neutron Boy Genius* (2001).

Mattingly, David B.

Born in Fort Collins, Colorado, David Mattingly attended the Colorado Institute of Art, Colorado State University, and later transferred to the Art Center College of Design in Pasadena, California. After his schooling he was hired by Walt Disney Studios as a matte artist, and ultimately he headed up the Matte Department there. He has worked on a number of Disney movies including *Tron* (1982), *The Black Hole* (1979) and the *Herbie* series. As a cover illustrator he has produced over 1000 covers and worked for most major US publishers of sf and fantasy, including Ace, Baen, Ballantine, Bantam, Berkley, DAW, Dell, Del Rey, Marvel, *Omni*, Penguin, *Playboy*, Scholastic, Signet and Tor. Aside from his Chesley, he is a two-time winner of the *Magazine and Bookseller*'s Best Cover of the Year Award. He has illustrated the popular *Heroes in Hell* series, the *New York Times* bestselling *Honor Harrington* series, and the most recent repackaging of Edgar Rice Burroughs's *Pellucidar* series, as well as all 54 books in Scholastic's bestselling *Animorphs* series. Other clients have included Michael Jackson, American Express, LucasFilm, Universal Studios, Totco Oil and Galloob Toys.

He continues to be sought as a matte artist. He painted the panoramic opening shot for Warren Beatty's *Dick Tracy* (1990) along with many other scenes in that movie. He painted the background for the corporate ID for Ivan Reitman's Northern Lights Productions. His commercial credits include Dupont Chemical, First Chicago Bank and Camel cigarettes. He now lives in Hoboken, New Jersey, with his wife Cathleen Cogswell and their three cats. Visit his website at http://www.davidmattingly.com.

Miller, Ian

Ian Miller was born in 1946 and received his art education at Northwich School of Art and St Martin's School of Art. He has had solo exhibitions at the Greenwich Theatre Gallery, the Jordon Gallery, the Zap Club, the Grange and the Burstow Gallery. Three books of his art have been published: *Green Dog Trumpet* (1979), *Secret Art* (1980) and *Ratspike* (1989). He has produced illustrated editions of Michael Crichton's *Eaters of the Dead* (1976), Ray Bradbury's *The Martian Chronicles* (1979), Edgar Allan Poe's *Tales of Mystery and Imagination* (1993), Anthony Masters's *Ivy* (1984), Gene Wolfe's *Biblioman* (1994) and Charles Dickens's *A Christmas Carol* (1994). His graphic novels are *The Luck in the Head* (1991), with M. John Harrison, and *The City* (1994), with James Herbert. He has been a significant contributor to animated movies, having done backgrounds and other work for *Shrek* (2001), the two unreleased movies *Cristos* and *Artic*, and two of Ralph Bakshi's features, *Wizards* (1977) and *Cool World* (1992).

Moore, Clayburn

Clayburn Moore has been working professionally as a sculptor since 1985. He received his BFA from the University of Texas at Austin, and completed his classical education at the Academy of Fine Arts in Florence, Italy. His reputation in the industry led to early sculpting contracts with comics companies DC, Dark Horse and Marvel. His companies Moore Creations, Inc. and Moore Action Collectibles, Inc. are partner corporations located in Fort Worth, Texas. Current licences in the comics industry include Top Cow properties *Fathom* and *Witchblade*, Eric Larson's *Savage Dragon*, Terry Moore's *Strangers in Paradise* and David Mack's *Kabuki*. Entertainment industry licences include Twentieth Century-Fox Entertainment's popular tv series *Angel* and *Buffy the Vampire Slayer*. Visit the websites at http://www.moorecreations.com and http://www.mooreaction.com.

Morrison, John A.

John A. Morrison is the owner and proprietor of Cornerstone Glassworks. Aside from the Chesley, he has won awards from the Dallas Society of Glass Artists, the Texas Visual Arts Association, the "Into the Future" Invitational Competition, the Carnegie Center, Art Glass International (Norway) and the World Glass Congress. His work has been featured in *Professional Stained Glass Magazine* and *US Glass Magazine*, and in 1991 he was the subject of the Channel 4 News Special *John Morrison, Glass Sculptor*. He has a unique claim to Chesleys fame: he creates the Chesley awards themselves. Visit his website at http://www.csgw.com.

Palencar, John Jude

John Jude Palencar has collected over 200 honours, including Gold and Silver Medals from the Society of Illustrators, two Gold Book Awards from *Spectrum* and three Chesleys in three consecutive years. His work has appeared on hundreds of book covers, and he has received commissions from *Time*, *The Smithsonian Magazine*, *The National Geographic Magazine*, the Philadelphia Opera and many others. Outside the USA, he has been a featured artist in *IDEA* magazine in Japan and has worked in Ireland as an artist in residence; his paintings were included in a special exhibit at the National Museum in Dublin entitled *Images of Ireland*. Most recently, his work was included in the exhibition *As Seen From Ohio: Nine Illustrators* at the Centro Cultural Recoleta in Argentina. His personal work is handled by Arcadia Gallery, New York City.

Persello, Gary

Born in Alliance, Ohio, in 1963, Gary Lee Persello gained an Associate Degree in Commercial Art on graduation from high school. His formal art education continued at Kent State University, Ohio, and the Pittsburgh Art Institute, from which he graduated with honours, majoring in visual communications with an emphasis on sculptural special effects. He later discovered his timeless medium, bronze, and explored all phases of the lost-wax process. Today he personally executes all casting and finishing processes of his work. He further enhances his sculptures with unique, richly coloured patinas. He has participated in local and national exhibitions and competitions, has been commissioned for many private works, and has received many honours for his art.

Robins, Arlin

Arlin Robins has been working professionally in the arts for nearly 30 years. She received her BFA from the Art Institute of Chicago, and continues to supplement her education as time allows. Her career touches on graphic arts, computer arts and animation, lithography, web design, painting, jewellery design and sculpture. She has recently moved to the field of interior design and renovation. Visit her website at http://www.arlinart.com.

Schomburg, Alex

Born in Puerto Rico in 1905, Alex Schomburg came to Manhattan as a teenager with his family, and in the 1920s opened a commercial studio with three of his brothers. Initially he produced art for advertising, but during the 1930s his focus was on illustration for the pulp magazines and during the 1940s on comic books; he is known to have done over 500 covers for comic books, including *Sub-Mariner*, *Human Torch*, *Marvel Mystery Comics*, *Thrilling Comics*, *Black Terror*, *The Green Hornet* . . . After this relatively brief but immensely productive comics career, he moved back to non-comics illustration, providing covers and interiors for most of the leading sf magazines, notably including *The Magazine of Fantasy & Science Fiction*, *Amazing Stories* and *Asimov's*. A book of his work was *Chroma: The Art of Alex Schomburg* (1986), with text by Jon Gustafson.

Shands, Davette

Fans of John Steakley's novel *Vampire$* know his heroine, Davette Shands, as a beautiful Texas oil heiress. The real Davette Shands, upon whom that character was based, has never been an oil heiress, but she does now live in Texas. She is equally talented as an artist, a photographer, a costumer, a dancer and a choreographer, but her abiding passion has always been the theatre. She is currently ranked as one of the top lead female actresses in the Dallas area. When she is not involved in a play, film or commercial, you can usually find her working up a screenplay or script. Visit her website at http://www.davette.com.

Shaw, Barclay

Since turning to the arts full-time in 1978, Barclay Shaw has painted well over 500 book and magazine cover illustrations, working for virtually every major US publishing house. He has received several Hugo nominations, and his original artwork has been displayed in museums and galleries as well as at sf/fantasy convention art shows. He now primarily provides high-end 3D computer graphics and animation support for the Defense Advanced Research Projects Agency as well as other defence-related concerns. Although the majority of Shaw's art centres on sf/fantasy themes,

his work covers an extremely broad range of subject matter and use of materials: from painting and sculpture to digital imagery, 3D animation and multimedia presentation. In addition to traditional art tools, his studio includes both Macintosh and Windows platforms and has full digital audio and video production capabilities.

Siudmak, Wojtek

Born in 1942 in Wielun, Poland, Wojtek Siudmak studied at Warsaw's College of the Plastic Arts and Academy of Fine Arts, then in 1966 moved to France to study at the Ecole des Beaux-Arts in Paris. His work has appeared in many group exhibitions throughout Europe, and he has had solo shows in France, Poland, Canada, the UK, the USA and Germany. In 2000 a show was presented projecting his art onto the front of the temple of Rameses III at Luxor, Egypt. Seven books of his work have been published under the series title *Siudmak – Art Fantastique*, the most recent appearing in November 2002; *Siudmak Portfolio, Univers Fantastique* appeared in 1981.

Snellings Clark, Lisa

Lisa Snellings Clark was the first student in her high school to receive the Thespian Award; she had painted sets, sculpted props, acted in plays, written short stories and composed piano works. She hasn't lost her fascination for using various media to explore a single theme. Her unique blend of humour and melancholy lends itself to works in many media and has inspired others to create poems, stories and plays based on her images. *Strange Attraction*, an anthology based on her work containing stories and poetry by Ray Bradbury, Neil Gaiman, Harlan Ellison, Charles de Lint and a host of others, edited by Edward Kramer, was released in hardcover in 2000. She continues to explore new ways to interact with her viewers through kinetic and multimedia works. She is currently working on a large, Rube Goldberg-inspired kinetic sculpture and "a sort of scary book for children".

Sudworth, Anne

Anne Sudworth has been drawing and painting since early childhood. As a professional painter she initially concentrated on racing scenes, which allowed her to express her deep passion for horses. Soon she was working extensively also in landscapes, particularly those of England's Lake District, whose wildness still inspires much of her work. However, there had long been another side to her painting, concerned more with the visionary and the fantastic than the everyday. In 1993 she presented her landmark exhibition *Visions and Views*, devoted to these more imaginative and fantastical works. The triumph of this exhibition established her as a respected gallery artist. She has since had many more solo exhibitions. Over the past decade the demand for her work has grown, and her original paintings and limited-edition prints are now sold internationally, both through galleries and as private commissions. Now working almost entirely in pastel, she is perhaps best-known for her *Earth Light Tree* paintings, an ongoing series that provides a central theme in her work. These pictures, of which *The Snow Tree* is one, show imaginary scenes in which trees, forests and woodlands glow with their own earthlight and lifeforce,

symbolizing the power and magic the earth holds. Visit her website at http://www.AnneSudworth.co.uk.

Targete, Jean Pierre

Jean Pierre Targete was born in New York City in 1967 and grew up in Miami, where he began drawing at the age of five. In his sophomore year, he was accepted into a program called PAVAC, the seed for Miami's now-renowned New World School of the Arts. At age 16, with the encouragement of his teachers at PAVAC and his parents, he won a local high school competition held by the publisher Scholastic, which gained him a full scholarship to the School of Visual Arts in New York City. He received his first professional commission from Avon Books in 1989. He has since illustrated book covers for – aside from Avon – Berkley/Ace Ballantine, Bantam, Tor and a host of others. He has recently finished a collectable plate series for The Bradford Exchange: *Visions of the Sorcerer*. His art has been displayed in the *Spectrum* annuals. He now lives in Miami. Visit his website at http://members.aol.com/jptargete/TARGETE.htm.

Walters, Bob

Bob Walters has been a professional artist for twenty years. His artwork has appeared in over a dozen museums, including the American Museum of Natural History and the Smithsonian, in more than twenty books and innumerable magazines throughout the world, in tv productions for PBS, Cosmos Studios and the Discovery Channel, and in electronic media such as the *Microsoft Encarta Encyclopedia*. He has a BFA from the Academy of Fine Art in Philadelphia and science credits from the University of Pennsylvania. He and his partner, Tess Kissinger, have a studio in Philadelphia where they pursue projects of all sorts which bring together art and science. Most famous for their work in palaeontology, they are also currently involved in museum exhibits in robotics, space art and artifacts, anthropology and the history of the planet, as well as in personal experiments in the computer animation of movements of extinct animals based on fossil evidence.

Whelan, Michael

Born in California in 1950, Michael Whelan studied art and biology at San Jose State University before working at the Art Center College of Design in Los Angeles. Since 1975 he has created hundreds of paintings seen on book covers, calendars, magazines and record albums. During this time he has garnered virtually every available art award in the international sf/fantasy field. He is a 15-time Hugo winner and three-time (the maximum) winner of the World Fantasy Award for Best Artist. The readers of *Locus* magazine have voted him Best Professional Artist for 21 years running. In 1994 he won a Grumbacher Gold Medal and in 1997 he was awarded a Gold Medal by the Society of Illustrators and an Award for Excellence in the *Communication Arts Annual*. Most recently he was awarded a *Spectrum* Gold Medal for his painting *The Reach*.

Throughout his illustration career he has found time to work on "self-commissioned" pieces not initially intended for publication but created solely to realize personal artistic themes. After successful solo shows of these personal works from 1997 onwards, he

now devotes as much of his time as possible to his gallery work.

His original paintings have been displayed and sold at galleries and museums around the world. He has published four books of his art: *Wonderworks* (1979), *Michael Whelan's Works of Wonder* (1987), *The Art of Michael Whelan* (1993) and *Something in My Eye* (1996). Posters, prints and other items featuring his art are available through Glass Onion Graphics in Danbury, Connecticut. Visit his website at http://www.michaelwhelan.com.

Willis, Drew

Drew Willis grew up in Houston, Texas, and was drawing everything that had to do with *Star Wars* from a very early age. He got his undergraduate degree in Philosophy from Boston College. After college he decided to get a degree in Illustration from the Academy of Art College in San Francisco. He moved to New York in 1999 to pursue illustration in a more serious manner. His work is heavily influenced by Norman Rockwell, J.S. Sargent, J.W. Waterhouse, J.C. Leyendecker, Andrew Loomis, Banana Blender Surprise and Donato Giancola, who very generously shared his vast knowledge at the School of Visual Arts in New York. His clients include HarperCollins, Hyperion, McGraw-Hill and Scholastic.

Wilson, Dawn

A 1982 graduate of Moore College of Art, Dawn Wilson-Enoch began her art career as a cover illustrator for sf and fantasy books. She exhibited extensively in the early 1980s at genre conventions on the East Coast, where she received numerous awards for both published and private works. Other exhibitions have included shows at various galleries and museums across the USA. In 1988 she moved to California with her husband and young son, and there she focused upon private works on shamanistic and folkloric themes. As of 1996 she has lived in northern New Mexico, where she is deepening her exploration of the desert otherworld through works in oils, pencil and mixed media. She has sold her work privately on a steady basis. Since 1999 she has made and exhibited desert faery dolls, which may be found at the Chalk Farm Gallery in Santa Fe. Currently she is developing a book of art, artefacts and writing based upon her sojourns into the desert otherworld.

Wurts, Janny

Born 1953, Janny Wurts is the author of eleven novels, a collection of short stories and, with Raymond E. Feist, the *Empire* trilogy. Through her combined talents as a writer/illustrator, she has immersed herself in a lifelong ambition: to create a seamless interface between words and pictures that will lead reader and viewer beyond the world we know. A self-taught painter, she draws directly from the imagination, creating scenes in a representational style that blurs the edges between dream and reality. She makes no preliminary sketches, but envisions her characters and the scenes that contain them before executing the final directly from her initial pencil drawing. Visit her website at http://www.jannywurts.com.

CHESLEY AWARDS NOMINATIONS 1985-2002

This listing is as complete as we have been able to make it – and certainly is more complete than any other we have been able to discover – but we're aware that there are still lacunae and, quite possibly, errors. We would welcome further information sent to us via the publisher so that we may make appropriate amendments in future editions of this book.

1985

COVER ILLUSTRATION, HARDCOVER
Stephen Gervais: *Ghost Story* (novel by Peter Straub, Hill House)
Carl Lundgren: *Wings of Flame* (novel by Nancy Springer, Tor)
David Mattingly: *The Infinity Link* (novel by Jeffrey A. Carver, Bluejay)
Michael Whelan: *Chanur's Venture* (novel by C.J. Cherryh, Phantasia)
Michael Whelan: *The Final Encyclopedia* (novel by Gordon R. Dickson, Tor)
Michael Whelan: *The Integral Trees* (novel by Larry Niven, Ballantine Del Rey)
Michael Whelan: *Job: A Comedy of Justice* (novel by Robert A. Heinlein, Ballantine Del Rey)

COVER ILLUSTRATION, PAPERBACK
Alan Lee: *Orsinian Tales* (collection by Ursula K. LeGuin, Bantam)
Carl Lundgren: *The Day of the Dissonance* (novel by Alan Dean Foster, Warner)
David Mattingly: *Fire Time* (novel by Poul Anderson, Baen)
James Warhola: *Neuromancer* (novel by William Gibson, Ace)
Michael Whelan: *Chanur's Venture* (novel by C.J. Cherryh, DAW)
Michael Whelan: *Elric at the End of Time* (novel by Michael Moorcock, DAW)

COVER ILLUSTRATION, MAGAZINE
J.K. Potter: *Dinner in Audoghast* (story by Bruce Sterling, *Asimov's*, May 1985)
Bob Walters: *Promises to Keep* (story by Jack McDevitt, *Asimov's*, December 1984)

INTERIOR ILLUSTRATION
Dell Harris: *Analog*, March 1985
Bob Walters: *Marooned on Planet Earth* (story by Thomas Wylde, *Asimov's*, March 1985)
Bob Walters: *True Names* (novel by Vernor Vinge, Bluejay)

COLOUR WORK, UNPUBLISHED
Joe Bergeron: *Astronomy*
David A. Cherry: *Man of Prophecy*
James C. Christensen: *Companions Through Necessity*
Carl Lundgren: *The Snow Queen*
Dawn Wilson: *Winter's King*

MONOCHROME WORK, UNPUBLISHED
Robert Daniels: *Replicant*
Guy Frechette: *Defiance*
Suzanna Griffin: *Can I Keep Him, Mom?*
Dell Harris: *Stinger*

THREE-DIMENSIONAL WORK
Guy Frechette: *Melchior, the Cat Wizard*
Hap Henriksen: *Merchant of Dreams*
Jim Nelson: *Scrimshaw Exhibit*

ARTISTIC ACHIEVEMENT
Leo and Diane Dillon
Bob Eggleton
Tom Kidd
Carl Lundgren
Don Maitz
David Mattingly
Elizabeth Pearse

CONTRIBUTION TO ASFA
David Lee Anderson
Matt Fertig
Michelle Lundgren

1987

COVER ILLUSTRATION, HARDCOVER
David Cherry: *Chanur's Homecoming* (novel by C.J. Cherryh, Phantasia)

COVER ILLUSTRATION, PAPERBACK
Michael Whelan: *The Cat Who Walks Through Walls* (novel by Robert A. Heinlein, Berkley)

COVER ILLUSTRATION, MAGAZINE
Bob Eggleton: *Vacuum Flowers* (serial by Michael Swanwick, *Asimov's*, January 1987)

INTERIOR ILLUSTRATION
Dell Harris: *Analog*
Bob Walters: *Vacuum Flowers* (serial by Michael Swanwick, *Asimov's*, December 1986—February 1987)

COLOUR WORK, UNPUBLISHED
Michael Whelan: *Sentinels*
David Cherry: *The Offering*

THREE-DIMENSIONAL WORK
Butch and Susan Honeck: *Magic Mountain*

ARTISTIC ACHIEVEMENT
Bob Eggleton
Alex Schomburg

CONTRIBUTION TO ASFA
Matt Fertig

1988

COVER ILLUSTRATION, HARDCOVER
Thomas Canty: *The Sun, the Moon, and the Stars* (novel by Steven Brust, Ace)
James C. Christensen: *Southshore* (novel by Sheri S. Tepper, Tor)
Leo and Diane Dillon: *The Essential Ellison* (collection by Harlan Ellison, Nemo)
James Gurney: *On Stranger Tides* (novel by Tim Powers, Ace)
David Mattingly: *The Rapture Effect* (novel by Jeffrey A. Carver, Tor)

Michael Whelan: *Being a Green Mother* (novel by Piers Anthony, Ballantine Del Rey)

COVER ILLUSTRATION, PAPERBACK
Roger Bergendorff: *Across the Sea of Suns* (novel by Gregory Benford, Bantam Spectra)
Jim Burns: *The River of Time* (novel by David Brin, Bantam Spectra)
Bob Eggleton: *The Manse* (novel by Lisa W. Cantrell, Tor)
Don Maitz: *Wizard War* (novel by Hugh Cook, Questar)
David Mattingly: *Angels in Hell* (novel by Janet Morris, Baen)
Michael Whelan: *In Conquest Born* (novel by C.S. Friedman, DAW)

COVER ILLUSTRATION, MAGAZINE
Hank Jankus: *Amazing Stories*, May 1987
Terry Lee: *Amazing Stories*, January 1988

INTERIOR ILLUSTRATION
Janet Aulisio: *A Bomb in the Head* (story by David E. Cortesi, *Amazing Stories*, May 1987)
Janet Aulisio: *Analog*, August, 1987
Etienne Sadorfi: *Omni*, May 1987

COLOUR WORK, UNPUBLISHED
Patricia Davis: *Tomorrow*
Carl Lundgren: *The Thing on Jenny's Barn*
Don Maitz: *Conjure Maitz*

MONOCHROME WORK, UNPUBLISHED
Ingrid Neilson: *Sherlock Bones*
Dawn Wilson: *Queen of the Snows*

THREE-DIMENSIONAL WORK
John Longendorfer: *Hawk Mountain*

ARTISTIC ACHIEVEMENT
Thomas Canty
Frank Frazetta
Rusty Hevelin
Michael Whelan

CONTRIBUTION TO ASFA
Matt Fertig
Jan Sherrell Gephardt
Ingrid Neilson
Richard Pini

1989

COVER ILLUSTRATION, HARDCOVER
Thomas Canty: *The White Raven* (novel by Diana L. Paxson, Morrow)
Will Cormier: *Mona Lisa Overdrive* (novel by William Gibson, Bantam Spectra)
Mark Harrison: *The Story of the Stone* (novel by Barry Hughart, Doubleday Foundation)
Don Maitz: *Cyteen* (novel by C.J. Cherryh, Warner)
Michael Whelan: *Catspaw* (novel by Joan D. Vinge, Warner)

COVER ILLUSTRATION, PAPERBACK
Richard Bober: *The Storyteller and the Jann* (novel by Stephen Goldin, Bantam Spectra)

Bob Eggleton: *Necroscope* (novel by Brian Lumley, Tor)
Stephen Hickman: *The Vang: The Military Form* (novel by Christopher B. Rowley, Ballantine Del Rey)
Jody Lee: *The Oathbound* (novel by Mercedes Lackey, DAW)
Dean Morrissey: *Moon Dreams* (novel by Brad Strickland, Signet)

COVER ILLUSTRATION, MAGAZINE
Bob Eggleton: *Amazing Stories*, September 1988
Bob Eggleton: *The Limit of Vision* (story by John Barnes, *Asimov's*, July 1988)
Gary L. Freeman: *Gilgamesh in Uruk* (story by Robert Silverberg, *Asimov's*, June 1988)
Hank Jankus: *Put Your Hands Together* (story by O. Niemand), *Asimov's*, February 1988

INTERIOR ILLUSTRATION
Janet Aulisio: *Long Song* (story by J. Brian Clarke, *Analog*, August 1988)
Lela Dowling: *Faerie Tale* (novel by Raymond E. Feist, Hill House)
Larry Elmore: *Rose of the Prophet: The Will of the Wanderer* (novel by Margaret Weis and Tracy Hickman, Bantam Spectra)
Alan Lee: *Merlin Dreams* (collection by Peter Dickinson, Gollancz)
Bob Walters: *Father to the Man* (story by Timothy Robert Sullivan, *Asimov's*, October 1988)

COLOUR WORK, UNPUBLISHED
Lari Dietrick: *Lady of the Lake*
Lela Dowling: *Sarah's Friend*
James Gurney: *Waterfall City*
Carl Lundgren: *Getting Colder*

MONOCHROME WORK, UNPUBLISHED
Alicia Austin: *The Reading Lesson*
Brad Foster: *Night Floater*
Dell Harris: *A Moon Over Atlantis*

THREE-DIMENSIONAL WORK
Guy Frechette: *Solitaire's Throne*
John A. Morrison: *Metropolis*
Nevenah Smith: *The Divine Comedy – Circle of Lovers*

ARTISTIC ACHIEVEMENT
Alicia Austin
Thomas Canty
James Gurney
Stephen Hickman
Don Maitz
Michael Whelan

CONTRIBUTION TO ASFA
David Cherry
Carol Donner
Matt Fertig
Jan Sherrell Gephardt
Teresa Patterson

1990

COVER ILLUSTRATION, HARDCOVER
Don Dixon: *Nemesis* (novel by Isaac Asimov, Doubleday)
Carol Heyer: *Beauty and the Beast* (story by Carol Heyer, Ideals)
Keith Parkinson: *Rusalka* (novel by C.J. Cherryh, Ballantine Del Rey)
Gary Ruddell: *Hyperion* (novel by Dan Simmons, Doubleday Foundation)
Michael Whelan: *Paradise* (novel by Mike Resnick, Tor)

COVER ILLUSTRATION, PAPERBACK
Thomas Canty: *The Silver Branch* (novel by Patricia Kenneady, Signet)
James Gurney: *Quozl* (novel by Alan Dean Foster, Ace)
Richard Hescox: *The Gate of Ivory* (novel by Doris Egan, DAW)
Stephen Hickman: *Gryphon* (novel by Crawford Killian, Ballantine)
Jody Lee: *Magic's Pawn* (novel by Mercedes Lackey, DAW)

COVER ILLUSTRATION, MAGAZINE
Bob Eggleton: *Amazing Stories*, March 1989
A.C. Farley: *Asimov's*, September 1989
Gervasio Gallardo: *Omni*, January 1989
Nicholas Jainschigg: *Asimov's*, June 1989
Frank Kelly Freas and Laura Brodian Kelly-Freas: *Scribe* (story "The Book of Souls" by Jason Van Hollander, *Marion Zimmer Bradley's Fantasy Magazine*, Fall 1989)

INTERIOR ILLUSTRATION
Janet Aulisio: *Date Night* (story by Robert R. Chase, *Analog*, June 1989)
James Gurney: *Quozl* (novel by Alan Dean Foster, Ace)
Todd Cameron Hamilton: *Dragonlover's Guide to Pern* (nonfiction book by Jody Lynn Nye and Anne McCaffrey, Ballantine Del Rey)
Carol Heyer: *Jim-Bob and the Alien* (serial by T. Serio and Vivian Vande Velde, *Aboriginal Science Fiction*, May-June 1989)
Courtney Skinner: *Eating Memories* (serial by Patricia Anthony, *Aboriginal Science Fiction*, May-June 1989)

COLOUR WORK, UNPUBLISHED
David A. Cherry: *A Stitch in Time*
Todd Cameron Hamilton: *The Guardsmen*
Tom Kidd: *Winsor McCay City*
Dean Morrissey: *Reef Window*
Michael Whelan: *Passage the Red Step*

MONOCHROME WORK, UNPUBLISHED
Holly Bird: *Gyr-Falcon*
Rick Lowry: *Bad Moon Rising*
Ruth Thompson: *The Guardian*
Dawn Wilson: *Grandmother White Condor*

THREE-DIMENSIONAL WORK
Guy Frechette: *The Last Warrior*
Clayburn Moore: *Emerald Passage*
Robert Pitz: *Flying King Cabinet*
Arlin Robins: *Wave Borne*
Nevenah Smith: *The Divine Comedy*

ART DIRECTOR
Joe Curcio, Tor
Dwayne Flinchum, *Omni*
Diane Luger, Ace/Berkley
Jamie Warren, Bantam Spectra
Betsy Wollheim and Shiela Gilbert, DAW

ARTISTIC ACHIEVEMENT
Susan Seddon Boulet
Jody Lee
Don Maitz
Real Musgrave
Kim Poor/Nova Graphics
Darrell K. Sweet

CONTRIBUTION TO ASFA
David A. Cherry
Maurine Dorris

Matt Fertig
Erin McKee
Teresa Patterson

1991

COVER ILLUSTRATION, HARDCOVER
Bob Eggleton: *Queen of Angels* (novel by Greg Bear, Questar)
Don Maitz: *Servant of the Empire* (novel by Raymond E. Feist and Janny Wurts, Foundation)
Keith Parkinson: *Chernevog* (novel by C.J. Cherryh, Del Rey)
Keith Parkinson: *The Ruby Knight* (novel by David Eddings, Del Rey)
Gary Ruddell: *The Hemingway Hoax* (novel by Joe Haldeman, Morrow)

COVER ILLUSTRATION, PAPERBACK
Carol Heyer: *Darkhold* (novel by Jerry Earl Brown, TSR)
Jody Lee: *Magic's Price* (novel by Mercedes Lackey, DAW)
Don Maitz: *Magic Casement* (novel by Dave Duncan, Del Rey)
Dorian Vallejo: *Silent Dances* (novel by A.C. Crispin and Kathleen O'Malley, Ace)
Michael Whelan: *The Madness Season* (novel by C.S. Friedman, DAW)
Michael Whelan: *The Martian Chronicles* (collection by Ray Bradbury, Spectra)

COVER ILLUSTRATION, MAGAZINE
Donald Clavette: *Science Fiction Chronicle*, June 1990
Bob Eggleton: *Aboriginal Science Fiction*, January 1990
Carol Heyer: *Dragon*, May 1990
Stephen Gervais: *The Magazine of Fantasy & Science Fiction*, April 1990
Todd Cameron Hamilton: *Analog*, September 1990

INTERIOR ILLUSTRATION
Janet Aulisio: *Wanderers* (story by Alexis G. Latner, *Analog*, June 1990)
Carol Heyer: *Zeus & Aphrodite* (*Legends & Lore*, TSR)
Val Lakey Lindahn: *The Flowers, the Birds, the Leaves, the Bees* (story by L.A. Taylor, *Analog*, June 1990)
Bob Walters: *Trembling Earth* (story by Allen Steele, *Asimov's*, November 1990)
Patrick Woodroffe: *Balook* frontispiece (novel by Piers Anthony, Underwood-Miller)

COLOUR WORK, UNPUBLISHED
Doug Chaffee: *Above Top Secret*
David Cherry: *Simple Pleasures*
Dean Morrissey: *Charting the Skies*
Janny Wurts: *Master of Whitestorm*

THREE-DIMENSIONAL WORK
James C. Christensen: *The Fishwalker*
Kim Fiebiger: *Airiana*
Bettyann Gaurino: *Eldritch Dreams*

ARTISTIC ACHIEVEMENT
Wayne Barlowe, for *Daggerwrist* from *Expedition* (illustrated book by Wayne Barlowe, Workman)
James Gurney, for *Dinosaur Parade* (Greenwich Workshop)
Richard Hescox
Stephen Hickman, for *The Fantasy Art of Stephen Hickman* (Donning)
Michael Whelan

ART DIRECTOR
Diane Luger, Ace

Don Munson, Ballantine/Del Rey
Don Puckey, Warner/Questar
Jamie Warren-Youll, Foundation/Spectra
Betsy Wollheim & Sheila Gilbert, DAW

CONTRIBUTION TO ASFA
Beth Avary
David Cherry
Erin McKee and Bettyann Guarino
Wilma Meier
Elizabeth Pearse

1992

COVER ILLUSTRATION, HARDCOVER
Mark Harrison: *Eight Skilled Gentlemen* (novel by Barry Hughart, Doubleday Foundation)
Keith Parkinson: *Yvgenie* (novel by C.J. Cherryh, Ballantine Del Rey)
Kirk Reinert: *Imajica* (novel by Clive Barker, HarperCollins)
Michael Whelan: *All the Weyrs of Pern* (novel by Anne McCaffrey, Ballantine Del Rey)
Michael Whelan: *The Summer Queen* (novel by Joan D. Vinge, Warner Questar)

COVER ILLUSTRATION, PAPERBACK
Doug Anderson: *Alien Minds* (novel by Keith Laumer, Baen)
David A. Cherry: *Sword & Sorceress VIII* (anthology edited by Marion Zimmer Bradley, DAW)
Jody Lee: *Wild Magic* (novel by Jo Clayton, DAW)
Don Maitz: *Emperor and Clown* (novel by Dave Duncan, Ballantine Del Rey)
Don Maitz: *Mythology Abroad* (novel by Jody Lynn Nye)

COVER ILLUSTRATION, MAGAZINE
Vincent Di Fate: *Analog*, August 1991
Frank Kelly Freas: *Analog*, December 1991
Nicholas Jainschigg: *Analog*, March 1991
Adrian Kleinbergen: *On Spec*, Spring 1991
David Mattingly: *Amazing Stories*, September 1991

INTERIOR ILLUSTRATION
Vincent Di Fate: *Rescue Run* (story by Anne McCaffrey, *Analog*, August 1991)
Laura Kelly-Freas: *Haut-Clare* (story by Eluki bes Shahar, *Marion Zimmer Bradley's Fantasy Magazine*, Summer 1991)
Alan Lee: *The Lord of the Rings* (novel by J.R.R. Tolkien, Unwin)
Bob Walters: *It Grows on You* (story by Stephen King, *Weird Tales*, Summer 1991)
William R. Warren Jr: *A Bargain at Any Price* (story by Grey Rollins, *Analog*, May 1991)

COLOUR WORK, UNPUBLISHED
David A. Cherry: *Filia Mea*
James C. Christensen: *Once Upon a Time*
Joe DeVito: *The Further Adventures of Wonder Woman*
Todd Cameron Hamilton: *Skytouchers*
Dawn Wilson: *Song of the Dead*

MONOCHROME WORK, UNPUBLISHED
Michael Whelan: *Weyrworld*

THREE-DIMENSIONAL WORK
Clayburn Moore: *Celestial Jade*

ART DIRECTOR
Betsy Wollheim and Sheila Gilbert, DAW

ARTISTIC ACHIEVEMENT
James Gurney

CONTRIBUTION TO ASFA
Jan Sherrell Gephardt
Richard Kelly

1993

COVER ILLUSTRATION, HARDCOVER
Den Beauvais: *The Dragon at War* (novel by Gordon R. Dickson, Ace)
Don Maitz: *Magician: Apprentice* (novel by Raymond E. Feist, Doubleday)
Barclay Shaw: *The False Mirror* (novel by Alan Dean Foster, Del Rey)
Dorian Vallejo: *The California Voodoo Game* (novel by Larry Niven and Steven Barnes, Del Rey)
Michael Whelan: *Illusion* (novel by Paula Volsky, Bantam Spectra)

COVER ILLUSTRATION, PAPERBACK
Jim Burns: *Artificial Things* (novel by Karen Joy Fowler, Bantam Spectra)
David Cherry: *Sword & Sorceress IX* (anthology edited by Marion Zimmer Bradley, DAW)
David Mattingly: *The Nine Lives of Catseye Gomez* (novel by Simon Hawke, Warner/Questar)
Mel Odom: *In the Blood* (novel by Nancy A. Collins, Roc)
Stephen Youll: *Speaking in Tongues* (novel by Ian McDonald, Bantam Spectra)

COVER ILLUSTRATION, MAGAZINE
John Berkey: *Omni*, October 1992
Jim Burns: *Poles Apart* (story by G. David Nordley, *Analog*, Mid-December 1992)
Bob Eggleton: *Weird Tales*, Summer 1992
Hajime Sorayama: *Omni*, March 1992
Michael Whelan: *Monument* (*Asimov's*, November 1992)

INTERIOR ILLUSTRATION
Alicia Austin: *Fur Magic* (ten colour interiors plus spot black-and-white illustrations)
Alan M. Clark: *Poles Apart* (story by G. David Nordley, *Analog*, Mid-December 1992)
Frank Kelly Freas: *Surface Wars* (story by Jack Massa, *Amazing Stories*, November 1992)
Laura Brodian Kelly Freas: *The White Snake* (story by Mary Gray, *Marion Zimmer Bradley's Fantasy Magazine*, Fall 1992)
Bob Walters: *The Way to Spook City* (*Playboy*, August 1992)

COLOUR WORK, UNPUBLISHED
Rosanna Azar: *Wisdom*
Lisa Hunt: *Tsarina of the Snows*
Tom Kidd: *Peale's New York Penthouse*
Carl Lundgren: *Channels*
Michael Whelan: *Subterraneans*
Janny Wurts: *The Wizard of Owls*

MONOCHROME WORK, UNPUBLISHED
Holly Bird: *The Blessed Damozel*
David Cherry: *Tag, You're It*
Lawrence Allen Williams: *Deadly Intentions*

THREE-DIMENSIONAL WORK
Robert Ashton: *The Earth Our Mother . . . The Stars Our Destiny*
Joel Hagen: *Alien Skull*
Guy Frechette: *Chess Table*

Clayburn Moore: *Prise der Fer*
Gary Persello: *Reflection*

ART DIRECTOR
Terry Czeczko, *Analog* and *Asimov's*
Kim Mohan, *Amazing Stories*
Don Puckey, Warner
Ruth Ross, Del Rey
Jamie Warren Youll, Bantam

ARTISTIC ACHIEVEMENT
Alicia Austin
H.R. Giger
James Gurney
William Stout
Ron Walotsky

CONTRIBUTION TO ASFA
Rae Dethlefsen and Scott Merritt
Maurine Dorris
Michelle Lundgren
Ingrid Neilson
David Lee Pancake

1994

COVER ILLUSTRATION, HARDCOVER
Thomas Canty: *Snow White, Blood Red* (anthology edited by Ellen Datlow and Terry Windling, AvoNova)
Frank Kelly Freas: *The Wishing Season* (novel by Esther Friesner, Atheneum)
Tom Kidd: *The Far Kingdoms* (novel by Chris Bunch and Allen Cole, Del Rey)
Jody Lee: *Winds of Fury* (novel by Mercedes Lackey, DAW)
Don Maitz: *Rude Astronauts* (novel by Allen Steele, Old Earth)

COVER ILLUSTRATION, PAPERBACK
Jim Burns: *His Conquering Sword* (novel by Kate Elliott, DAW)
Bob Eggleton: *Dragons* (anthology edited by Jack Dann and Gardner Dozois, Ace)
Michael Parks: *Omni Best SF 3* (anthology edited by Ellen Datlow, Omni Books)
Kirk Reinert: *Hottest Blood* (anthology edited by Jeff Gelb and Michael Garrett, Pocket)
Stephen Youll: *Gojiro* (novel by Mark Jacobson, Bantam Spectra)

COVER ILLUSTRATION, MAGAZINE
Jim Burns: *Analog*, December 1993
Clyde Duensing and Carl Lundgren: *Aboriginal Science Fiction*, Summer 1993
Frank Kelly Freas: *Amazing Stories*, March 1993
Stephen Hickman: *Science Fiction Age*, May 1993
Wojtek Sludmak: *Asimov's*, December 1993

INTERIOR ILLUSTRATION
Alan M. Clark: *The Toad of Heaven* (story by Robert Reed, *Asimov's*, June 1993)
Vincent Di Fate: *Incident at The Angel of Boundless Compassion* (story by Mark O. Halverson, *Analog*, June 1993)
Leo and Diane Dillon: *The Sorcerer's Apprentice* (children's book by Nancy Willard, Scholastic/Sky Blue Press)
James Mahon: *Fox Magic* (story by Kij Johnson, *Asimov's*, December 1993)
Ron Walotsky: *Goldilocks and the Virtual Bears* (poem by W. Gregory Stewart, *Amazing Stories*, January 1993)

COLOUR WORK, UNPUBLISHED
Bob Eggleton: *Orcaurora*
James Gurney: *Garden of Hope*
Richard Hescox: *Song of the Siren*
Tom Kidd: *Szukalski Sculpture Garden*
Nathan Massengill: *Copper Graphic*
Hannah Shapero: *Alkyris, City of Dreams*
Michael Whelan: *The Leavetaking*

MONOCHROME WORK, UNPUBLISHED
Rob Alexander: *Deathscape*
Carl Lundgren: *Impudence*
Michael Whelan: *The Apotheosis of War*

THREE-DIMENSIONAL WORK
Robert Ashton: *View Through Gandalf's Crystal*
John Longendorfer: *Once There Were Giants*
Clayburn Moore: *Hannah and the Saber Tooth*
Ron Walotsky: *Ancient Warrior Mask*
Jennifer Weyland: *Flying Pegasus and Rider*

ART DIRECTOR
Terry Czeczko, *Analog* and *Asimov's*
Ron McCutchen, *Cricket* and *Spider*
Kim Mohan, *Amazing Stories*
Betsy Wollheim and Sheila Gilbert, DAW
Jamie Warren Youll, Bantam

ARTISTIC ACHIEVEMENT
Susan Seddon Boulet
James Christensen
Leo and Diane Dillon
Frank Kelly Freas
Ron Walotsky
Michael Whelan

CONTRIBUTION TO ASFA
Holly Bird
Carl Lundgren
Michelle Lundgren
David Lee Pancake
Teresa Patterson and Pegasus Management Crew

1995

COVER ILLUSTRATION, HARDCOVER
Den Beauvais: *The Dragon, the Earl, and the Troll* (novel by Gordon R. Dickson, Ace)
Jody Lee: *Storm Warning* (novel by Mercedes Lackey, DAW)
Ron Walotsky: *2001: A Space Odyssey* (novel by Arthur C. Clarke, G.K. Hall)
Michael Whelan: *Foreigner* (novel by C.J. Cherryh, DAW)
Janny Wurts: *The Curse of the Mistwraith* (novel by Janny Wurts, HarperCollins UK)

COVER ILLUSTRATION, PAPERBACK
Braidt Bralds: *CatFantastic III* (anthology edited by Andre Norton and Martin H. Greenberg, DAW)
Alan M. Clark: *Geckos* (novel by Carrie Richerson, Roadkill)
Leo and Diane Dillon: *The Lion, the Witch and the Wardrobe* (novel by C.S. Lewis, HarperPaperbacks)
Jody Lee: *Witch and Wombat* (novel by Carolyn Cushman, Warner Questar)

COVER ILLUSTRATION, MAGAZINE
Bob Eggleton: *Soon Comes the Night* (story by Gregory Benford, *Asimov's*, August 1994)
Mark Harrison: *The God who Slept with Women* (story by Brian W. Aldiss, *Asimov's*, May 1994)

John Maggard: *Hurricane!* (story by Bud Sparhawk, *Analog*, September 1994)
Chris Moore: *The Height of Intrigue* (story by Stephen Goldin, *Analog*, November 1994)
Wojtek Siudmak: *Evolution* (story by Grey Rollins, *Analog*, December 1994)

INTERIOR ILLUSTRATION
Rob Alexander: *Poseidon's Daughter* (*Duelist* #6, August 1995)
Susan Seddon Boulet: *Buffalo Gals, Won't You Come Out Tonight?* (collection by Ursula K. LeGuin, Pomegranate)
Alan M. Clark: *Starmind* (novel by Spider Robinson and Jeanne Robinson, Ace)
Larry Dixon: *The Black Gryphon* (novel by Mercedes Lackey and Larry Dixon, DAW)
Brian Froud: *Lady Cottington's Pressed Fairy Book* (book by Terry Jones and Brian Froud, Pavilion)
Jonathan and Lisa Hunt: *Werewolves of Luna* (story by R. Garcia y Robertson, *Asimov's*, December 1994)

COLOUR WORK, UNPUBLISHED
Alan M. Clark: *The Pain Doctors of Suture Self General*
Mark Harrison: *Leyak-Legong*
Don Maitz: *Silver Lining*
Kevin Murphy: *Void Engineers*
Susan Van Camp: *Midnight Medusa*

MONOCHROME WORK, UNPUBLISHED
Lisa Hunt: *Moondance*
Rick Lieder: *Escape of the Smoke Nuisance*
Carl Lundgren: *Promise*
Jeff Pitarelli: *Julie's Nightmare*

THREE-DIMENSIONAL WORK
Robert Ashton: *Through the Eye of the Wizard*
Jeff Coleman: *Chinese Demon*
Lee Dillon: *Narnia*
Clayburn Moore: *Pit*
Lisa Snellings: *Don't Ask Jack*

ART DIRECTOR
Cathy Burnett and Arnie Fenner, Spectrum Design
Gene Mydlowski, HarperCollins
Ruth Ross, Del Rey
Carol Russo, Warner
Betsy Wollheim and Sheila Gilbert, DAW

ARTISTIC ACHIEVEMENT
Jim Burns
Frank Frazetta
Brian Froud
Jael
Gahan Wilson

CONTRIBUTION TO ASFA
Holly Bird
Howard Frank/Network General Corp.
David Lee Pancake
Diana Harlan Stein
Janny Wurts

1996

COVER ILLUSTRATION, HARDCOVER
Bob Eggleton: *Cthulhu 2000* (anthology edited by Jim Turner, Arkham)
Tom Kidd: *Kingdoms of the Night* (novel by Chris Bunch and Allan Cole, Ballantine Del Rey)
Charles Vess: *A Sorcerer and a Gentleman* (novel by Elizabeth Willey, Tor)

Ron Walotsky: *Temporary Agency* (novel by Rachel Pollack, St Martin's)
Michael Whelan: *Invader* (novel by C.J. Cherryh, DAW)

COVER ILLUSTRATION, PAPERBACK
Newell Convers and Courtney Skinner: *The Printer's Devil* (novel by Chico Kidd, Baen)
Daniel Craig: *Regenesis* (novel by Julia Ecklar, Ace)
Donato Giancola: *Lethe* (novel by Tricia Sullivan, Bantam Spectra)
Jody Lee: *Hunter's Oath* (novel by Michelle West, DAW)
Don Maitz: *A Farce to be Reckoned With* (novel by Roger Zelazny and Robert Sheckley, Bantam Spectra)

COVER ILLUSTRATION, MAGAZINE
Jim Burns: *Final Review* (story by G. David Nordley, *Analog*, July 1995)
Bob Eggleton: *Tide of Stars* (story by Julia Ecklar, *Analog*, January 1995)
Bob Eggleton: *Marion Zimmer Bradley's Fantasy Magazine*, Summer 1995
Hajime Sorayama: *Omni*, Fall 1995
Ron Walotsky: *The Spine Divers* (story by Ray Aldridge, *The Magazine of Fantasy & Science Fiction*, June 1995)

INTERIOR ILLUSTRATION
Bob Eggleton: *Hero* (story by Stephen Baxter, *Asimov's*, January 1995)
Darryl Elliott: *The Doryman* (story by Mary Rosenblum, *Asimov's*, December 1995)
James Gurney: *Dinotopia: The World Beneath* (Turner)
Todd Lockwood: *Thorns* (story by Martha Wells, *Realms of Fantasy*, June 1995)
Ron Walotsky: *The Crystal Palace of Adamas* (children's book by Richard M. Wainwright, Family Life Publishing)

COLOUR WORK, UNPUBLISHED
Stephen Hickman: *The Archers*
David Martin: *Heart of Thunder*
Dennis Nolan: *Pan*
Ezra Tucker: *Return of the Titans*
Michael Whelan: *Malthusian Wave*

MONOCHROME WORK, UNPUBLISHED
Frank Frazetta: *Vampirella*
Todd Lockwood: *Cerberus*

THREE-DIMENSIONAL WORK
Clayburn Moore: *Lady Death*
Barclay Shaw: *Ellison Wonderland Chess Table*
Lisa Snellings: *This Wheel, Too, Goes Round*
Ron Walotsky: *Ancient Warrior*
Jennifer Weyland: *Lightning*

ART DIRECTOR
Gene Mydlowski, HarperCollins
Tom Staebler, *Playboy*
David Usher, The Greenwich Workshop
Betsy Wollheim and Sheila Gilbert, DAW
Jamie Warren Youll, Bantam Spectra

ARTISTIC ACHIEVEMENT
Thomas Canty
Roger Dean
Leo and Diane Dillon
Bob Eggleton
Hajime Sorayama

CONTRIBUTION TO ASFA
Ingrid Neilson

1997

COVER ILLUSTRATION, HARDCOVER
Kinuko Y. Craft: *Winter Rose* (novel by Patricia A. McKillip, Ace)
Leo and Diane Dillon: *Sabriel* (novel by Garth Nix, HarperCollins)
Barclay Shaw: *The Ringworld Throne* (novel by Larry Niven, Ballantine Del Rey)
Michael Whelan: *The Golden Key* (novel by Melanie Rawn, Jennifer Roberson and Kate Elliott, DAW)
Stephen Youll: *Cloud's Rider* (novel by C.J. Cherryh, Warner Aspect)

COVER ILLUSTRATION, PAPERBACK
Donato Giancola: *Eggheads* (novel by Emily Devenport, Penguin/Roc)
Stephen Hickman: *The Gates of Twilight* (novel by Paula Volsky, Bantam Spectra)
John Howe: *Castle Fantastic* (anthology edited by John DeChancie and Martin H. Greenberg, DAW)
Ron Walotsky: *Unknown Regions* (novel by Robert Holdstock, vt *The Fetch*, Roc)
Michael Whelan: *Royal Assassin* (novel by Robin Hobb, Bantam)
Stephen Youll: *Exile's Children* (novel by Angus Wells, Bantam Spectra)

COVER ILLUSTRATION, MAGAZINE
Brom: *Realms of Fantasy*, April 1996
Jim Burns: *Analog*, October 1996
Vincent Di Fate: *Analog*, April 1996
Bob Eggleton: *Airborn* (story by Nina Kiriki Hoffman, *The Magazine of Fantasy & Science Fiction*, May 1996)
Todd Lockwood: *Gas Fish* (story by Mary Rosenblum, *Asimov's*, February 1996)
Ian Miller: *Worlds of Fantasy & Horror #3*
Wojtek Siudmak: *Asimov's*, May 1996

INTERIOR ILLUSTRATION
James Christensen: *The Voyage of the Bassett* (book by James Christensen, Renwick St James and Alan Dean Foster, Artisian)
Darryl Elliott: *Blood of the Dragon* (story by George R.R. Martin, *Asimov's*, July 1996)
Brian Froud: *Strange Stains and Mysterious Smells* (book by Terry Jones and Brian Froud, Simon & Schuster)
Todd Lockwood: *Death Loves Me* (story by Tanith Lee, *Realms of Fantasy*, August 1996)
Don Maitz: *Desperation* (novel by Stephen King, Donald M. Grant)
Dennis Nolan: *William Shakespeare's A Midsummer Night's Dream* (children's retelling by Bruce Coville, Dial)

COLOUR WORK, UNPUBLISHED
Rob Alexander: *Sinja's World*
Richard Hescox: *Aurora*
Carl Lundgren: *No Blood . . . So Far*
David Martin: *Haida*
Michael Whelan: *Lumen 4*

MONOCHROME WORK, UNPUBLISHED
Joy Marie Ledet: *Twig*
Todd Lockwood: *Kali*
Jeff Pitarelli: *Julie II*
Sheila Rayyan: *Raven-Haired Beauty*
Davette Shands: *Waiting for Antony*

THREE-DIMENSIONAL WORK
Clayburn Moore and Frank Frazetta: *Princess*
Real Musgrave: *Pillow Fight*

J.A. Pippett: *Time Bandit*
Lisa Snellings: *Crowded After Hours*
Jennifer Weyland: *Pegasus*

ART DIRECTOR
Maria Cabardo, Wizards of the Coast
Terri Czeczko, *Asimov's*
Stephen Daniele, TSR
Carl Gnam, *Science Fiction Age*
Jamie Warren Youll, Bantam

ARTISTIC ACHIEVEMENT
Stephen Hickman
Greg and Tim Hildebrandt
Ralph McQuarrie
Don Maitz
Real Musgrave

CONTRIBUTION TO ASFA
Jon Gustafson
Kim Anne Innes
Don Maitz
Teresa Patterson and Scott Merritt
Jeff Watson

1998

COVER ILLUSTRATION, HARDCOVER
Alan M. Clark: *Things Left Behind* (novel by Gary Braunbeck, CD Publications)
Bob Eggleton: *The Howling Stones* (novel by Alan Dean Foster, Del Rey)
Don Maitz: *Corum: The Coming of Chaos* (omnibus by Michael Moorcock, White Wolf)
John Jude Palencar: *Lady of Avalon* (novel by Marion Zimmer Bradley, Viking)
Michael Whelan: *The Mageborn Traitor* (novel by Melanie Rawn, DAW)

COVER ILLUSTRATION, PAPERBACK
Tom Canty: *Competitions* (novel by Sharon Green, AvoNova)
Michael Dashow: *The Rhinoceros Who Quoted Nietzsche and Other Odd Acquaintances* (collection by Peter S. Beagle, Tachyon)
Jody Lee: *The Stone Prince* (novel by Fiona Patton, DAW)
Todd Lockwood: *The Wayward Knights* (novel by Roland Green, TSR)
Don Maitz: *Merlin's Harp* (novel by Anne Eliot Crompton, Roc)
John Jude Palencar: *Jovah's Angel* (novel by Sharon Shinn, Ace)
Stephen Youll: *A Game of Thrones* (novel by George R.R. Martin, Bantam)

COVER ILLUSTRATION, MAGAZINE
Olivia De Berardinis, *Heavy Metal*, May 1997
Bob Eggleton, *O Pioneer!* (serial by Frederik Pohl, *Analog*, October 1997)
Todd Lockwood, *Black Dragon* (*Dragon*, August 1997)
Don Maitz, *Realms of Fantasy*, April 1997
Barclay Shaw, *The Magazine of Fantasy & Science Fiction*, April 1997

INTERIOR ILLUSTRATION
Rick Berry, *Repent Harlequin, Said the Ticktockman* (chapbook by Harlan Ellison, Underwood)
Tom Canty, *The Queen of Hearts* (*Fractures in Rhyme*, Art Against AIDS Project)
John Howe, *A Diversity of Dragons* (nonfiction book by Anne McCaffrey and Richard Woods, HarperPrism)
Nicholas Jainschigg: *Grey* (story by Mercedes Lackey,

Marion Zimmer Bradley's Fantasy Magazine, Autumn 1997)
Alan Lee: *The Hobbit* (novel by J.R.R. Tolkien, Houghton Mifflin)
Todd Lockwood: *On the Inside* (story by Robert Silverberg, *Science Fiction Age*, November 1997)

COLOUR WORK, UNPUBLISHED
Greg and Tim Hildebrandt: *Michael the Archangel*
Stephen Hickman: *The Astronomer Prince*
Don Maitz, *Chasing the Wind*
Jennifer Emmett Weyland, *Perrin, Queen of Autumn*

MONOCHROME WORK, UNPUBLISHED
Charles Keegan: *Teenage Angst*
Richard Kirk: *Mr. Buttons*
Joy Marie Ledat: *Silently Moving People*
Erin McKee: *Harlequin*
Stanley W. Morrison: *The Hatchling*
Jeff Pitarelli: *Callisto*

THREE-DIMENSIONAL WORK
Daniel Horne: *Gandalf the Gray*
Clayburn Moore: *Witchblade*
J.A. Pippett: *Reach*
Laura Reynolds: *Princess Holly*
Schiflett Brothers: *Dragonheart*

ART DIRECTOR
Warren Lapine, DNA Publications
Don Puckey, Warner
David Stevenson, Ballantine
Matt Wilson, Wizards of the Coast
Jamie Warren Youll, Bantam

ARTISTIC ACHIEVEMENT
Olivia De Berardinis
Rick Berry
Vincent Di Fate
Alan Lee
Syd Mead
John Jude Palencar
Bernie Wrightson

CONTRIBUTION TO ASFA
Jane Frank, Worlds of Wonder
Todd Lockwood
Morgana
Teresa Patterson
Janny Wurts

1999

COVER ILLUSTRATION, HARDCOVER
Jim Burns: *Darwinia* (novel by Robert Charles Wilson, Tor)
Kinuko Y. Craft: *Song for the Basilisk* (novel by Patricia A. McKillip, Ace)
Bob Eggleton: *The Last Dragon Lord* (novel by Joanne Bertin, Tor)
Donato Giancola: *Icefalcon's Quest* (novel by Barbara Hambly, Del Rey)
Michael Whelan: *Otherland: River of Blue Fire* (novel by Tad Williams, DAW)

COVER ILLUSTRATION, PAPERBACK
Michael Dashow: *The Boss in the Wall* (novel by Avram Davidson and Grania Davis, Tachyon)
Donato Giancola: *Five Worlds #3: Return* (novel by Al Sarrantonio, Roc)
Stephen Hickman: *Star Child* (novel by James P. Hogan, Baen)
Pamela Lee: *Dreaming in Smoke* (novel by Tricia Sullivan, Bantam Spectra)

John Jude Palencar: *Tales of the Cthulhu Mythos* (anthology edited by Anonymous, Del Rey)
Walter Velez: *The Flying Sorcerers* (anthology edited by Peter Haining, Ace)

COVER ILLUSTRATION, MAGAZINE
Jill Bauman: *The Magazine of Fantasy & Science Fiction*, July 1998
Brom: *Dungeon*, #70
Jim Burns: *Analog*, April 1998
Bob Eggleton: *The Magazine of Fantasy & Science Fiction*, May 1998
Chris Moore: *Science Fiction Age*, March 1998
Wojtek Siudmak: *Asimov's*, April 1998

INTERIOR ILLUSTRATION
Jill Bauman: *Darker Than You Think* (novel by Jack Williamson, Easton Press)
Kinuko Y. Craft: *Pegasus* (children's book by Marianna Mayer, Morrow)
Bob Eggleton: *The Book of Sea Monsters* (illustrated book by Bob Eggleton and Nigel Suckling, Paper Tiger)
Brian Froud: *Good Faeries/Bad Faeries* (illustrated book by Brian Froud and Terri Windling, Simon & Schuster)
Chris Moore: *Founding Fathers* (story by Stephen Dedman, *Science Fiction Age*, March 1998)

COLOUR WORK, UNPUBLISHED
Bob Eggleton: *Rage & Despair*
Marc Fishman: *Salvation*
Stephen Hickman: *Pharazar*
Jael: *Family Personalitrees*
Charles Lang: *Solo at Sunset*
Don Maitz: *Far From Home*
John Jude Palencar: *Storm Worship/The Storm Twins*

MONOCHROME WORK, UNPUBLISHED
Beryl Bush: *Bottom and Titania*
H. Ed Cox: *A Hard Act to Follow*
Stephen Daniele: *Griffon Rider*
Joy Marie Ledet: *Aisling*

THREE-DIMENSIONAL WORK
Randy Bowen: *Bionica*
Halla Fleischer: *Basil the Basilisk Tries a Breathmint*
Barsom Manashian: *Miss Muffet* (based on a painting by Brom)
Laura Reynolds: *Isengrim*
Lisa Snellings: *A Short Trip to October*

GAMING-RELATED ILLUSTRATION
Brom: *Plainscape: The Inner Plains*
Todd Lockwood: *DragonLance Classics 15th Anniversary Game Module*
Terese Nielsen: *Ertai, Wizard Adept* (Magic™ card)
R.K. Post: *Alternity: Player's Handbook*

PRODUCT ILLUSTRATION
Donato Giancola: *Archangel* (Magic™ cards package art)
Todd Lockwood: *Dragonlance 5th Age Calendar* (cover art)
John Jude Palencar: *The Truth About Myths & Monsters* (billboard art, National Geographic Channel)
Pixar Studios: *A Bug's Life* (movie poster)
Blizzard Entertainment: *Starcraft* (computer game box art)

ART DIRECTOR
Arnie Fenner and Cathy Fenner, Spectrum Design, Underwood
Irene Gallo, Tor

Don Puckey, Warner Aspect
David Stevenson, Del Rey
Jamie Warren Youll, Bantam Spectra

ARTISTIC ACHIEVEMENT
Jill Bauman
Brom
Alan M. Clark
Bob Eggleton
Jeff Jones
Moebius

CONTRIBUTION TO ASFA
Tomas L. Ryan de Heredia
Kim Ann Innes
Jael, Thea Glas, Ingrid and John Neilson
Morgana
Jeff Watson

2000

COVER ILLUSTRATION, HARDCOVER
Bob Eggleton: *Dragon and Phoenix* (novel by Joanne Bertin, Tor)
Bob Eggleton: *Rainbow Mars* (novel by Larry Niven, Tor)
Jody Lee: *The Black Swan* (novel by Mercedes Lackey, DAW)
Todd Lockwood: *The Spine of the World* (novel by R.A. Salvatore, Wizards of the Coast)
Michael Whelan: *Otherland: Mountain of Black Glass* (novel by Tad Williams, DAW)

COVER ILLUSTRATION, PAPERBACK
Rowena Morrill: *The Garden of the Stone* (novel by Victoria Strauss, Avon Eos)
John Jude Palencar: *The Terrorists of Irustan* (novel by Louise Marley, Ace)
Jean Pierre Targete: *Wrapt in Crystal* (novel by Sharon Shinn, Ace)
James Warhola: *Callahan's Crosstime Saloon* (collection by Spider Robinson, Tor)
Stephen Youll: *Eberien #1: The Company of Glass* (novel by Valery Leith, Bantam Spectra)

COVER ILLUSTRATION, MAGAZINE
Jill Bauman: *The Magazine of Fantasy & Science Fiction*, June 1999
Alan M. Clark: *Cemetery Dance*, Fall 1999
Bob Eggleton: *Strongbow* (story by R. Garcia y Robertson, *The Magazine of Fantasy & Science Fiction*, August 1999)
Greg Hildebrandt: *Realms of Fantasy*, August 1999
Ron Walotsky: *The Magazine of Fantasy & Science Fiction*, April 1999

INTERIOR ILLUSTRATION
Vincent Di Fate: *Rules of Engagement* (novel by Elizabeth Moon, Easton Press)
James Gurney: *Dinotopia: First Flight* (illustrated book by James Gurney, HarperCollins)
Jael: *The Little Princess* (novel by Francis Hodgson Burnett, Kidsbooks)
Marianne Plumridge: *Rainbow Mothra* (G-Fan, March/April 1999)
Omar Rayyan: *Weighing the Elephant* (Spider, March 1999)

COLOUR WORK, UNPUBLISHED
Bob Eggleton: *Dragonstorm*
Marc Fishman: *Titania*
Stephen Hickman: *At the Entmoot*
Don Maitz: *King Solomon's Mines*
Marianne Plumridge: *Aphrodite Rising*
Michael Whelan: *Peace*

MONOCHROME WORK, UNPUBLISHED
Rick Berry: *Artemis*
Bob Eggleton: *Dragonhenge*
Stanley Morrison: *Asian Wonders*
Sheila Rayyan: *Claire et la Luna*
Sheila Rayyan: *It Followed Me Home, Can I Keep It?*

THREE-DIMENSIONAL WORK
Marian Crane: *Maschera d'Osso*
Halla Fleisher: *Never Say Die*
Johnna Klukas: *From the Astrologer's Anteroom*
Marianne Plumridge: *Heartsong*
Lisa Snellings: *Bendyman*

GAMING-RELATED ILLUSTRATION
Brom: *Warriors of Heaven and Guide to Hell* (Duelist insert poster)
Donato Giancola: *Ivy Scholar* (card art, Magic: The Gathering™)
Carol Heyer: *Dune* (Last Unicorn Games/Wizards of the Coast card art)
Todd Lockwood: *Creatures of the Night* (Golems)
R.K. Post: *Unmask* (card art, Magic: The Gathering™)

PRODUCT ILLUSTRATION
Richard Bober: *Cleopatra* (plate art, Bradford Exchange)
Ian McCaig: character and costume design, *Star Wars, Episode One: The Phantom Menace*
Kinuko Y. Craft: *Honey Lemon Ginseng Green Tea* (box art, Celestial Seasonings)
Keith Parkinson: *Everquest* (cover art, 989 Studios/Sony)
Drew Struzan: (poster art, *Star Wars, Episode One: The Phantom Menace*)

ART DIRECTOR
Jim Baen, Baen
Cathy Fenner and Arnie Fenner, *Spectrum* and *Legacy*
Irene Gallo, Tor
Don Puckey, Warner Aspect
Ron Spears, Wizards of the Coast

ARTISTIC ACHIEVEMENT
John Berkey
Rick Berry
David Cherry
Stephen Hickman
Ron Walotsky

CONTRIBUTION TO ASFA
Jael
Jeff Watson
Mel White
Wizards of the Coast

2001

COVER ILLUSTRATION, HARDCOVER
Kinuko Y. Craft: *The Tower at Stony Wood* (novel by Patricia A. McKillip, Ace)
Bob Eggleton: *Darkness Descending* (novel by Harry M. Turtledove, Tor)
Donato Giancola: *The Lord of the Rings* (novel by J.R.R. Tolkien, Science Fiction Book Club)
John Jude Palencar: *Forests of the Heart* (novel by Charles De Lint, Tor)
Michael Whelan: *Tangled Up In Blue* (novel by Joan D. Vinge, Tor)

COVER ILLUSTRATION, PAPERBACK
Donato Giancola: *Carthage Ascendant: The Book of Ash #2* (novel by Mary Gentle, HarperPrism)
Don Maitz: *The Magic Dead* (novel by Peter Garrison, Ace)

Mark Zug: *Clandestine Circle* (novel by Mark Herbert, Wizards of the Coast)
Larry Elmore: *The Chick's in the Mail* (anthology edited by Esther Friesner, Baen)
Jean Pierre Targete: *Circle at Center* (novel by Douglas Niles, Ace)

COVER ILLUSTRATION, MAGAZINE
Brom: *Dragon*, June 2000
Bob Eggleton: *Sue* (Chicon Program Book)
Frank Kelly Freas: *Analog*, October 2000
Jael: *Dreams of Decadence*, Summer 2000
Joe Jusko: *Tomb Raider #6*
Todd Lockwood: *Dragon*, July 2000
Omar Rayyan: *Dragon*, November 2000
Luis Royo: *Heavy Metal*, November 2000

INTERIOR ILLUSTRATION
Kinuko Y. Craft: *Cinderella* (children's book by Kinuko Y. Craft, Sea Star)
Leo and Diane Dillon: *2000 Leagues Under the Sea* (novel by Jules Verne, Morrow)
Ruth Sanderson: *Where Have the Unicorns Gone?* (children's book by Jane Yolen, Simon & Schuster)
William Stout: *The New Dinosaurs* (illustrated book by William Stout, iBooks)

COLOUR WORK, UNPUBLISHED
H. Ed Cox: *Dance of the Dead*
Lubov: *Daybreak*
Marianne Plumridge: *Appointment with Death*
Omar Rayyan: *The Berry Market*
Michael Whelan: *The Reach*

MONOCHROME WORK, UNPUBLISHED
Jill Bauman: *The Secret Garden* (sketch for colour final published by Longmeadow Press)
Charles Keegan: *Anubis*
Joel Keener: *Enchanted Wood*
Stanley W. Morrison: *Baby Dragon*
Drew Willis: *A Wizard of Earthsea*

THREE-DIMENSIONAL WORK
Robert Belgrad: *The White Dragon*
Wendy Froud: *Goth Faery*
Johnna Klukas: *Bookstand*
Sandra Lira: *Millennium Angel*
Clayburn Moore: *Frazetta's Barbarian*

GAMING-RELATED ILLUSTRATION
Tristan Elwell: *Staunch Defenders* (card art, Magic™)
Jeff Laubenstein: *Castles and Covenants* (White Wolf Publishing)
Todd Lockwood: *Forge of Fury* (module, Dungeons & Dragons™)
Ian Miller: *Crucible: Conquest of the Final Realm*
Drew Struzan: *Star Wars Role Playing Game* (core rulebook cover)

PRODUCT ILLUSTRATION
Braldt Bralds: *Boucat* (Greenwich Workshop art print)
Kinuko Y. Craft: *Angel* (Christmas greeting card, Marcel Schurman Co.)
Donato Giancola: *Dracopaleontology* (SFBC flyer/calendar)
Todd Lockwood: *Redgar* (stand-up ad, Dungeons & Dragons™)

Keith Parkinson: *Everquest: The Scars of Velious* (cover, Sony/989 Studios)

ART DIRECTOR
Jim Baen, Baen
Irene Gallo, Tor
Sheila Gilbert, DAW
Jon Schindehette, TSR and Wizards of the Coast
Jamie Warren Youll, Bantam Spectra

ARTISTIC ACHIEVEMENT
Frank Kelly Freas
Tom Kidd
Don Maitz
John Jude Palencar
Lisa Snellings

CONTRIBUTION TO ASFA
Todd Lockwood, Jon Schindehette and Wizards of the Coast
Morgana McGee
Mel White

2002

COVER ILLUSTRATION, HARDCOVER
Bob Eggleton: *Dragon Society* (novel by Lawrence Watt-Evans, Tor)
Donato Giancola: *Ashling* (novel by Isobelle Carmody, Tor)
Don Maitz: *Kingdoms of Light* (novel by Alan Dean Foster, Warner Aspect)
Keith Parkinson: *The Pillars of Creation* (novel by Terry Goodkind, Tor)
Michael Whelan: *Otherland: Sea of Silver Light* (novel by Tad Williams, DAW)

COVER ILLUSTRATION, PAPERBACK
Leo and Diane Dillon: *Lirael* (novel by Garth Nix, Allen & Unwin)
Bob Eggleton: *Forge of the Elders* (novel by L. Neil Smith, Baen)
Donato Giancola: *The Hobbit* (graphic novel adaptation of the novel by J.R.R. Tolkien, Del Rey)
John Jude Palencar: *The Bone Doll's Twin* (novel by Lynn Flewelling, Bantam Spectra)
Stephen Youll: *The Way of the Rose* (novel by Valery Leith, Bantam Spectra)

COVER ILLUSTRATION, MAGAZINE
James C. Christensen: *The Leading Edge*, April 2001
Bob Eggleton: *Analog*, July/August 2001
James Gurney: *From A to Z in the Sarsaparilla Alphabet* (story by Harlan Ellison, *The Magazine of Fantasy & Science Fiction*, February 2001)
Jael: *Science Fiction Chronicle*, July 2001
Todd Lockwood: *Dragon*, June 2001

INTERIOR ILLUSTRATION
David Cherry: *The World of Shannara* (nonfiction book by Terry Brooks and Teresa Patterson, Del Rey)
Kinuko Y. Craft: *The Adventures of Tom Thumb* (children's book by Marianne Mayer, Sea Star)
Tom Kidd: *The War of the Worlds* (novel by H.G. Wells, Books of Wonder)
Don Maitz: *The Dreamthief's Daughter* (novel by Michael Moorcock, *American Fantasy*, March 2001)

Ruth Sanderson: *The Golden Mare, the Firebird, and the Magic Ring* (children's book by Ruth Sanderson, Little Brown)

COLOUR WORK, UNPUBLISHED
Jael: *Floue*
Omar Rayyan: *Felis Nocturnus*
Anne Sudworth: *The Snow Tree*
Michael Whelan: *Lumen 6.2*
Lawrence Allen Williams: *Titania*

MONOCHROME WORK, UNPUBLISHED
Colleen Doran: *The Six Swans*
Daniel Horne: *Arcadia Study*
Tom Kidd: *The Faeries of Spellcaster*
Nick Stathopoulos: *Dragon Study #1*
Hicaru Tanaka: *Knight in Gray*

THREE-DIMENSIONAL WORK
Wendy Froud: *Narnia's Friend*
Johnna Klukas: *Hall Table of the Mountain King*
Sandra Lira: *XT-793*
Clayburn Moore: *Fathom*
Lisa Snellings Clark: *Flying Blind*

GAMING-RELATED ILLUSTRATION
Donato Giancola: *Shivan Dragon* (card art, Magic™)
Todd Lockwood: *Lord of the Iron Fortress* (module cover, Dungeons & Dragons™)
William O'Connor: *Respite* (card art, Legend of the Five Rings™)
r.k. post: *Lightning Angel* (card art, Magic: Apocalypse Expansion™)
Ruth Thompson: *Hackmaster: The Player's Book* (Wizards of the Coast/Lucas Film Books)

PRODUCT ILLUSTRATION
David Cherry: *Poseidon* (poster art, Age of Mythology)
Kinuko Y. Craft: *Die Valküre* (poster, Dallas Opera)
James Christensen: *Faery Tales* (fine art print, The Greenwich Workshop)
Keith Parkinson: *Shadows of Luclin* (box art, Everquest™)
Matthew Stawicki: *Magic Invasion* (advertisement, Wizards of the Coast)

ART DIRECTOR
Jim Baen, Baen
Paul Barnett, Paper Tiger
Irene Gallo, Tor
Don Puckey, Warner Aspect
Ron Spears, Wizards of the Coast

ARTISTIC ACHIEVEMENT
Kinuko Y. Craft
Donato Giancola
John Howe
Michael Kaluta
Real Musgrave

CONTRIBUTION TO ASFA
Holly Bird
Todd Lockwood, Jon Schindehette and Wizards of the Coast
Morgana
Lynn Perkins
Geoffrey Surrette

INDEX OF ARTISTS AND WORKS

Page numbers refer to captions